THE RENAISSANCE

Studies in Art and Poetry

WALTER PATER

DOVER PUBLICATIONS, INC.
Mineola, New York

Bibliographical Note

This Dover edition, first published in 2005, is an unabridged republication of the Fourth Edition of the work originally published in 1893 by Macmillan and Co., London and New York. This was the last version to be corrected and revised by the author himself, since Pater died in 1894.

International Standard Book Number: 0-486-44025-7

Manufactured in the United States of America
Dover Publications, Inc., 31 East 2nd Street, Mineola, N.Y. 11501

Contents

Yet shall ye be as the wings of a dove

PREFACE

MANY attempts have been made by writers on art and poetry to define beauty in the abstract, to express it in the most general terms, to find some universal formula for it. The value of these attempts has most often been in the suggestive and penetrating things said by the way. Such discussions help us very little to enjoy what has been well done in art or poetry, to discriminate between what is more and what is less excellent in them, or to use words like beauty, excellence, art, poetry, with a more precise meaning than they would otherwise have. Beauty, like all other qualities presented to human experience, is relative; and the definition of it becomes unmeaning and useless in proportion to its abstractness. To define beauty, not in the most abstract but in the most concrete terms possible, to find, not its universal formula, but the formula which expresses most adequately this or that special manifestation of it, is the aim of the true student of æsthetics.

"To see the object as in itself it really is, has been justly said to be the aim of all true criticism whatever; and in æsthetic criticism the first step towards seeing one's object as it really is, is to know one's own impression as it really is, to discriminate it, to realise it distinctly. The objects with which æsthetic criticism deals—music, poetry, artistic and accomplished forms of human life—are indeed receptacles of so many powers or forces: they possess, like the products of nature, so many virtues or qualities. What is this song or picture, this engaging personality presented in life or in a book, to *me*? What effect does it really produce on me? Does it give me pleasure? and if so, what sort or degree of pleasure? How is my nature modified by its presence, and under its influence? The answers to these questions are the original facts with which the æsthetic critic has to do; and, as in the study of light, of morals, of number, one must realise such primary

1

data for one's self, or not at all. And he who experiences these impressions strongly, and drives directly at the discrimination and analysis of them, has no need to trouble himself with the abstract question what beauty is in itself, or what its exact relation to truth or experience—metaphysical questions, as unprofitable as metaphysical questions elsewhere. He may pass them all by as being, answerable or not, of no interest to him.

The æsthetic critic, then, regards all the objects with which he has to do, all works of art, and the fairer forms of nature and human life, as powers or forces producing pleasurable sensations, each of a more or less peculiar or unique kind. This influence he feels, and wishes to explain, by analysing and reducing it to its elements. To him, the picture, the landscape, the engaging personality in life or in a book, *La Gioconda,* the hills of Carrara, Pico of Mirandola, are valuable for their virtues, as we say, in speaking of a herb, a wine, a gem; for the property each has of affecting one with a special, a unique, impression of pleasure. Our education becomes complete in proportion as our susceptibility to these impressions increases in depth and variety. And the function of the æsthetic critic is to distinguish, to analyse, and separate from its adjuncts, the virtue by which a picture, a landscape, a fair personality in life or in a book, produces this special impression of beauty or pleasure, to indicate what the source of that impression is, and under what conditions it is experienced. His end is reached when he has disengaged that virtue, and noted it, as a chemist notes some natural element, for himself and others; and the rule for those who would reach this end is stated with great exactness in the words of a recent critic of Sainte-Beuve:—*De se borner à connaître de près les belles choses, et à s'en nourrir en exquis amateurs, en humanistes accomplis.*

What is important, then, is not that the critic should possess a correct abstract definition of beauty for the intellect, but a certain kind of temperament, the power of being deeply moved by the presence of beautiful objects. He will remember always that beauty exists in many forms. To him all periods, types, schools of taste, are in themselves equal. In all ages there have been some excellent workmen, and some excellent work done. The

question he asks is always:—In whom did the stir, the genius, the sentiment of the period find itself? where was the receptacle of its refinement, its elevation, its taste? "The ages are all equal," says William Blake, "but genius is always above its age."

Often it will require great nicety to disengage this virtue from the commoner elements with which it may be found in combination. Few artists, not Goethe or Byron even, work quite cleanly, casting off all *débris,* and leaving us only what the heat of their imagination has wholly fused and transformed. Take, for instance, the writings of Wordsworth. The heat of his genius, entering into the substance of his work, has crystallised a part, but only a part, of it; and in that great mass of verse there is much which might well be forgotten. But scattered up and down it, sometimes fusing and transforming entire composi tions, like the Stanzas on *Resolution and Independence,* or the *Ode on the Recollections of Childhood,* sometimes, as if at random, depositing a fine crystal here or there, in a matter it does not wholly search through and transmute, we trace the action of his unique, incommunicable faculty, that strange, mystical sense of a life in natural things, and of man's life as a part of nature, drawing strength and colour and character from local influences, from the hills and streams, and from natural sights and sounds. Well! that is the *virtue,* the active principle in Wordsworth's poetry; and then the function of the critic of Wordsworth is to follow up that active principle, to disengage it, to mark the degree in which it penetrates his verse.

The subjects of the following studies are taken from the history of the *Renaissance,* and touch what I think the chief points in that complex, many-sided movement. I have explained in the first of them what I understand by the word, giving it a much wider scope than was intended by those who originally used it to denote that revival of classical antiquity in the fifteenth century which was only one of many results of a general excitement and enlightening of the human mind, but of which the great aim and achievements of what, as Christian art, is often falsely opposed to the Renaissance, were another result. This outbreak of the human spirit may be traced far into the middle age itself, with its motives already clearly pronounced, the care for physical

beauty, the worship of the body, the breaking down of those limits which the religious system of the middle age imposed on the heart and the imagination. I have taken as an example of this movement, this earlier Renaissance within the middle age itself, and as an expression of its qualities, two little compositions in early French; not because they constitute the best possible expression of them, but because they help the unity of my series, inasmuch as the Renaissance ends also in France, in French poetry, in a phase of which the writings of Joachim du Bellay are in many ways the most perfect illustration. The Renaissance, in truth, put forth in France an aftermath, a wonderful later growth, the products of which have to the full that subtle and delicate sweetness which belongs to a refined and comely decadence, as its earliest phases have the freshness which belongs to all periods of growth in art, the charm of *ascêsis*, of the austere and serious girding of the loins in youth.

But it is in Italy, in the fifteenth century, that the interest of the Renaissance mainly lies,—in that solemn fifteenth century which can hardly be studied too much, not merely for its positive results in the things of the intellect and the imagination, its concrete works of art, its special and prominent personalities, with their profound æsthetic charm, but for its general spirit and character, for the ethical qualities of which it is a consummate type.

The various forms of intellectual activity which together make up the culture of an age, move for the most part from different starting-points, and by unconnected roads. As products of the same generation they partake indeed of a common character, and unconsciously illustrate each other; but of the producers themselves, each group is solitary, gaining what advantage or disadvantage there may be in intellectual isolation. Art and poetry, philosophy and the religious life, and that other life of refined pleasure and action in the conspicuous places of the world, are each of them confined to its own circle of ideas, and those who prosecute either of them are generally little curious of the thoughts of others. There come, however, from time to time, eras of more favourable conditions, in which the thoughts of men draw nearer together than is their wont, and the many

interests of the intellectual world combine in one complete type of general culture. The fifteenth century in Italy is one of these happier eras, and what is sometimes said of the age of Pericles is true of that of Lorenzo:—it is an age productive in personalities, many-sided, centralised, complete. Here, artists and philosophers and those whom the action of the world has elevated and made keen, do not live in isolation, but breathe a common air, and catch light and heat from each other's thoughts. There is a spirit of general elevation and enlightenment in which all alike communicate. The unity of this spirit gives unity to all the various products of the Renaissance; and it is to this intimate alliance with mind, this participation in the best thoughts which that age produced, that the art of Italy in the fifteenth century owes much of its grave dignity and influence.

I have added an essay on Winckelmann, as not incongruous with the studies which precede it, because Winckelmann, coming in the eighteenth century, really belongs in spirit to an earlier age. By his enthusiasm for the things of the intellect and the imagination for their own sake, by his Hellenism, his life-long struggle to attain to the Greek spirit, he is in sympathy with the humanists of a previous century. He is the last fruit of the Renaissance, and explains in a striking way its motive and tendencies.

1873.

TWO EARLY FRENCH STORIES

T HE history of the Renaissance ends in France, and carries us away from Italy to the beautiful cities of the country of the Loire. But it was in France also, in a very important sense, that the Renaissance had begun. French writers, who are fond of connecting the creations of Italian genius with a French origin, who tell us how Saint Francis of Assisi took not his name only, but all those notions of chivalry and romantic love which so deeply penetrated his thoughts, from a French source, how Boccaccio borrowed the outlines of his stories from the old French *fabliaux*, and how Dante himself expressly connects the origin of the art of miniature-painting with the city of Paris, have often dwelt on this notion of a Renaissance in the end of the twelfth and the beginning of the thirteenth century, a Renaissance within the limits of the middle age itself—a brilliant, but in part abortive effort to do for human life and the human mind what was afterwards done in the fifteenth. The word *Renaissance*, indeed, is now generally used to denote not merely the revival of classical antiquity which took place in the fifteenth century, and to which the word was first applied, but a whole complex movement, of which that revival of classical antiquity was but one element or symptom. For us the Renaissance is the name of a many-sided but yet united movement, in which the love of the things of the intellect and the imagination for their own sake, the desire for a more liberal and comely way of conceiving life, make themselves felt, urging those who experience this desire to search out first one and then another means of intellectual or imaginative enjoyment, and directing them not only to the discovery of old and forgotten sources of this enjoyment, but to the divination of fresh sources thereof—new experiences, new subjects of poetry, new forms of art. Of such feeling there was a great outbreak in the end of the

6

twelfth and the beginning of the following century. Here and there, under rare and happy conditions, in pointed architecture, in the doctrines of romantic love, in the poetry of Provence, the rude strength of the middle age turns to sweetness; and the taste for sweetness generated there becomes the seed of the classical revival in it, prompting it constantly to seek after the springs of perfect sweetness in the Hellenic world. And coming after a long period in which this instinct had been crushed, that true "dark age," in which so many sources of intellectual and imaginative enjoyment had actually disappeared, this outbreak is rightly called a Renaissance, a revival.

Theories which bring into connexion with each other modes of thought and feeling, periods of taste, forms of art and poetry, which the narrowness of men's minds constantly tends to oppose to each other, have a great stimulus for the intellect, and are almost always worth understanding. It is so with this theory of a Renaissance within the middle age, which seeks to establish a continuity between the most characteristic work of that period, the sculpture of Chartres, the windows of Le Mans, and the work of the later Renaissance, the work of Jean Cousin and Germain Pilon, thus healing that rupture between the middle age and the Renaissance which has so often been exaggerated. But it is not so much the ecclesiastical art of the middle age, its sculpture and painting—work certainly done in a great measure for pleasure's sake, in which even a secular, a rebellious spirit often betrays itself—but rather its profane poetry, the poetry of Provence, and the magnificent after-growth of that poetry in Italy and France, which those French writers have in view when they speak of this medieval Renaissance. In that poetry, earthly passion, with its intimacy, its freedom, its variety—the liberty of the heart—makes itself felt; and the name of Abelard, the great scholar and the great lover, connects the expression of this liberty of heart with the free play of human intelligence around all subjects presented to it, with the liberty of the intellect, as that age understood it.

Every one knows the legend of Abelard; a legend hardly less passionate, certainly not less characteristic of the middle age, than the legend of Tannhäuser; how the famous and comely

clerk, in whom Wisdom herself, self-possessed, pleasant, and discreet, seemed to sit enthroned, came to live in the house of a canon of the church of *Notre-Dame,* where dwelt a girl, Heloïse, believed to be the old priest's orphan niece; how the old priest had testified his love for her by giving her an education then unrivalled, so that rumour asserted that, through the knowledge of languages, enabling her to penetrate into the mysteries of the older world, she had become a sorceress, like the Celtic druidesses; and how as Abelard and Heloïse sat together at home there, to refine a little further on the nature of abstract ideas, "Love made himself of the party with them." You conceive the temptations of the scholar, who, in such dreamy tranquillity, amid the bright and busy spectacle of the "Island," lived in a world of something like shadows; and that for one who knew so well how to assign its exact value to every abstract thought, those restraints which lie on the consciences of other men had been relaxed. It appears that he composed many verses in the vulgar tongue: already the young men sang them on the quay below the house. Those songs, says M. de Rémusat, were probably in the taste of the *Trouvères,* "of whom he was one of the first in date, or, so to speak, the predecessor." It is the same spirit which has moulded the famous "letters," written in the quaint Latin of the middle age.

At the foot of that early Gothic tower, which the next generation raised to grace the precincts of Abelard's school, on the "Mountain of Saint Geneviève," the historian Michelet sees in thought "a terrible assembly; not the hearers of Abelard alone, fifty bishops, twenty cardinals, two popes, the whole body of scholastic philosophy; not only the learned Heloïse, the teaching of languages, and the Renaissance; but Arnold of Brescia—that is to say, the revolution." And so from the rooms of this shadowy house by the Seine side we see that spirit going abroad, with its qualities already well defined, its intimacy, its languid sweetness, its rebellion, its subtle skill in dividing the elements of human passion, its care for physical beauty, its worship of the body, which penetrated the early literature of Italy, and finds an echo even in Dante.

That Abelard is not mentioned in the *Divine Comedy* may

appear a singular omission to the reader of Dante, who seems to have inwoven into the texture of his work whatever had impressed him as either effective in colour or spiritually significant among the recorded incidents of actual life. Nowhere in his great poem do we find the name, nor so much as an allusion to the story of one who had left so deep a mark on the philosophy of which Dante was an eager student, of whom in the *Latin Quarter*, and from the lips of scholar or teacher in the University of Paris, during his sojourn among them, he can hardly have failed to hear. We can only suppose that he had indeed considered the story and the man, and abstained from passing judgment as to his place in the scheme of "eternal justice."

In the famous legend of Tannhäuser, the erring knight makes his way to Rome, to seek absolution at the centre of Christian religion. "So soon," thought and said the Pope, "as the staff in his hand should bud and blossom, so soon might the soul of Tannhäuser be saved, and no sooner"; and it came to pass not long after that the dry wood of a staff which the Pope had carried in his hand was covered with leaves and flowers. So, in the cloister of Godstow, a petrified tree was shown of which the nuns told that the fair Rosamond, who had died among them, had declared that, the tree being then alive and green, it would be changed into stone at the hour of her salvation. When Abelard died, like Tannhäuser, he was on his way to Rome. What might have happened had he reached his journey's end is uncertain; and it is in this uncertain twilight that his relation to the general beliefs of his age has always remained. In this, as in other things, he prefigures the character of the Renaissance, that movement in which, in various ways, the human mind wins for itself a new kingdom of feeling and sensation and thought, not opposed to but only beyond and independent of the spiritual system then actually realised. The opposition into which Abelard is thrown, which gives its colour to his career, which breaks his soul to pieces, is a no less subtle opposition than that between the merely professional, official, hireling ministers of that system, with their ignorant worship of system for its own sake, and the true child of light, the humanist, with reason and heart and senses quick, while theirs were almost dead. He

reaches out towards, he attains, modes of ideal living, beyond the prescribed limits of that system, though in essential germ, it may be, contained within it. As always happens, the adherents of the poorer and narrower culture had no sympathy with, because no understanding of, a culture richer and more ample than their own. After the discovery of wheat they would still live upon acorns—*après l'invention du blé ils voulaient encore vivre du gland;* and would hear of no service to the higher needs of humanity with instruments not of their forging.

But the human spirit, bold through those needs, was too strong for them. Abelard and Heloïse write their letters—letters with a wonderful outpouring of soul—in medieval Latin; and Abelard, though he composes songs in the vulgar tongue, writes also in Latin those treatises in which he tries to find a ground of reality below the abstractions of philosophy, as one bent on trying all things by their congruity with human experience, who had felt the hand of Heloïse, and looked into her eyes, and tested the resources of humanity in her great and energetic nature. Yet it is only a little later, early in the thirteenth century, that French prose romance begins; and in one of the pretty volumes of the *Bibliothèque Elzevirienne* some of the most striking fragments of it may be found, edited with much intelligence. In one of these thirteenth-century stories, *Li Amitiez de Ami et Amile,* that free play of human affection, of the claims of which Abelard's story is an assertion, makes itself felt in the incidents of a great friendship, a friendship pure and generous, pushed to a sort of passionate exaltation, and more than faithful unto death. Such comradeship, though instances of it are to be found everywhere, is still especially a classical motive; Chaucer expressing the sentiment of it so strongly in an antique tale, that one knows not whether the love of both Palamon and Arcite for Emelya, or of those two for each other, is the chiefer subject of the *Knight's Tale—*

> He cast his eyen upon Emelya,
> And therewithal he bleynte and cried, ah!
> As that he stongen were unto the herte.

What reader does not refer something of the bitterness of that cry to the spoiling, already foreseen, of the fair friendship,

which had made the prison of the two lads sweet hitherto with its daily offices?

The friendship of Amis and Amile is deepened by the romantic circumstance of an entire personal resemblance between the two heroes, through which they pass for each other again and again, and thereby into many strange adventures; that curious interest of the *Doppelgänger,* which begins among the stars with the Dioscuri, being entwined in and out through all the incidents of the story, like an outward token of the inward similitude of their souls. With this, again, is connected, like a second reflexion of that inward similitude, the conceit of two marvellously beautiful cups, also exactly like each other—children's cups, of wood, but adorned with gold and precious stones. These two cups, which by their resemblance help to bring the friends together at critical moments, were given to them by the Pope, when he baptised them at Rome, whither the parents had taken them for that purpose, in gratitude for their birth. They cross and recross very strangely in the narrative, serving the two heroes almost like living things, and with that well-known effect of a beautiful object, kept constantly before the eye in a story or poem, of keeping sensation well awake, and giving a certain air of refinement to all the scenes into which it enters. That sense of fate, which hangs so much of the shaping of human life on trivial objects, like Othello's strawberry handkerchief, is thereby heightened, while witness is borne to the enjoyment of beautiful handiwork by a primitive people, their simple wonder at it, so that they give it an oddly significant place among the factors of a human history.

Amis and Amile, then, are true to their comradeship through all trials; and in the end it comes to pass that at a moment of great need Amis takes the place of Amile in a tournament for life or death. "After this it happened that a leprosy fell upon Amis, so that his wife would not approach him, and wrought to strangle him. He departed therefore from his home, and at last prayed his servants to carry him to the house of Amile"; and it is in what follows that the curious strength of the piece shows itself:—

"His servants, willing to do as he desired, carried him to the place where Amile was; and they began to sound their rattles

before the court of Amile's house, as lepers are accustomed to do. And when Amile heard the noise he commanded one of his servants to carry meat and bread to the sick man, and the cup which was given to him at Rome filled with good wine. And when the servant had done as he was commanded, he returned and said, Sir, if I had not thy cup in my hand, I should believe that the cup which the sick man has was thine, for they are alike, the one to the other, in height and fashion. And Amile said, Go quickly and bring him to me. And when Amis stood before his comrade Amile demanded of him who he was, and how he had gotten that cup. I am of Briquain le Chastel, answered Amis, and the cup was given to me by the Bishop of Rome, who baptised me. And when Amile heard that, he knew that it was his comrade Amis, who had delivered him from death, and won for him the daughter of the King of France to be his wife. And straightway he fell upon him, and began weeping greatly, and kissed him. And when his wife heard that, she ran out with her hair in disarray, weeping and distressed exceedingly, for she remembered that it was he who had slain the false Ardres. And thereupon they placed him in a fair bed, and said to him, Abide with us until God's will be accomplished in thee, for all we have is at thy service. So he and the two servants abode with them.

"And it came to pass one night, when Amis and Amile lay in one chamber without other companions, that God sent His angel Raphael to Amis, who said to him, Amis, art thou asleep? And he, supposing that Amile had called him, answered and said, I am not asleep, fair comrade! And the angel said to him, Thou hast answered well, for thou art the comrade of the heavenly citizens.—I am Raphael, the angel of our Lord, and am come to tell thee how thou mayest be healed; for thy prayers are heard. Thou shalt bid Amile, thy comrade, that he slay his two children and wash thee in their blood, and so thy body shall be made whole. And Amis said to him, Let not this thing be, that my comrade should become a murderer for my sake. But the angel said, It is convenient that he do this. And thereupon the angel departed.

"And Amile also, as if in sleep, heard those words; and he awoke and said, Who is it, my comrade, that hath spoken with

thee? And Amis answered, No man; only I have prayed to our Lord, as I am accustomed. And Amile said, Not so! but some one hath spoken with thee. Then he arose and went to the door of the chamber; and finding it shut he said, Tell me, my brother, who it was said those words to thee to-night. And Amis began to weep greatly, and told him that it was Raphael, the angel of the Lord, who had said to him, Amis, our Lord commands thee that -thou bid Amile slay his two children, and wash thee in their blood, and so thou shalt be healed of thy leprosy. And Amile was greatly disturbed at those words, and said, I would have given to thee my man-servants and my maid-servants and all my goods, and thou feignest that an angel hath spoken to thee that I should slay my two children. And immediately Amis began to weep, and said, I know that I have spoken to thee a terrible thing, but constrained thereto; I pray thee cast me not away from the shelter of thy house. And Amile answered that what he had covenanted with him, that he would perform, unto the hour of his death: But I conjure thee, said he, by the faith which there is between me and thee, and by our comradeship, and by the baptism we received together at Rome, that thou tell me whether it was man or angel said that to thee. And Amis answered again, So truly as an angel hath spoken to me this night, so may God deliver me from my infirmity!

"Then Amile began to weep in secret, and thought within himself: If this man was ready to die before the king for me, shall I not for him slay my children? Shall I not keep faith with him who was faithful to me even unto death? And Amile tarried no longer, but departed to the chamber of his wife, and bade her go hear the Sacred Office. And he took a sword, and went to the bed where the children were lying, and found them asleep. And he lay down over them and began to weep bitterly and said, Hath any man yet heard of a father who of his own will slew his children? Alas, my children! I am no longer your father, but your cruel murderer.

"And the children awoke at the tears of their father, which fell upon them; and they looked up into his face and began to laugh. And as they were of the age of about three years, he said, Your laughing will be turned into tears, for your innocent blood must

now be shed, and therewith he cut off their heads. Then he laid them back in the bed, and put the heads upon the bodies, and covered them as though they slept: and with the blood which he had taken he washed his comrade, and said, Lord Jesus Christ! who hast commanded men to keep faith on earth, and didst heal the leper by Thy word! cleanse now my comrade, for whose love I have shed the blood of my children.

"Then Amis was cleansed of his leprosy. And Amile clothed his companion in his best robes; and as they went to the church to give thanks, the bells, by the will of God, rang of their own accord. And when the people of the city heard that, they ran together to see the marvel. And the wife of Amile, when he saw Amis and Amile coming, asked which of the twain was her husband, and said, I know well the vesture of them both, but I know not which of them is Amile. And Amile said to her, I am Amile, and my companion is Amis, who is healed of his sickness. And she was full of wonder, and desired to know in what manner he was healed. Give thanks to our Lord, answered Amile, but trouble not thyself as to the manner of the healing.

"Now neither the father nor the mother had yet entered where the children were; but the father sighed heavily, because they were dead, and the mother asked for them, that they might rejoice together; but Amile said, Dame! let the children sleep. And it was already the hour of Tierce. And going in alone to the children to weep over them, he found them at play in the bed; only, in the place of the sword-cuts about their throats was as it were a thread of crimson. And he took them in his arms and carried them to his wife and said, Rejoice greatly, for thy children whom I had slain by the commandment of the angel are alive, and by their blood is Amis healed."

There, as I said, is the strength of the old French story. For the Renaissance has not only the sweetness which it derives from the classical world, but also that curious strength of which there are great resources in the true middle age. And as I have illustrated the early strength of the Renaissance by the story of Amis and Amile, a story which comes from the North, in which a certain racy Teutonic flavour is perceptible, so I shall illustrate

that other element, its early sweetness, a languid excess of sweetness even, by another story printed in the same volume of the *Bibliothèque Elzevirienne,* and of about the same date, a story which comes, characteristically, from the South, and connects itself with the literature of Provence.

The central love-poetry of Provence, the poetry of the *Tenson* and the *Aubade,* of Bernard de Ventadour and Pierre Vidal, is poetry for the few, for the elect and peculiar people of the kingdom of sentiment. But below this intenser poetry there was probably a wide range of literature, less serious and elevated, reaching, by lightness of form and comparative homeliness of interest, an audience which the concentrated passion of those higher lyrics left untouched. This literature has long since perished, or lives only in later French or Italian versions. One such version, the only representative of its species, M. Fauriel thought he detected in the story of *Aucassin and Nicolette,* written in the French of the latter half of the thirteenth century, and preserved in a unique manuscript, in the national library of Paris; and there were reasons which made him divine for it a still more ancient ancestry, traces in it of an Arabian origin, as in a leaf lost out of some early *Arabian Nights*[1].

The little book loses none of its interest through the criticism which finds in it only a traditional subject, handed on by one people to another; for after passing thus from hand to hand, its outline is still clear, its surface untarnished; and, like many other stories, books, literary and artistic conceptions of the middle age, it has come to have in this way a sort of personal history, almost as full of risk and adventure as that of its own heroes. The writer himself calls the piece a *cantefable,* a tale told in prose, but with its incidents and sentiment helped forward by songs,

[1] Recently, *Aucassin and Nicolette* has been edited and translated into English, with much graceful scholarship, by Mr. F. W. Bourdillon. Still more recently we have had a translation—a poet's translation—from the ingenious and versatile pen of Mr. Andrew Lang. The reader should consult also the chapter on "The Outdoor Poetry," in Vernon Lee's most interesting *Euphorion; being Studies of the Antique and Mediaeval in the Renaissance,* a work abounding in knowledge and insight on the subjects of which it treats.

inserted at irregular intervals. In the junctions of the story itself
there are signs of roughness and want of skill, which make one
suspect that the prose was only put together to connect a series
of songs—a series of songs so moving and attractive that people
wished to heighten and dignify their effect by a regular frame-
work of setting. Yet the songs themselves are of the simplest
kind, not rhymed even, but only imperfectly assonant, stanzas of
twenty or thirty lines apiece, all ending with a similar vowel
sound. And here, as elsewhere in that early poetry, much of the
interest lies in the spectacle of the formation of a new artistic
sense. A novel art is arising, the music of rhymed poetry, and in
the songs of Aucassin and Nicolette, which seem always on the
point of passing into true rhyme, but which halt somehow, and
can never quite take flight, you see people just growing aware of
the elements of a new music in their possession, and anticipat-
ing how pleasant such music might become.

The piece was probably intended to be recited by a company
of trained performers, many of whom, at least for the lesser
parts, were probably children. The songs are introduced by the
rubric, *Or se cante (ici on chante)* and each division of prose by
the rubric, *Or dient et content et fabloient (ici on conte)*. The
musical notes of a portion of the songs have been preserved; and
some of the details are so descriptive that they suggested to
M. Fauriel the notion that the words had been accompanied
throughout by dramatic action. That mixture of simplicity and
refinement which he was surprised to find in a composition of
the thirteenth century, is shown sometimes in the turn given to
some passing expression or remark; thus "the Count de Garins
was old and frail, his time was over"—*Li quens Garins de
Beaucaire estoit vix et frales; si avoit son tans trespassè*. And
then all is so realised! One sees the ancient forest, with its dis-
used roads grown deep with grass, and the place where seven
roads meet—*u a forkeut set cemin qui s'en vont par le païs;* we
hear the light-hearted country-people calling each other by
their rustic names, and putting forward, as their spokesman, one
among them who is more eloquent and ready than the rest—*li
un qui plus fu enparlés des autres;* for the little book has its bur-
lesque element also, so that one hears the faint, far-off laughter

still. Rough as it is, the piece certainly possesses this high quality of poetry, that it aims at a purely artistic effect. Its subject is a great sorrow, yet it claims to be a thing of joy and refreshment, to be entertained not for its matter only, but chiefly for its manner; it is *cortois,* it tells us, *et bien assis.*

For the student of manners, and of the old French language and literature, it has much interest of a purely antiquarian order. To say of an ancient literary composition that it has an antiquarian interest, often means that it has no distinct æsthetic interest for the reader of to-day. Antiquarianism, by a purely historical effort, by putting its object in perspective, and setting the reader in a certain point of view, from which what gave pleasure to the past is pleasurable for him also, may often add greatly to the charm we receive from ancient literature. But the first condition of such aid must be a real, direct, æsthetic charm in the thing itself. Unless it has that charm, unless some purely artistic quality went to its original making, no merely antiquarian effort can ever give it an æsthetic value, or make it a proper subject of æsthetic criticism. This quality, wherever it exists, it is always pleasant to define, and discriminate from the sort of borrowed interest which an old play, or an old story, may very likely acquire through a true antiquarianism. The story of Aucassin and Nicolette has something of this quality. Aucassin, the only son of Count Garins of Beaucaire, is passionately in love with Nicolette, a beautiful girl of unknown parentage, bought of the Saracens, whom his father will not permit him to marry. The story turns on the adventures of these two lovers, until at the end of the piece their mutual fidelity is rewarded. These adventures are of the simplest sort, adventures which seem to be chosen for the happy occasion they afford of keeping the eye of the fancy, perhaps the outward eye, fixed on pleasant objects, a garden, a ruined tower, the little hut of flowers which Nicolette constructs in the forest whither she escapes from her enemies, as a token to Aucassin that she has passed that way. All the charm of the piece is in its details, in a turn of peculiar lightness and grace given to the situations and traits of sentiment, especially in its quaint fragments of early French prose.

All through it one feels the influence of that faint air of over-

wrought delicacy, almost of wantonness, which was so strong a characteristic of the poetry of the Troubadours. The Troubadours themselves were often men of great rank; they wrote for an exclusive audience, people of much leisure and great refinement, and they came to value a type of personal beauty which has in it but little of the influence of the open air and sunshine. There is a languid Eastern deliciousness in the very scenery of the story, the full-blown roses, the chamber painted in some mysterious manner where Nicolette is imprisoned, the cool brown marble, the almost nameless colours, the odour of plucked grass and flowers. Nicolette herself well becomes this scenery, and is the best illustration of the quality I mean—the beautiful, weird, foreign girl, whom the shepherds take for a fay, who has the knowledge of simples, the healing and beautifying qualities of leaves and flowers, whose skilful touch heals Aucassin's sprained shoulder, so that he suddenly leaps from the ground; the mere sight of whose white flesh, as she passed the place where he lay, healed a pilgrim stricken with sore disease, so that he rose up, and returned to his own country. With this girl Aucassin is so deeply in love that he forgets all knightly duties. At last Nicolette is shut up to get her out of his way, and perhaps the prettiest passage in the whole piece is the fragment of prose which describes her escape:—

"Aucassin was put in prison, as you have heard, and Nicolette remained shut up in her chamber. It was summertime, in the month of May, when the days are warm and long and clear, and the nights coy and serene.

"One night Nicolette, lying on her bed, saw the moon shine clear through the little window, and heard the nightingale sing in the garden, and then came the memory of Aucassin, whom she so much loved. She thought of the Count Garins of Beaucaire, who mortally hated her, and, to be rid of her, might at any moment cause her to be burned or drowned. She perceived that the old woman who kept her company was asleep; she rose and put on the fairest gown she had; she took the bedclothes and the towels, and knotted them together like a cord,

as far as they would go. Then she tied the end to a pillar of the window, and let herself slip down quite softly into the garden, and passed straight across it, to reach the town.

"Her hair was yellow in small curls, her smiling eyes blue-green, her face clear and feat, the little lips very red, the teeth small and white; and the daisies which she crushed in passing, holding her skirt high behind and before, looked dark against her feet; the girl was so white!

"She came to the garden-gate and opened it, and walked through the streets of Beaucaire, keeping on the dark side of the way to be out of the light of the moon, which shone quietly in the sky. She walked as fast as she could, until she came to the tower where Aucassin was. The tower was set about with pillars, here and there. She pressed herself against one of the pillars, wrapped herself closely in her mantle, and putting her face to a chink of the tower, which was old and ruined, she heard Aucassin crying bitterly within, and when she had listened awhile she began to speak."—

But scattered up and down through this lighter matter, always tinged with humour and often passing into burlesque, which makes up the general substance of the piece, there are morsels of a different quality, touches of some intenser sentiment, coming it would seem from the profound and energetic spirit of the Provençal poetry itself, to which the inspiration of the book has been referred. Let me gather up these morsels of deeper colour, these expressions of the ideal intensity of love, the motive which really unites together the fragments of the little composition. Dante, the perfect flower of ideal love, has recorded how the tyranny of that "Lord of terrible aspect" became actually physical, blinding his senses, and suspending his bodily forces. In this, Dante is but the central expression and type of experiences known well enough to the initiated, in that passionate age. Aucassin represents this ideal intensity of passion—

> *Aucassin, li biax, li blons,*
> *Li gentix, li amorous;—*

slim, tall, debonair, *dansellon,* as the singers call him, with his curled yellow hair, and eyes of *vair,* who faints with love, as Dante fainted, who rides all day through the forest in search of Nicolette, while the thorns tear his flesh, so that one might have traced him by the blood upon the grass, and who weeps at eventide because he has not found her, who has the malady of his love, and neglects all knightly duties. Once he is induced to put himself at the head of his people, that they, seeing him before them, might have more heart to defend themselves; then a song relates how the sweet, grave figure goes forth to battle, in dainty, tight-laced armour. It is the very image of the Provençal love-god, no longer a child, but grown to pensive youth, as Pierre Vidal met him, riding on a white horse, fair as the morning, his vestment embroidered with flowers. He rode on through the gates into the open plain beyond. But as he went, that great malady of his love came upon him. The bridle fell from his hands; and like one who sleeps walking, he was carried on into the midst of his enemies, and heard them talking together how they might most conveniently kill him.

One of the strongest characteristics of that outbreak of the reason and the imagination, of that assertion of the liberty of the heart, in the middle age, which I have termed a medieval Renaissance, was its antinomianism, its spirit of rebellion and revolt against the moral and religious ideas of the time. In their search after the pleasures of the senses and the imagination, in their care for beauty, in their worship of the body, people were impelled beyond the bounds of the Christian ideal; and their love became sometimes a strange idolatry, a strange rival religion. It was the return of that ancient Venus, not dead, but only hidden for a time in the caves of the Venusberg, of those old pagan gods still going to and fro on the earth, under all sorts of disguises. And this element in the middle age, for the most part ignored by those writers who have treated it pre-eminently as the "Age of Faith"—this rebellious and antinomian element, the recognition of which has made the delineation of the middle age by the writers of the Romantic school in France, by Victor Hugo for instance in *Notre-Dame de Paris,* so suggestive and exciting—is found alike in the history of Abelard and the legend of

Tannhäuser. More and more, as we come to mark changes and distinctions of temper in what is often in one all-embracing confusion called the middle age, that rebellion, that sinister claim for liberty of heart and thought, comes to the surface. The Albigensian movement, connected so strangely with the history of Provençal poetry, is deeply tinged with it. A touch of it makes the Franciscan order, with its poetry, its mysticism, its "illumination," from the point of view of religious authority, justly suspect. It influences the thoughts of those obscure prophetical writers, like Joachim of Flora, strange dreamers in a world of flowery rhetoric of that third and final dispensation of a "spirit of freedom," in which law shall have passed away. Of this spirit *Aucassin and Nicolette* contains perhaps the most famous expression: it is the answer Aucassin gives when he is threatened with the pains of hell, if he makes Nicolette his mistress. A creature wholly of affection and the senses, he sees on the way to paradise only a feeble and worn-out company of aged priests, "clinging day and night to the chapel altars," barefoot or in patched sandals. With or even without Nicolette, "his sweet mistress whom he so much loves," he, for his part, is ready to start on the way to hell, along with "the good scholars," as he says, and the actors, and the fine horsemen dead in battle, and the men of fashion[2], and "the fair courteous ladies who had two or three chevaliers apiece beside their own true lords," all gay with music, in their gold, and silver, and beautiful furs—"the vair and the grey."

But in the *House Beautiful* the saints too have their place; and the student of the Renaissance has this advantage over the student of the emancipation of the human mind in the Reformation, or the French Revolution, that in tracing the footsteps of humanity to higher levels, he is not beset at every turn by the inflexibilities and antagonisms of some well-recognised controversy, with rigidly defined opposites, exhausting the intel-

[2] *Parage*, peerage:—which came to signify all that ambitious youth affected most on the outside of life, in that old world of the Troubadours, with whom this term is of frequent recurrence.

ligence and limiting one's sympathies. The opposition of the
professional defenders of a mere system to that more sincere
and generous play of the forces of human mind and character,
which I have noted as the secret of Abelard's struggle, is indeed
always powerful. But the incompatibility with one another of
souls really "fair" is not essential; and within the enchanted
region of the Renaissance, one needs not be for ever on one's
guard. Here there are no fixed parties, no exclusions: all
breathes of that unity of culture in which "whatsoever things are
comely" are reconciled, for the elevation and adorning of our
spirits. And just in proportion as those who took part in the
Renaissance become centrally representative of it, just so much
the more is this condition realised in them. The wicked popes,
and the loveless tyrants, who from time to time became its
patrons, or mere speculators in its fortunes, lend themselves
easily to disputations, and, from this side or that, the spirit of
controversy lays just hold upon them. But the painter of the
Last Supper, with his kindred, lives in a land where controversy
has no breathing-place. They refuse to be classified. In the story
of *Aucassin and Nicolette,* in the literature which it represents,
the note of defiance, of the opposition of one system to another,
is sometimes harsh. Let me conclude then with a morsel from
Amis and Amile, in which the harmony of human interests is still
entire. For the story of the great traditional friendship, in which,
as I said, the liberty of the heart makes itself felt, seems, as we
have it, to have been written by a monk:—*La vie des saints mar-
tyrs Amis et Amile.* It was not till the end of the seventeenth
century that their names were finally excluded from the martyr-
ology; and their story ends with this monkish miracle of earthly
comradeship, more than faithful unto death.—

"For, as God had united them in their lives in one accord, so
they were not divided in their death, falling together side by
side, with a host of other brave men, in battle for King Charles
at Mortara, so called from that great slaughter. And the bishops
gave counsel to the king and queen that they should bury the
dead, and build a church in that place; and their counsel pleased
the king greatly. And there were built two churches, the one by

commandment of the king in honour of Saint Oseige, and the other by commandment of the queen in honour of Saint Peter.

"And the king caused the two chests of stone to be brought in the which the bodies of Amis and Amile lay; and Amile was carried to the church of Saint Peter, and Amis to the church of Saint Oseige; and the other corpses were buried, some in one place and some in the other. But lo! next morning, the body of Amile in his coffin was found lying in the church of Saint Oseige, beside the coffin of Amis his comrade. Behold then this wondrous amity, which by death could not be dissevered!

"This miracle of God did, who gave to His disciples power to remove mountains. And by reason of this miracle the king and queen remained in that place for a space of thirty days, and performed the offices of the dead who were slain, and honoured the said churches with great gifts. And the bishop ordained many clerks to serve in the church of Saint Oseige, and commanded them that they should guard duly, with great devotion, the bodies of the two companions, Amis and Amile."

1872.

PICO DELLA MIRANDOLA

No account of the Renaissance can be complete without some notice of the attempt made by certain Italian scholars of the fifteenth century to reconcile Christianity with the religion of ancient Greece. To reconcile forms of sentiment which at first sight seem incompatible, to adjust the various products of the human mind to one another in one many-sided type of intellectual culture, to give humanity, for heart and imagination to feed upon, as much as it could possibly receive, belonged to the generous instincts of that age. An earlier and simpler generation had seen in the gods of Greece so many malignant spirits, the defeated but still living centres of the religion of darkness, struggling, not always in vain, against the kingdom of light. Little by little, as the natural charm of pagan story reasserted itself over minds emerging out of barbarism, the religious significance which had once belonged to it was lost sight of, and it came to be regarded as the subject of a purely artistic or poetical treatment. But it was inevitable that from time to time minds should arise, deeply enough impressed by its beauty and power to ask themselves whether the religion of Greece was indeed a rival of the religion of Christ; for the older gods had rehabilitated themselves, and men's allegiance was divided. And the fifteenth century was an impassioned age, so ardent and serious in its pursuit of art that it consecrated everything with which art had to do as a religious object. The restored Greek literature had made it familiar, at least in Plato, with a style of expression concerning the earlier gods, which had about it something of the warmth and unction of a Christian hymn. It was too familiar with such language to regard mythology as a mere story; and it was too serious to play with a religion.

"Let me briefly remind the reader"—says Heine, in the *Gods in Exile*, an essay full of that strange blending of sentiment which

24

is characteristic of the traditions of the middle age concerning
the pagan religions—"how the gods of the older world, at the
time of the definite triumph of Christianity, that is, in the third
century, fell into painful embarrassments, which greatly
resembled certain tragical situations of their earlier life. They
now found themselves beset by the same troublesome neces-
sities to which they had once before been exposed during the
primitive ages, in that revolutionary epoch when the Titans
broke out of the custody of Orcus, and, piling Pelion on Ossa,
scaled Olympus. Unfortunate gods! They had then to take
flight ignominiously, and hide themselves among us here on
earth, under all sorts of disguises. The larger number betook
themselves to Egypt, where for greater security they assumed
the forms of animals, as is generally known. Just in the same
way, they had to take flight again, and seek entertainment in
remote hiding-places, when those iconoclastic zealots, the
black brood of monks, broke down all the temples, and pur-
sued the gods with fire and curses. Many of these unfortunate
emigrants, now entirely deprived of shelter and ambrosia,
must needs take to vulgar handicrafts, as a means of earning
their bread. Under these circumstances, many whose sacred
groves had been confiscated, let themselves out for hire as
woodcutters in Germany, and were forced to drink beer
instead of nectar. Apollo seems to have been content to take
service under graziers, and as he had once kept the cows of
Admetus, so he lived now as a shepherd in Lower Austria.
Here, however, having become suspected on account of his
beautiful singing, he was recognised by a learned monk as one
of the old pagan gods, and handed over to the spiritual tri-
bunal. On the rack he confessed that he was the god Apollo;
and before his execution he begged that he might be suffered
to play once more upon the lyre, and to sing a song. And he
played so touchingly, and sang with such magic, and was withal
so beautiful in form and feature, that all the women wept, and
many of them were so deeply impressed that they shortly
afterwards fell sick. Some time afterwards the people wished
to drag him from the grave again, that a stake might be driven
through his body, in the belief that he had been a vampire, and

that the sick women would by this means recover. But they found the grave empty."

The Renaissance of the fifteenth century was, in many things, great rather by what it designed than by what it achieved. Much which it aspired to do, and did but imperfectly or mistakenly, was accomplished in what is called the *éclaircissement* of the eighteenth century, or in our own generation; and what really belongs to the revival of the fifteenth century is but the leading instinct, the curiosity, the initiatory idea. It is so with this very question of the reconciliation of the religion of antiquity with the religion of Christ. A modern scholar occupied by this problem might observe that all religions may be regarded as natural products, that, at least in their origin, their growth, and decay, they have common laws, and are not to be isolated from the other movements of the human mind in the periods in which they respectively prevailed; that they arise spontaneously out of the human mind, as expressions of the varying phases of its sentiment concerning the unseen world; that every intellectual product must be judged from the point of view of the age and the people in which it was produced. He might go on to observe that each has contributed something to the development of the religious sense, and ranging them as so many stages in the gradual education of the human mind, justify the existence of each. The basis of the reconciliation of the religions of the world would thus be the inexhaustible activity and creativeness of the human mind itself, in which all religions alike have their root, and in which all alike are reconciled; just as the fancies of childhood and the thoughts of old age meet and are laid to rest, in the experience of the individual.

Far different was the method followed by the scholars of the fifteenth century. They lacked the very rudiments of the historic sense, which, by an imaginative act, throws itself back into a world unlike one's own, and estimates every intellectual creation in its connexion with the age from which it proceeded. They had no idea of development, of the differences of ages, of the process by which our race has been "educated." In their attempts to reconcile the religions of the world, they were thus thrown back upon the quicksand of allegorical interpretation.

The religions of the world were to be reconciled, not as successive stages in a regular development of the religious sense, but as subsisting side by side, and substantially in agreement with one another. And here the first necessity was to misrepresent the language, the conceptions, the sentiments, it was proposed to compare and reconcile. Plato and Homer must be made to speak agreeably to Moses. Set side by side, the mere surfaces could never unite in any harmony of design. Therefore one must go below the surface, and bring up the supposed secondary, or still more remote meaning,—that diviner signification held in reserve, *in recessu divinius aliquid,* latent in some stray touch of Homer, or figure of speech in the books of Moses.

And yet as a curiosity of the human mind, a "madhouse-cell," if you will, into which we may peep for a moment, and see it at work weaving strange fancies, the allegorical interpretation of the fifteenth century has its interest. With its strange web of imagery, its quaint conceits, its unexpected combinations and subtle moralising, it is an element in the local colour of a great age. It illustrates also the faith of that age in all oracles, its desire to hear all voices, its generous belief that nothing which had ever interested the human mind could wholly lose its vitality. It is the counterpart, though certainly the feebler counterpart, of that practical truce and reconciliation of the gods of Greece with the Christian religion, which is seen in the art of the time. And it is for his share in this work, and because his own story is a sort of analogue or visible equivalent to the expression of this purpose in his writings, that something of a general interest still belongs to the name of Pico della Mirandola, whose life, written by his nephew Francis, seemed worthy, for some touch of sweetness in it, to be translated out of the original Latin by Sir Thomas More, that great lover of Italian culture, among whose works the life of Pico, *Earl of Mirandola, and a great lord of Italy,* as he calls him, may still be read, in its quaint, antiquated English.

Marsilio Ficino has told us how Pico came to Florence. It was the very day—some day probably in the year 1482—on which Ficino had finished his famous translation of Plato into Latin, the work to which he had been dedicated from childhood by

Cosmo de' Medici, in furtherance of his desire to resuscitate the knowledge of Plato among his fellow-citizens. Florence indeed, as M. Renan has pointed out, had always had an affinity for the mystic and dreamy philosophy of Plato, while the colder and more practical philosophy of Aristotle had flourished in Padua, and other cities of the north; and the Florentines, though they knew perhaps very little about him, had had the name of the great idealist often on their lips. To increase this knowledge, Cosmo had founded the Platonic academy, with periodical discussions at the Villa Careggi. The fall of Constantinople in 1453, and the council in 1438 for the reconciliation of the Greek and Latin Churches, had brought to Florence many a needy Greek scholar. And now the work was completed, the door of the mystical temple lay open to all who could construe Latin, and the scholar rested from his labour; when there was introduced into his study, where a lamp burned continually before the bust of Plato, as other men burned lamps before their favourite saints, a young man fresh from a journey, "of feature and shape seemly and beauteous, of stature goodly and high, of flesh tender and soft, his visage lovely and fair, his colour white, intermingled with comely reds, his eyes grey, and quick of look, his teeth white and even, his hair yellow and abundant," and trimmed with more than the usual artifice of the time.

It is thus that Sir Thomas More translates the words of the biographer of Pico, who, even in outward form and appearance, seems an image of that inward harmony and completeness, of which he is so perfect an example. The word *mystic* has been usually derived from a Greek word which signifies *to shut,* as if one *shut one's lips,* brooding on what cannot be uttered; but the Platonists themselves derive it rather from the act of *shutting the eyes,* that one may see the more, inwardly. Perhaps the eyes of the mystic Ficino, now long past the midway of life, had come to be thus half-closed; but when a young man, not unlike the archangel Raphael, as the Florentines of that age depicted him in his wonderful walk with Tobit, or Mercury, as he might have appeared in a painting by Sandro Botticelli or Piero di Cosimo, entered his chamber, he seems to have thought there was something not wholly earthly about him; at least, he ever afterwards

believed that it was not without the co-operation of the stars that the stranger had arrived on that day. For it happened that they fell into a conversation, deeper and more intimate than men usually fall into at first sight. During this conversation Ficino formed the design of devoting his remaining years to the translation of Plotinus, that new Plato, in whom the mystical element in the Platonic philosophy had been worked out to the utmost limit of vision and ecstasy; and it is in dedicating this translation to Lorenzo de' Medici that Ficino has recorded these incidents.

It was after many wanderings, wanderings of the intellect as well as physical journeys, that Pico came to rest at Florence. Born in 1463, he was then about twenty years old. He was called Giovanni at baptism, Pico, like all his ancestors, from Picus, nephew of the Emperor Constantine, from whom they claimed to be descended, and Mirandola from the place of his birth, a little town afterwards part of the duchy of Modena, of which small territory his family had long been the feudal lords. Pico was the youngest of the family, and his mother, delighting in his wonderful memory, sent him at the age of fourteen to the famous school of law at Bologna. From the first, indeed, she seems to have had some presentiment of his future fame, for, with a faith in omens characteristic of her time, she believed that a strange circumstance had happened at the time of Pico's birth—the appearance of a circular flame which suddenly vanished away, on the wall of the chamber where she lay. He remained two years at Bologna; and then, with an inexhaustible, unrivalled thirst for knowledge, the strange, confused, uncritical learning of that age, passed through the principal schools of Italy and France, penetrating, as he thought, into the secrets of all ancient philosophies, and many eastern languages. And with this flood of erudition came the generous hope, so often disabused, of reconciling the philosophers with one another, and all alike with the Church. At last he came to Rome. There, like some knight-errant of philosophy, he offered to defend nine hundred bold paradoxes, drawn from the most opposite sources, against all comers. But the pontifical court was led to suspect the orthodoxy of some of these propositions, and even the reading of the book which contained them was forbidden by the

Pope. It was not until 1493 that Pico was finally absolved, by a brief of Alexander the Sixth. Ten years before that date he had arrived at Florence; an early instance of those who, after following the vain hope of an impossible reconciliation from system to system, have at last fallen back unsatisfied on the simplicities of their childhood's belief.

The oration which Pico composed for the opening of this philosophical tournament still remains; its subject is the dignity of human nature, the greatness of man. In common with nearly all medieval speculation, much of Pico's writing has this for its drift; and in common also with it, Pico's theory of that dignity is founded upon a misconception of the place in nature both of the earth and of man. For Pico the earth is the centre of the universe: and around it, as a fixed and motionless point, the sun and moon and stars revolve, like diligent servants or ministers. And in the midst of all is placed man, *nodus et vinculum mundi,* the bond or copula of the world, and the "interpreter of nature": that famous expression of Bacon's really belongs to Pico. *Tritum est in scholis,* he says, *esse hominem minorem mundum, in quo mixtum ex elementis corpus et spiritus coelestis et plantarum anima vegetalis et brutorum sensus et ratio et angelica mens et Dei similitudo conspicitur:*—"It is a commonplace of the schools that man is a little world, in which we may discern a body mingled of earthy elements, and ethereal breath, and the vegetable life of plants, and the senses of the lower animals, and reason, and the intelligence of angels, and a likeness to God."

A commonplace of the schools! But perhaps it had some new significance and authority, when men heard one like Pico reiterate it; and, false as its basis was, the theory had its use. For this high dignity of man, thus bringing the dust under his feet into sensible communion with the thoughts and affections of the angels, was supposed to belong to him, not as renewed by a religious system, but by his own natural right. The proclamation of it was a counterpoise to the increasing tendency of medieval religion to depreciate man's nature, to sacrifice this or that element in it, to make it ashamed of itself, to keep the degrading or painful accidents of it always in view. It helped man onward to that reassertion of himself, that rehabilitation of human nature,

the body, the senses, the heart, the intelligence, which the
Renaissance fulfills. And yet to read a page of one of Pico's for-
gotten books is like a glance into one of those ancient sepul-
chres, upon which the wanderer in classical lands has sometimes
stumbled, with the old disused ornaments and furniture of a
world wholly unlike ours still fresh in them. That whole concep-
tion of nature is so different from our own. For Pico the world
is a limited place, bounded by actual crystal walls, and a mater-
ial firmament; it is like a painted toy, like that map or system of
the world, held, as a great target or shield, in the hands of the
creative *Logos*, by whom the Father made all things, in one of
the earlier frescoes of the *Campo Santo* at Pisa. How different
from this childish dream is our own conception of nature, with
its unlimited space, its innumerable suns, and the earth but a
mote in the beam; how different the strange new awe, or super-
stition, with which it fills our minds! "The silence of those infi-
nite spaces," says Pascal, contemplating a starlight night, "the
silence of those infinite spaces terrifies me:"—*Le silence éternel
de ces espaces infinis m'effraie.*

He was already almost wearied out when he came to
Florence. He had loved much and been beloved by women,
"wandering over the crooked hills of delicious pleasure"; but
their reign over him was over, and long before Savonarola's
famous "bonfire of vanities," he had destroyed those love-songs
in the vulgar tongue, which would have been so great a relief to
us, after the scholastic prolixity of his Latin writings. It was in
another spirit that he composed a Platonic commentary, the
only work of his in Italian which has come down to us, on the
"Song of Divine Love"—*secondo la mente ed opinione dei
Platonici*—"according to the mind and opinion of the
Platonists," by his friend Hieronymo Beniveni, in which, with an
ambitious array of every sort of learning, and a profusion of
imagery borrowed indifferently from the astrologers, the
Cabala, and Homer, and Scripture, and Dionysius the
Areopagite, he attempts to define the stages by which the soul
passes from the earthly to the unseen beauty. A change indeed
had passed over him, as if the chilling touch of the abstract and
disembodied beauty Platonists profess to long for were already

upon him. Some sense of this, perhaps, coupled with that over-
brightness which in the popular imagination always betokens an
early death, made Camilla Rucellai, one of those prophetic
women whom the preaching of Savonarola had raised up in
Florence, declare, seeing him for the first time, that he would
depart in the time of lilies—prematurely, that is, like the field-
flowers which are withered by the scorching sun almost as soon
as they are sprung up. He now wrote down those thoughts on
the religious life which Sir Thomas More turned into English,
and which another English translator thought worthy to be
added to the books of the *Imitation*. "It is not hard to know God,
provided one will not force oneself to define Him:"—has been
thought a great saying of Joubert's. "Love God," Pico writes to
Angelo Politian, "we rather may, than either know Him, or by
speech utter Him. And yet had men liefer by knowledge never
find that which they seek, than by love possess that thing, which
also without love were in vain found."

Yet he who had this fine touch for spiritual things did not—
and in this is the enduring interest of his story—even after his
conversion, forget the old gods. He is one of the last who seri-
ously and sincerely entertained the claim on men's faith of the
pagan religions; he is anxious to ascertain the true significance
of the obscurest legend, the lightest tradition concerning them.
With many thoughts and many influences which led him in that
direction, he did not become a monk; only he became gentle
and patient in disputation; retaining "somewhat of the old
plenty, in dainty viand and silver vessel," he gave over the
greater part of his property to his friend, the mystical poet
Beniveni, to be spent by him in works of charity, chiefly in the
sweet charity of providing marriage-dowries for the peasant girls
of Florence. His end came in 1494, when, amid the prayers and
sacraments of Savonarola, he died of fever, on the very day on
which Charles the Eighth entered Florence, the seventeenth of
November, yet in the time of lilies—the lilies of the shield of
France, as the people now said, remembering Camilla's
prophecy. He was buried in the conventual church of Saint
Mark, in the hood and white frock of the Dominican order.

It is because the life of Pico, thus lying down to rest in the

Dominican habit, yet amid thoughts of the older gods, himself like one of those comely divinities, reconciled indeed to the new religion, but still with a tenderness for the earlier life, and desirous literally to "bind the ages each to each by natural piety"—it is because this life is so perfect a parallel to the attempt made in his writings to reconcile Christianity with the ideas of paganism, that Pico, in spite of the scholastic character of those writings, is really interesting. Thus, in the *Heptaplus, or Discourse on the Seven Days of the Creation*, he endeavours to reconcile the accounts which pagan philosophy had given of the origin of the world with the account given in the books of Moses—the *Timæus* of Plato with the book of *Genesis*. The *Heptaplus* is dedicated to Lorenzo the Magnificent, whose interest, the preface tells us, in the secret wisdom of Moses is well known. If Moses seems in his writings simple and even popular, rather than either a philosopher or a theologian, that is because it was an institution with the ancient philosophers, either not to speak of divine things at all, or to speak of them dissemblingly: hence their doctrines were called mysteries. Taught by them, Pythagoras became so great a "master of silence," and wrote almost nothing, thus hiding the words of God in his heart, and speaking wisdom only among the perfect. In explaining the harmony between Plato and Moses, Pico lays hold on every sort of figure and analogy, on the double meanings of words, the symbols of the Jewish ritual, the secondary meanings of obscure stories in the later Greek mythologists. Everywhere there is an unbroken system of correspondences. Every object in the terrestrial world is an analogue, a symbol or counterpart, of some higher reality in the starry heavens, and this again of some law of the angelic life in the world beyond the stars. There is the element of fire in the material world: the sun is the fire of heaven; and in the super-celestial world there is the fire of the seraphic intelligence. "But behold how they differ! The elementary fire burns, the heavenly fire vivifies, the super-celestial fire loves." In this way, every natural object, every combination of natural forces, every accident in the lives of men, is filled with higher meanings. Omens, prophecies, supernatural coincidences, accompany Pico himself all through life. There are oracles in

every tree and mountain-top, and a significance in every acci-
dental combination of the events of life.

This constant tendency to symbolism and imagery gives Pico's
work a figured style, by which it has some real resemblance to
Plato's, and he differs from other mystical writers of his time by
a genuine desire to know his authorities at first hand. He reads
Plato in Greek, Moses in Hebrew, and by this his work really
belongs to the higher culture. Above all, we have a constant
sense in reading him, that his thoughts, however little their pos-
itive value may be, are connected with springs beneath them of
deep and passionate emotion; and when he explains the grades
or steps by which the soul passes from the love of a physical
object to the love of unseen beauty, and unfolds the analogies
between this process and other movements upward of human
thought, there is a glow and vehemence in his words which
remind one of the manner in which his own brief existence
flamed itself away.

I said that the Renaissance of the fifteenth century was, in
many things, great rather by what it designed or aspired to do,
than by what it actually achieved. It remained for a later age to
conceive the true method of effecting a scientific reconciliation
of Christian sentiment with the imagery, the legends, the theories
about the world, of pagan poetry and philosophy. For that age
the only possible reconciliation was an imaginative one, and
resulted from the efforts of artists, trained in Christian schools,
to handle pagan subjects; and of this artistic reconciliation work
like Pico's was but the feebler counterpart. Whatever philoso-
phers had to say on one side or the other, whether they were
successful or not in their attempts to reconcile the old to the
new, and to justify the expenditure of so much care and thought
on the dreams of a dead faith, the imagery of the Greek religion,
the direct charm of its story, were by artists valued and culti-
vated for their own sake. Hence a new sort of mythology, with a
tone and qualities of its own. When the ship-load of sacred earth
from the soil of Jerusalem was mingled with the common clay in
the *Campo Santo* at Pisa, a new flower grew up from it, unlike
any flower men had seen before, the anemone with its concen-
tric rings of strangely blended colour, still to be found by those

who search long enough for it, in the long grass of the
Maremma. Just such a strange flower was that mythology of the
Italian Renaissance, which grew up from the mixture of two tra-
ditions, two sentiments, the sacred and the profane. Classical
story was regarded as so much imaginative material to be
received and assimilated. It did not come into men's minds to
ask curiously of science, concerning the origin of such story, its
primary form and import, its meaning for those who projected
it. The thing sank into their minds, to issue forth again with all
the tangle about it of medieval sentiment and ideas. In the *Doni
Madonna* in the *Tribune* of the *Uffizii*, Michelangelo actually
brings the pagan religion, and with it the unveiled human form,
the sleepy-looking fauns of a Dionysiac revel, into the presence
of the Madonna, as simpler painters had introduced there other
products of the earth, birds or flowers, while he has given to that
Madonna herself much of the uncouth energy of the older and
more primitive "Mighty Mother."

 This picturesque union of contrasts, belonging properly to the
art of the close of the fifteenth century, pervades, in Pico della
Mirandola, an actual person, and that is why the figure of Pico
is so attractive. He will not let one go; he wins one on, in spite
of one's self, to turn again to the pages of his forgotten books,
although we know already that the actual solution proposed in
them will satisfy us as little as perhaps it satisfied him. It is said
that in his eagerness for mysterious learning he once paid a
great sum for a collection of cabalistic manuscripts, which
turned out to be forgeries; and the story might well stand as a
parable of all he ever seemed to gain in the way of actual knowl-
edge. He had sought knowledge, and passed from system to sys-
tem, and hazarded much; but less for the sake of positive knowl-
edge than because he believed there was a spirit of order and
beauty in knowledge, which would come down and unite what
men's ignorance had divided, and renew what time had made
dim. And so, while his actual work has passed away, yet his own
qualities are still active, and himself remains, as one alive in the
grave, *caesiis et vigilibus oculis,* as his biographer describes him,
and with that sanguine, clear skin, *decenti rubore interspersa,* as
with the light of morning upon it; and he has a true place in that

group of great Italians who fill the end of the fifteenth century with their names, he is a true *humanist*. For the essence of humanism is that belief of which he seems never to have doubted, that nothing which has ever interested living men and women can wholly lose its vitality—no language they have spoken, nor oracle beside which they have hushed their voices, no dream which has once been entertained by actual human minds, nothing about which they have ever been passionate, or expended time and zeal.

1871.

SANDRO BOTTICELLI

IN Leonardo's treatise on painting only one contemporary is mentioned by name— Sandro Botticelli. This pre-eminence may be due to chance only, but to some will rather appear a result of deliberate judgment; for people have begun to find out the charm of Botticelli's work, and his name, little known in the last century, is quietly becoming important. In the middle of the fifteenth century he had already anticipated much of that meditative subtlety, which is sometimes supposed peculiar to the great imaginative workmen of its close. Leaving the simple religion which had occupied the followers of Giotto for a century, and the simple naturalism which had grown out of it, a thing of birds and flowers only, he sought inspiration in what to him were works of the modern world, the writings of Dante and Boccaccio, and in new readings of his own of classical stories: or, if he painted religious incidents, painted them with an undercurrent of original sentiment, which touches you as the real matter of the picture through the veil of its ostensible subject. What is the peculiar sensation, what is the peculiar quality of pleasure, which his work has the property of exciting in us, and which we cannot get elsewhere? For this, especially when he has to speak of a comparatively unknown artist, is always the chief question which a critic has to answer.

In an age when the lives of artists were full of adventure, his life is almost colourless. Criticism indeed has cleared away much of the gossip which Vasari accumulated, has touched the legend of Lippo and Lucrezia, and rehabilitated the character of Andrea del Castagno. But in Botticelli's case there is no legend to dissipate. He did not even go by his true name: Sandro is a nickname, and his true name is Filipepi, Botticelli being only the name of the goldsmith who first taught him art. Only two things happened to him, two things which he shared with other

37

artists:—he was invited to Rome to paint in the Sistine Chapel, and he fell in later life under the influence of Savonarola, passing apparently almost out of men's sight in a sort of religious melancholy, which lasted till his death in 1515, according to the received date. Vasari says that he plunged into the study of Dante, and even wrote a comment on the *Divine Comedy.* But it seems strange that he should have lived on inactive so long; and one almost wishes that some document might come to light, which, fixing the date of his death earlier, might relieve one, in thinking of him, of his dejected old age.

He is before all things a poetical painter, blending the charm of story and sentiment, the medium of the art of poetry, with the charm of line and colour, the medium of abstract painting. So he becomes the illustrator of Dante. In a few rare examples of the edition of 1481, the blank spaces, left at the beginning of every canto for the hand of the illuminator, have been filled, as far as the nineteenth canto of the *Inferno,* with impressions of engraved plates, seemingly by way of experiment, for in the copy in the Bodleian Library, one of the three impressions it contains has been printed upside down, and much awry, in the midst of the luxurious printed page. Giotto, and the followers of Giotto, with their almost childish religious aim, had not learned to put that weight of meaning into outward things, light, colour, everyday gesture, which the poetry of the *Divine Comedy* involves, and before the fifteenth century Dante could hardly have found an illustrator. Botticelli's illustrations are crowded with incident, blending, with a naïve carelessness of pictorial propriety, three phases of the same scene into one plate. The grotesques, so often a stumbling-block to painters, who forget that the words of a poet, which only feebly present an image to the mind, must be lowered in key when translated into visible form, make one regret that he has not rather chosen for illustration the more subdued imagery of the *Purgatorio.* Yet in the scene of those who "go down quick into hell," there is an inventive force about the fire taking hold on the upturned soles of the feet, which proves that the design is no mere translation of Dante's words, but a true painter's vision; while the scene of the Centaurs wins one at once, for, forgetful of the actual circum-

stances of their appearance, Botticelli has gone off with delight on the thought of the Centaurs themselves, bright, small creatures of the woodland, with arch baby faces and mignon forms, drawing tiny bows.

Botticelli lived in a generation of naturalists, and he might have been a mere naturalist among them. There are traces enough in his work of that alert sense of outward things, which, in the pictures of that period, fills the lawns with delicate living creatures, and the hillsides with pools of water, and the pools of water with flowering reeds. But this was not enough for him; he is a visionary painter, and in his visionariness he resembles Dante. Giotto, the tried companion of Dante, Masaccio, Ghirlandajo even, do but transcribe, with more or less refining, the outward image; they are dramatic, not visionary painters; they are almost impassive spectators of the action before them. But the genius of which Botticelli is the type usurps the data before it as the exponent of ideas, moods, visions of its own; in this interest it plays fast and loose with those data, rejecting some and isolating others, and always combining them anew. To him, as to Dante, the scene, the colour, the outward image or gesture, comes with all its incisive and importunate reality; but awakes in him, moreover, by some subtle law of his own structure, a mood which it awakes in no one else, of which it is the double or repetition, and which it clothes, that all may share it, with visible circumstance.

But he is far enough from accepting the conventional orthodoxy of Dante which, referring all human action to the simple formula of purgatory, heaven and hell, leaves an insoluble element of prose in the depths of Dante's poetry. One picture of his, with the portrait of the donor, Matteo Palmieri, below, had the credit or discredit of attracting some shadow of ecclesiastical censure. This Matteo Palmieri, (two dim figures move under that name in contemporary history), was the reputed author of a poem, still unedited, *La Città Divina*, which represented the human race as an incarnation of those angels who, in the revolt of Lucifer, were neither for Jehovah nor for His enemies, a fantasy of that earlier Alexandrian philosophy about which the Florentine intellect in that century was so curious. Botticelli's

picture may have been only one of those familiar composi-
tions in which religious reverie has recorded its impressions
of the various forms of beatified existence—*Glorias,* as they
were called, like that in which Giotto painted the portrait of
Dante; but somehow it was suspected of embodying in a pic-
ture the wayward dream of Palmieri, and the chapel where it
hung was closed. Artists so entire as Botticelli are usually
careless about philosophical theories, even when the philoso-
pher is a Florentine of the fifteenth century, and his work a
poem in *terza rima.* But Botticelli, who wrote a commentary
on Dante, and became the disciple of Savonarola, may well
have let such theories come and go across him. True or false,
the story interprets much of the peculiar sentiment with
which he infuses his profane and sacred persons, comely, and
in a certain sense like angels, but with a sense of displacement
or loss about them—the wistfulness of exiles, conscious of a
passion and energy greater than any known issue of them
explains, which runs through all his varied work with a senti-
ment of ineffable melancholy.

So just what Dante scorns as unworthy alike of heaven and
hell, Botticelli accepts, that middle world in which men take no
side in great conflicts, and decide no great causes, and make
great refusals. He thus sets for himself the limits within which
art, undisturbed by any moral ambition, does its most sincere
and surest work. His interest is neither in the untempered good-
ness of Angelico's saints, nor the untempered evil of Orcagna's
Inferno; but with men and women, in their mixed and uncertain
condition, always attractive, clothed sometimes by passion with
a character of loveliness and energy, but saddened perpetually
by the shadow upon them of the great things from which they
shrink. His morality is all sympathy; and it is this sympathy, con-
veying into his work somewhat more than is usual of the true
complexion of humanity, which makes him, visionary as he is, so
forcible a realist.

It is this which gives to his Madonnas their unique expression
and charm. He has worked out in them a distinct and peculiar
type, definite enough in his own mind, for he has painted it over
and over again, sometimes one might think almost mechanically,

as a pastime during that dark period when his thoughts were so heavy upon him. Hardly any collection of note is without one of these circular pictures, into which the attendant angels depress their heads so naïvely. Perhaps you have sometimes wondered why those peevish-looking Madonnas, conformed to no acknowledged or obvious type of beauty, attract you more and more, and often come back to you when the Sistine Madonna and the Virgins of Fra Angelico are forgotten. At first, contrasting them with those, you may have thought that there was something in them mean or abject even, for the abstract lines of the face have little nobleness, and the colour is wan. For with Botticelli she too, though she holds in her hands the "Desire of all nations," is one of those who are neither for Jehovah nor for His enemies; and her choice is on her face. The white light on it is cast up hard and cheerless from below, as when snow lies upon the ground, and the children look up with surprise at the strange whiteness of the ceiling. Her trouble is in the very caress of the mysterious child, whose gaze is always far from her, and who has already that sweet look of devotion which men have never been able altogether to love, and which still makes the born saint an object almost of suspicion to his earthly brethren. Once, indeed, he guides her hand to transcribe in a book the words of her exaltation, the *Ave,* and the *Magnificat,* and the *Gaude Maria,* and the young angels, glad to rouse her for a moment from her dejection, are eager to hold the inkhorn and to support the book. But the pen almost drops from her hand, and the high cold words have no meaning for her, and her true children are those others, among whom, in her rude home, the intolerable honour came to her, with that look of wistful inquiry on their irregular faces which you see in startled animals—gipsy children, such as those who, in Apennine villages, still hold out their long brown arms to beg of you, but on Sundays become *enfants du chœur,* with their thick black hair nicely combed, and fair white linen on their sunburnt throats.

What is strangest is that he carries this sentiment into classical subjects, its most complete expression being a picture in the *Uffizii,* of Venus rising from the sea, in which the grotesque emblems of the middle age, and a landscape full of its peculiar

feeling, and even its strange draperies, powdered all over in the Gothic manner with a quaint conceit of daisies, frame a figure that reminds you of the faultless nude studies of Ingres. At first, perhaps, you are attracted only by a quaintness of design, which seems to recall all at once whatever you have read of Florence in the fifteenth century; afterwards you may think that this quaintness must be incongruous with the subject, and that the colour is cadaverous or at least cold. And yet, the more you come to understand what imaginative colouring really is, that all colour is no mere delightful quality of natural things, but a spirit upon them by which they become expressive to the spirit, the better you will like this peculiar quality of colour; and you will find that quaint design of Botticelli's a more direct inlet into the Greek temper than the works of the Greeks themselves even of the finest period. Of the Greeks as they really were, of their difference from ourselves, of the aspects of their outward life, we know far more than Botticelli, or his most learned contemporaries; but for us long familiarity has taken off the edge of the lesson, and we are hardly conscious of what we owe to the Hellenic spirit. But in pictures like this of Botticelli's you have a record of the first impression made by it on minds turned back towards it, in almost painful aspiration, from a world in which it had been ignored so long; and in the passion, the energy, the industry of realisation, with which Botticelli carries out his intention, is the exact measure of the legitimate influence over the human mind of the imaginative system of which this is perhaps the central subject. The light is indeed cold—mere sunless dawn; but a later painter would have cloyed you with sunshine; and you can see the better for that quietness in the morning air each long promontory, as it slopes down to the water's edge. Men go forth to their labours until the evening; but she is awake before them, and you might think that the sorrow in her face was at the thought of the whole long day of love yet to come. An emblematical figure of the wind blows hard across the grey water, moving forward the dainty-lipped shell on which she sails, the sea "showing his teeth," as it moves, in thin lines of foam, and sucking in, one by one, the falling roses, each severe in outline, plucked off short at the stalk, but embrowned a little,

as Botticelli's flowers always are. Botticelli meant all this imagery to be altogether pleasurable; and it was partly an incompleteness of resources, inseparable from the art of that time, that subdued and chilled it. But his predilection for minor tones counts also; and what is unmistakable is the sadness with which he has conceived the goddess of pleasure, as the depository of a great power over the lives of men.

I have said that the peculiar character of Botticelli is the result of a blending in him of a sympathy for humanity in its uncertain condition, its attractiveness, its investiture at rarer moments in a character of loveliness and energy, with his consciousness of the shadow upon it of the great things from which it shrinks, and that this conveys into his work somewhat more than painting usually attains of the true complexion of humanity. He paints the story of the goddess of pleasure in other episodes besides that of her birth from the sea, but never without some shadow of death in the grey flesh and wan flowers. He paints Madonnas, but they shrink from the pressure of the divine child, and plead in unmistakable undertones for a warmer, lower humanity. The same figure—tradition connects it with Simonetta, the mistress of Giuliano de' Medici—appears again as Judith, returning home across the hill country, when the great deed is over, and the moment of revulsion come, when the olive branch in her hand is becoming a burthen; as *Justice*, sitting on a throne, but with a fixed look of self-hatred which makes the sword in her hand seem that of a suicide; and again as *Veritas*, in the allegorical picture of *Calumnia,* where one may note in passing the suggestiveness of an accident which identifies the image of Truth with the person of Venus. We might trace the same sentiment through his engravings; but his share in them is doubtful, and the object of this brief study has been attained, if I have defined aright the temper in which he worked.

But, after all, it may be asked, is a painter like Botticelli—a secondary painter, a proper subject for general criticism? There are a few great painters, like Michelangelo or Leonardo, whose work has become a force in general culture, partly for this very reason that they have absorbed into themselves all such work-

men as Sandro Botticelli; and, over and above mere technical or antiquarian criticism, general criticism may be very well employed in that sort of interpretation which adjusts the position of these men to general culture, whereas smaller men can be the proper subjects only of technical or antiquarian treatment. But, besides those great men, there is a certain number of artists who have a distinct faculty of their own by which they convey to us a peculiar quality of pleasure which we cannot get elsewhere; and these too have their place in general culture, and must be interpreted to it by those who have felt their charm strongly, and are often the object of a special diligence and a consideration wholly affectionate, just because there is not about them the stress of a great name and authority. Of this select number Botticelli is one. He has the freshness, the uncertain and diffident promise, which belong to the earlier Renaissance period itself, and make it perhaps the most interesting period in the history of the mind. In studying his work one begins to understand to how great a place in human culture the art of Italy had been called.

1870.

LUCA DELLA ROBBIA

THE Italian sculptors of the earlier half of the fifteenth century are more than mere forerunners of the great masters of its close, and often reach perfection, within the narrow limits which they chose to impose on their work. Their sculpture shares with the paintings of Botticelli and the churches of Brunelleschi that profound expressiveness, that intimate impress of an indwelling soul, which is the peculiar fascination of the art of Italy in that century. Their works have been much neglected, and often almost hidden away amid the frippery of modern decoration, and we come with some surprise on the places where their fire still smoulders. One longs to penetrate into the lives of the men who have given expression to so much power and sweetness. But it is part of the reserve, the austere dignity and simplicity of their existence, that their histories are for the most part lost, or told but briefly. From their lives, as from their work, all tumult of sound and colour has passed away. Mino, the Raphael of sculpture, Maso del Rodario, whose works add a further grace to the church of Como, Donatello even,—one asks in vain for more than a shadowy outline of their actual days.

Something more remains of Luca della Robbia; something more of a history, of outward changes and fortunes, is expressed through his work. I suppose nothing brings the real air of a Tuscan town so vividly to mind as those pieces of pale blue and white earthenware, by which he is best known, like fragments of the milky sky itself, fallen into the cool streets, and breaking into the darkened churches. And no work is less imitable: like Tuscan wine, it loses its savour when moved from its birthplace, from the crumbling walls where it was first placed. Part of the charm of this work, its grace and purity and finish of expression, is common to all the Tuscan sculptors of the fifteenth century; for Luca was first of all a worker in marble, and his works in *terra*

45

cotta only transfer to a different material the principles of his sculpture.

These Tuscan sculptors of the fifteenth century worked for the most part in low relief, giving even to their monumental effigies something of its depression of surface, getting into them by this means a pathetic suggestion of the wasting and etherealisation of death. They are haters of all heaviness and emphasis, of strongly-opposed light and shade, and seek their means of delineation among those last refinements of shadow, which are almost invisible except in a strong light, and which the finest pencil can hardly follow. The whole essence of their work is *expression,* the passing of a smile over the face of a child, the ripple of the air on a still day over the curtain of a window ajar.

What is the precise value of this system of sculpture, this low relief? Luca della Robbia, and the other sculptors of the school to which he belongs, have before them the universal problem of their art; and this system of low relief is the means by which they meet and overcome the special limitation of sculpture.

That limitation results from the material, and other necessary conditions, of all sculptured work, and consists in the tendency of such work to a hard realism, a one-sided presentment of mere form, that solid material frame which only motion can relieve, a thing of heavy shadows, and an individuality of expression pushed to caricature. Against this tendency to the hard presentment of mere form trying vainly to compete with the reality of nature itself, all noble sculpture constantly struggles; each great system of sculpture resisting, it in its own way, etherealising, spiritualising, relieving, its stiffness, its heaviness, and death. The use of colour in sculpture is but an unskilful contrivance to effect, by borrowing from another art, what the nobler sculpture effects by strictly appropriate means. To get not colour, but the equivalent of colour; to secure the expression and the play of life; to expand the too firmly fixed individuality of pure, unrelieved, uncoloured form:—this is the problem which the three great styles in sculpture have solved in three different ways.

Allgemeinheit—breadth, generality, universality—is the word chosen by Winckelmann, and after him by Goethe and many German critics, to express that law of the most excellent Greek

sculptors, of Pheidias and his pupils, which prompted them constantly to seek the type in the individual, to abstract and express only what is structural and permanent, to purge from the individual all that belongs only to him, all the accidents, the feelings and actions of the special moment, all that (because in its own nature it endures but for a moment) is apt to look like a frozen thing if one arrests it.

In this way their works came to be like some subtle extract or essence, or almost like pure thoughts or ideas: and hence the breadth of humanity in them, that detachment from the conditions of a particular place or people, which has carried their influence far beyond the age which produced them, and insured them universal acceptance.

That was the Greek way of relieving the hardness and unspirituality of pure form. But it involved to a certain degree the sacrifice of what we call *expression;* and a system of abstraction which aimed always at the broad and general type, at the purging away from the individual of what belonged only to him, and of the mere accidents of a particular time and place, imposed upon the range of effects open to the Greek sculptor limits somewhat narrowly defined. When Michelangelo came, therefore, with a genius spiritualised by the reverie of the middle age, penetrated by its spirit of inwardness and introspection, living not a mere outward life like the Greek, but a life full of intimate experiences, sorrows, consolations, a system which sacrificed so much of what was inward and unseen could not satisfy him. To him, lover and student of Greek sculpture as he was, work which did not bring what was inward to the surface, which was not concerned with individual expression, with individual character and feeling, the special history of the special soul, was not worth doing at all.

And so, in a way quite personal and peculiar to himself, which often is, and always seems, the effect of accident, he secured for his work individuality and intensity of expression, while he avoided a too heavy realism, that tendency to harden into caricature which the representation of feeling in sculpture is apt to display. What time and accident, its centuries of darkness under the furrows of the "little Melian farm," have done with singular

felicity of touch for the Venus of Melos, fraying its surface and softening its lines, so that some spirit in the thing seems always on the point of breaking out, as though in it classical sculpture had advanced already one step into the mystical Christian age, its expression being in the whole range of ancient work most like that of Michelangelo's own:—this effect Michelangelo gains by leaving nearly all his sculpture in a puzzling sort of incompleteness, which suggests rather than realises actual form. Something of the wasting of that snow-image which he moulded at the command of Piero de' Medici, when the snow lay one night in the court of the *Pitti* palace, almost always lurks about it, as if he had determined to make the quality of a task, exacted from him half in derision, the pride of all his work. Many have wondered at that incompleteness, suspecting, however, that Michelangelo himself loved and was loath to change it, and feeling at the same time that they too would lose something if the half-realised form ever quite emerged from the stone, so rough-hewn here, so delicately finished there; and they have wished to fathom the charm of this incompleteness. Well! that incompleteness is Michelangelo's equivalent for colour in sculpture; it is his way of etherealising pure form, of relieving its stiff realism, and communicating to it breath, pulsation, the effect of life. It was a characteristic too which fell in with his peculiar temper and mode of living, his disappointments and hesitations. And it was in reality perfect finish. In this way he combines the utmost amount of passion and intensity with the sense of a yielding and flexible life: he gets not vitality merely, but a wonderful force, of expression.

Midway between these two systems—the system of the Greek sculptors and the system of Michelangelo—comes the system of Luca della Robbia and the other Tuscan sculptors of the fifteenth century, partaking both of the *Allgemeinheit* of the Greeks, their way of extracting certain select elements only of pure form and sacrificing all the rest, and the studied incompleteness of Michelangelo, relieving that sense of intensity, passion, energy, which might otherwise have stiffened into caricature. Like Michelangelo, these sculptors fill their works with intense and individualised expression. Their noblest works are

the careful sephulchral portraits of particular persons—the monument of Conte Ugo in the *Badía* of Florence, of the youthful Medea Colleoni, with the wonderful, long throat, in the chapel on the cool north side of the Church of *Santa Maria Maggiore* at Bergamo—monuments such as abound in the churches of Rome, inexhaustible in suggestions of repose, of a subdued sabbatic joy, a kind of sacred grace and refinement. And these elements of tranquillity, of repose, they unite to an intense and individual expression by a system of conventionalism as skilful and subtle as that of the Greeks, repressing all such curves as indicate solid form, and throwing the whole into low relief.

The life of Luca, a life of labour and frugality, with no adventure and no excitement except what belongs to the trial of new artistic processes, the struggle with new artistic difficulties, the solution of purely artistic problems, fills the first seventy years of the fifteenth century. After producing many works in marble for the *Duomo* and the *Campanile* of Florence, which place him among the foremost masters of the sculpture of his age, he became desirous to realise the spirit and manner of that sculpture, in a humbler material, to unite its science, its exquisite and expressive system of low relief, to the homely art of pottery, to introduce those high qualities into common things, to adorn and cultivate daily household life. In this he is profoundly characteristic of the Florence of that century, of that in it which lay below its superficial vanity and caprice, a certain old-world modesty and seriousness and simplicity. People had not yet begun to think that what was good art for churches was not so good, or less fitted, for their own houses. Luca's new work was in plain white earthenware at first, a mere rough imitation of the costly, laboriously wrought marble, finished in a few hours. But on this humble path he found his way to a fresh success, to another artistic grace. The fame of the oriental pottery, with its strange, bright colours—colours of art, colours not to be attained in the natural stone—mingled with the tradition of the old Roman pottery of the neighbourhood. The little red, coral-like jars of Arezzo, dug up in that district from time to time, are much prized. These colours haunted Luca's fancy. "He still continued

seeking something more," his biographer says of him; "and instead of making his figures of baked earth simply white, he added the further invention of giving them colour, to the astonishment and delight of all who beheld them"—*Cosa singolare, e multo utile per la state!*—a curious thing, and very useful for summer-time, full of coolness and repose for hand and eye. Luca loved the forms of various fruits, and wrought them into all sorts of marvellous frames and garlands, giving them their natural colours, only subdued a little, a little paler than nature.

I said that the art of Luca della Robbia possessed in an unusual measure that special characteristic which belongs to all the workmen of his school, a characteristic which, even in the absence of much positive information about their actual history, seems to bring those workmen themselves very near to us. They bear the impress of a personal quality, a profound expressiveness, what the French call *intimité,* by which is meant some subtler sense of originality—the seal on a man's work of what is most inward and peculiar in his moods, and manner of apprehension: it is what we call *expression,* carried to its highest intensity of degree. That characteristic is rare in poetry, rarer still in art, rarest of all in the abstract art of sculpture; yet essentially, perhaps, it is the quality which alone makes work in the imaginative order really worth having at all. It is because the works of the artists of the fifteenth century possess this quality in an unmistakable way that one is anxious to know all that can be known about them, and explain to one's self the secret of their charm.

1872.

THE POETRY OF MICHELANGELO

CRITICS of Michelangelo have sometimes spoken as if the only characteristic of his genius were a wonderful strength, verging, as in the things of the imagination great strength always does, on what is singular or strange. A certain strangeness, something of the blossoming of the aloe, is indeed an element in all true works of art: that they shall excite or surprise us is indispensable. But that they shall give pleasure and exert a charm over us is indispensable too; and this strangeness must be sweet also—a lovely strangeness. And to the true admirers of Michelangelo this is the true type of the Michelangelesque—sweetness and strength, pleasure with surprise, an energy of conception which seems at every moment about to break through all the conditions of comely form, recovering, touch by touch, a loveliness found usually only in the simplest natural things—ex forti dulcedo.

In this way he sums up for them the whole character of medieval art itself in that which distinguishes it most clearly from classical work, the presence of a convulsive energy in it, becoming in lower hands merely monstrous or forbidding, and felt, even in its most graceful products, as a subdued quaintness or grotesque. Yet those who feel this grace or sweetness in Michelangelo might at the first moment be puzzled if they were asked wherein precisely such quality resided. Men of inventive temperament—Victor Hugo, for instance, in whom, as in Michelangelo, people have for the most part been attracted or repelled by the strength, while few have understood his sweetness—have sometimes relieved conceptions of merely moral or spiritual greatness, but with little æsthetic charm of their own, by lovely accidents or accessories, like the butterfly which alights on the blood-stained barricade in Les Misérables, or those sea-birds for whom the monstrous Gilliatt comes to be as

51

some wild natural thing, so that they are no longer afraid of him, in *Les Travailleurs de la Mer.* But the austere genius of Michelangelo will not depend for its sweetness on any mere accessories like these. The world of natural things has almost no existence for him; "When one speaks of him," says Grimm, "woods, clouds, seas, and mountains disappear, and only what is formed by the spirit of man remains behind"; and he quotes a few slight words from a letter of his to Vasari as the single expression in all he has left of a feeling for nature. He has traced no flowers, like those with which Leonardo stars over his gloomiest rocks; nothing like the fretwork of wings and flames in which Blake frames his most startling conceptions. No forest-scenery like Titian's fills his backgrounds, but only blank ranges of rock, and dim vegetable forms as blank as they, as in a world before the creation of the first five days.

Of the whole story of the creation he has painted only the creation of the first man and woman, and, for him at least, feebly, the creation of light. It belongs to the quality of his genius thus to concern itself almost exclusively with the making of man. For him it is not, as in the story itself, the last and crowning act of a series of developments, but the first and unique act, the creation of life itself in its supreme form, off-hand and immediately, in the cold and lifeless stone. With him the beginning of life has all the characteristics of resurrection; it is like the recovery of suspended health or animation, with its gratitude, its effusion, and eloquence. Fair as the young men of the Elgin marbles, the Adam of the Sistine Chapel is unlike them in a total absence of that balance and completeness which express so well the sentiment of a self-contained, independent life. In that languid figure there is something rude and satyr-like, something akin to the rugged hillside on which it lies. His whole form is gathered into an expression of mere expectancy and reception; he has hardly strength enough to lift his finger to touch the finger of the creator; yet a touch of the finger-tips will suffice.

This creation of life—life coming always as relief or recovery, and always in strong contrast with the rough-hewn mass in which it is kindled—is in various ways the motive of all his work, whether its immediate subject be pagan or Christian, legend or

allegory; and this, although at least one-half of his work was designed for the adornment of tombs—the tomb of Julius, the tombs of the Medici. Not the Judgment but the Resurrection is the real subject of his last work in the Sistine Chapel; and his favourite pagan subject is the legend of Leda, the delight of the world breaking from the egg of a bird. As I have already pointed out, he secures that ideality of expression which in Greek sculpture depends on a delicate system of abstraction, and in early Italian sculpture on lowness of relief, by an incompleteness, which is surely not always undesigned, and which, as I think, no one regrets, and trusts to the spectator to complete the half emergent form. And as his persons have something of the unwrought stone about them, so, as if to realise the expression by which the old Florentine records describe a sculptor—*master of live stone*—with him the very rocks seem to have life. They have but to cast away the dust and scurf that they may rise and stand on their feet. He loved the very quarries of Carrara, those strange grey peaks which even at mid-day convey into any scene from which they are visible something of the solemnity and stillness of evening, sometimes wandering among them month after month, till at last their pale ashen colours seem to have passed into his painting; and on the crown of the head of the *David* there still remains a morsel of uncut stone, as if by one touch to maintain its connexion with the place from which it was hewn.

And it is in this penetrative suggestion of life that the secret of that sweetness of his is to be found. He gives us indeed no lovely natural objects like Leonardo or Titian, but only the coldest, most elementary shadowing of rock or tree; no lovely draperies and comely gestures of life, but only the austere truths of human nature; "simple persons"—as he replied in his rough way to the querulous criticism of Julius the Second, that there was no gold on the figures of the Sistine Chapel—"simple persons, who wore no gold on their garments"; but he penetrates us with a feeling of that power which we associate with all the warmth and fulness of the world, the sense of which brings into one's thoughts a swarm of birds and flowers and insects. The brooding spirit of life itself is there; and the summer may burst out in a moment.

He was born in an interval of a rapid midnight journey in March, at a place in the neighbourhood of Arezzo, the thin, clear air of which was then thought to be favourable to the birth of children of great parts. He came of a race of grave and dignified men, who, claiming kinship with the family of Canossa, and some colour of imperial blood in their veins, had, generation after generation, received honourable employment under the government of Florence. His mother, a girl of nineteen years, put him out to nurse at a country-house among the hills of Settignano, where every other inhabitant is a worker in the marble-quarries, and the child early became familiar with that strange first stage in the sculptor's art. To this succeeded the influence of the sweetest and most placid master Florence had yet seen, Domenico Ghirlandajo. At fifteen he was at work among the curiosities of the garden of the Medici, copying and restoring antiques, winning the condescending notice of the great Lorenzo. He knew too how to excite strong hatreds; and it was at this time that in a quarrel with a fellow-student he received a blow on the face which deprived him for ever of the comeliness of outward form.

It was through an accident that he came to study those works of the early Italian sculptors which suggested much of his own grandest work, and impressed it with so deep a sweetness. He believed in dreams and omens. One of his friends dreamed twice that Lorenzo, then lately dead, appeared to him in grey and dusty apparel. To Michelangelo this dream seemed to portend the troubles which afterwards really came, and with the suddenness which was characteristic of all his movements, he left Florence. Having occasion to pass through Bologna, he neglected to procure the little seal of red wax which the stranger entering Bologna must carry on the thumb of his right hand. He had no money to pay the fine, and would have been thrown into prison had not one of the magistrates interposed. He remained in this man's house a whole year, rewarding his hospitality by readings from the Italian poets whom he loved. Bologna, with its endless colonnades and fantastic leaning towers, can never have been one of the lovelier cities of Italy. But about the portals of its vast unfinished churches and its dark shrines, half hid-

den by votive flowers and candles, lie some of the sweetest works of the early Tuscan sculptors, Giovanni da Pisa and Jacopo della Quercia, things as winsome as flowers; and the year which Michelangelo spent in copying these works was not a lost year. It was now, on returning to Florence, that he put forth that unique presentment of Bacchus, which expresses, not the mirthfulness of the god of wine, but his sleepy serious-ness, his enthusiasm, his capacity for profound dreaming. No one ever expressed more truly than Michelangelo the notion of inspired sleep, of faces charged with dreams. A vast fragment of marble had long lain below the *Loggia* of Orcagna, and many a sculptor had had his thoughts of a design which should just fill this famous block of stone, cutting the diamond, as it were, without loss. Under Michelangelo's hand it became the *David* which stood till lately on the steps of the *Palazzo Vecchio*, when it was replaced below the *Loggia*. Michelangelo was now thirty years old, and his reputation was established. Three great works fill the remainder of his life—three works often inter-rupted, carried on through a thousand hesitations, a thousand disappointments, quarrels with his patrons, quarrels with his family, quarrels perhaps most of all with himself—the Sistine Chapel, the Mausoleum of Julius the Second, and the Sacristy of *San Lorenzo*.

In the story of Michelangelo's life the strength, often turning to bitterness, is not far to seek. A discordant note sounds throughout it which almost spoils the music. He "treats the Pope as the King of France himself would not dare to treat him"; he goes along the streets of Rome "like an executioner," Raphael says of him. Once he seems to have shut himself up with the intention of starving himself to death. As we come, in reading his life, on its harsh, untempered incidents, the thought again and again arises that he is one of those who incur the judgment of Dante, as having "wilfully lived in sadness." Even his tender-ness and pity are embittered by their strength. What passionate weeping in that mysterious figure which, in the *Creation of Adam,* crouches below the image of the Almighty, as he comes with the forms of things to be, woman and her progeny, in the fold of his garment! What a sense of wrong in those two captive

youths, who feel the chains like scalding water on their proud and delicate flesh! The idealist who became a reformer with Savonarola, and a republican superintending the fortification of Florence—the nest where he was born, *il nido ove naqqu'io*, as he calls it once, in a sudden throb of affection—in its last struggle for liberty, yet believed always that he had imperial blood in his veins and was the kindred of the great Matilda, had within the depths of his nature some secret spring of indignation or sorrow. We know little of his youth, but all tends to make one believe in the vehemence of its passions. Beneath the Platonic calm of the sonnets there is latent a deep delight in carnal form and colour. There, and still more in the madrigals, he often falls into the language of less tranquil affections; while some of them have the colour of penitence, as from a wanderer returning home. He who spoke so decisively of the supremacy in the imaginative world of the unveiled human form had not been always, we may think, a mere Platonic lover. Vague and wayward his loves may have been; but they partook of the strength of his nature, and sometimes, it may be, would by no means become music, so that the comely order of his days was quite put out: *par che amaro ogni mio dolce io senta.*

But his genius is in harmony with itself; and just as in the products of his art we find resources of sweetness within their exceeding strength, so in his own story also, bitter as the ordinary sense of it may be, there are select pages shut in among the rest—pages one might easily turn over too lightly, but which yet sweeten the whole volume. The interest of Michelangelo's poems is that they make us spectators of this struggle; the struggle of a strong nature to adorn and attune itself; the struggle of a desolating passion, which yearns to be resigned and sweet and pensive, as Dante's was. It is a consequence of the occasional and informal character of his poetry, that it brings us nearer to himself, his own mind and temper, than any work done only to support a literary reputation could possibly do. His letters tell us little that is worth knowing about him—a few poor quarrels about money and commissions. But it is quite otherwise with these songs and sonnets, written down at odd moments, sometimes on the margins of his sketches, themselves often unfinished sketches,

arresting some salient feeling or unpremeditated idea as it passed. And it happens that a true study of these has become within the last few years for the first time possible. A few of the sonnets circulated widely in manuscript, and became almost within Michelangelo's own lifetime a subject of academical discourses. But they were first collected in a volume in 1623 by the great-nephew of Michelangelo, Michelangelo Buonarroti the younger. He omitted much, re-wrote the sonnets in part, and sometimes compressed two or more compositions into one, always losing something of the force and incisiveness of the original. So the book remained, neglected even by Italians themselves in the last century, through the influence of that French taste which despised all compositions of the kind, as it despised and neglected Dante. "His reputation will ever be on the increase, because he is so little read," says Voltaire of Dante.— But in 1858 the last of the Buonarroti bequeathed to the municipality of Florence the curiosities of his family. Among them was a precious volume containing the autograph of the sonnets. A learned Italian, Signor Cesare Guasti, undertook to collate this autograph with other manuscripts at the Vatican and elsewhere, and in 1863 published a true version of Michelangelo's poems, with dissertations and a paraphrase.[1]

People have often spoken of these poems as if they were a mere cry of distress, a lover's complaint over the obduracy of Vittoria Colonna. But those who speak thus forget that though it is quite possible that Michelangelo had seen Vittoria, that somewhat shadowy figure, as early as 1537, yet their closer intimacy did not begin till about the year 1542, when Michelangelo was nearly seventy years old. Vittoria herself, an ardent neo-catholic, vowed to perpetual widowhood since the news had reached her, seventeen years before, that her husband, the youthful and princely Marquess of Pescara, lay dead of the wounds he had received in the battle of Pavia, was then no longer an object of great passion. In a dialogue written by the painter, Francesco

[1] The sonnets have been translated into English, with much skill, and poetic taste, by Mr. J. A. Symonds.

d'Ollanda, we catch a glimpse of them together in an empty church at Rome, one Sunday afternoon, discussing indeed the characteristics of various schools of art, but still more the writings of Saint Paul, already following the ways and tasting the sunless pleasures of weary people, whose care for external things is slackening. In a letter still extant he regrets that when he visited her after death he had kissed her hands only. He made, or set to work to make, a crucifix for her use, and two drawings, perhaps in preparation for it, are now in Oxford. From allusions in the sonnets, we may divine that when they first approached each other he had debated much with himself whether this last passion would be the most unsoftening, the most desolating of all—*un dolce amaro, un sì e no mi muovi*. Is it carnal affection, or, *del suo prestino stato* (of Plato's anti-natal state) *il raggio ardente?* The older, conventional criticism, dealing with the text of 1623, had lightly assumed that all or nearly all the sonnets were actually addressed to Vittoria herself; but Signor Guasti finds only four, or at most five, which can be so attributed on genuine authority. Still, there are reasons which make him assign the majority of them to the period between 1542 and 1547, and we may regard the volume as a record of this resting-place in Michelangelo's story. We know how Goethe escaped from the stress of sentiments too strong for him by making a book about them; and for Michelangelo, to write down his passionate thoughts at all, to express them in a sonnet, was already in some measure to command, and have his way with them—

> *La vita del mia amor non è il cor mio,*
> *Ch'amor, di quel ch'io t'amo, è senza core.*

It was just because Vittoria raised no great passion that the space in his life where she reigns has such peculiar suavity; and the spirit of the sonnets is lost if we once take them out of that dreamy atmosphere in which men have things as they will, because the hold of all outward things upon them is faint and uncertain. Their prevailing tone is a calm and meditative sweetness. The cry of distress is indeed there, but as a mere residue,

a trace of bracing chalybeate salt, just discernible in the song which rises like a clear, sweet spring from a charmed space in his life.

This charmed and temperate space in Michelangelo's life, without which its excessive strength would have been so imperfect, which saves him from the judgment of Dante on those who "wilfully lived in sadness," is then a well-defined period there, reaching from the year 1542 to the year 1547, the year of Vittoria's death. In it the lifelong effort to tranquillise his vehement emotions by withdrawing them into the region of ideal sentiment, becomes successful; and the significance of Vittoria is, that she realises for him a type of affection which even in disappointment may charm and sweeten his spirit.

In this effort to tranquillise and sweeten life by idealising its vehement sentiments, there were two great traditional types, either of which an Italian of the sixteenth century might have followed. There was Dante, whose little book of the *Vita Nuova* had early become a pattern of imaginative love, maintained somewhat feebly by the later followers of Petrarch; and, since Plato had become something more than a name in Italy by the publication of the Latin translation of his works by Marsilio Ficino, there was the Platonic tradition also. Dante's belief in the resurrection of the body, through which, even in heaven, Beatrice loses for him no tinge of flesh-colour, or fold of raiment even; and the Platonic dream of the passage of the soul through one form of life after another, with its passionate haste to escape from the burden of bodily form altogether; are, for all effects of art or poetry, principles diametrically opposite. Now it is the Platonic tradition rather than Dante's that has moulded Michelangelo's verse. In many ways no sentiment could have been less like Dante's love for Beatrice than Michelangelo's for Vittoria Colonna. Dante's comes in early youth: Beatrice is a child, with the wistful, ambiguous vision of a child, with a character still unaccentuated by the influence of outward circumstances, almost expressionless. Vittoria, on the other hand, is a woman already weary, in advanced age, of grave intellectual qualities. Dante's story is a piece of figured work, inlaid with lovely incidents. In Michelangelo's poems, frost and fire are

almost the only images—the refining fire of the goldsmith; once or twice the phœnix; ice melting at the fire; fire struck from the rock which it afterwards consumes. Except one doubtful allusion to a journey, there are almost no incidents. But there is much of the bright, sharp, unerring skill, with which in boyhood he gave the look of age to the head of a faun by chipping a tooth from its jaw with a single stroke of the hammer. For Dante, the amiable and devout materialism of the middle age sanctifies all that is presented by hand and eye; while Michelangelo is always pressing forward from the outward beauty—*il bel del fuor che agli occhi piace,* to apprehend the unseen beauty; *transcenda nella forma universale*—that abstract form of beauty, about which the Platonists reason. And this gives the impression in him of something flitting and unfixed, of the houseless and complaining spirit, almost clairvoyant through the frail and yielding flesh. He accounts for love at first sight by a previous state of existence—*la dove io t'amai prima.*

And yet there are many points in which he is really like Dante, and comes very near to the original image, beyond those later and feebler followers in the wake of Petrarch. He learns from Dante rather than from Plato, that for lovers, the surfeiting of desire—*ove gran desir gran copia affrena,* is a state less happy than poverty with abundance of hope—*una miseria di speranza piena.* He recalls him in the repetition of the words *gentile* and *cortesia,* in the personification of *Amor,* in the tendency to dwell minutely on the physical effects of the presence of a beloved object on the pulses and the heart. Above all, he resembles Dante in the warmth and intensity of his political utterances, for the lady of one of his noblest sonnets was from the first understood to be the city of Florence; and he avers that all must be asleep in heaven, if she, who was created "of angelic form" for a thousand lovers, is appropriated by one alone, some Piero, or Alessandro de' Medici. Once and again he introduces Love and Death, who dispute concerning him. For, like Dante and all the nobler souls of Italy, he is much occupied with thoughts of the grave, and his true mistress is death,—death at first as the worst of all sorrows and disgraces, with a clod of the field for its brain; afterwards, death in its high distinction, its

detachment from vulgar needs, the angry stains of life and action escaping fast.

Some of those whom the gods love die young. This man, because the gods loved him, lingered on to be of immense, patriarchal age, till the sweetness it had taken so long to secrete in him was found at last. Out of the strong come forth sweetness, *ex forti dulcedo.* The world had changed around him. The "new catholicism" had taken the place of the Renaissance. The spirit of the Roman Church had changed: in the vast world's cathedral which his skill had helped to raise for it, it looked stronger than ever. Some of the first members of the *Oratory* were among his intimate associates. They were of a spirit as unlike as possible from that of Lorenzo, or Savonarola even. The opposition of the Reformation to art has been often enlarged upon; far greater was that of the Catholic revival. But in thus fixing itself in a frozen orthodoxy, the Roman Church had passed beyond him, and he was a stranger to it. In earlier days, when its beliefs had been in a fluid state, he too might have been drawn into the controversy. He might have been for spiritualising the papal sovereignty, like Savonarola; or for adjusting the dreams of Plato and Homer with the words of Christ, like Pico of Mirandola. But things had moved onward, and such adjustments were no longer possible. For himself, he had long since fallen back on that divine ideal, which above the wear and tear of creeds has been forming itself for ages as the possession of nobler souls. And now he began to feel the soothing influence which since that time the Roman Church has often exerted over spirits too independent to be its subjects, yet brought within the neighbourhood of its action; consoled and tranquillised, as a traveller might be, resting for one evening in a strange city, by its stately aspect and the sentiment of its many fortunes, just because with those fortunes he has nothing to do. So he lingers on; a *revenant,* as the French say, a ghost out of another age, in a world too coarse to touch his faint sensibilities very closely; dreaming, in a worn-out society, theatrical in its life, theatrical in its art, theatrical even in its devotion, on the morning of the world's history, on the primitive form of man, on the images under which that primitive world had conceived of spiritual forces.

✻ ✻ ✻

I have dwelt on the thought of Michelangelo as thus lingering beyond his time in a world not his own, because, if one is to distinguish the peculiar savour of his work, he must be approached, not through his followers, but through his predecessors; not through the marbles of *Saint Peter's*, but through the work of the sculptors of the fifteenth century over the tombs and altars of Tuscany. He is the last of the Florentines, of those on whom the peculiar sentiment of the Florence of Dante and Giotto descended: he is the consummate representative of the form that sentiment took in the fifteenth century with men like Luca Signorelli and Mino da Fiesole. Up to him the tradition of sentiment is unbroken, the progress towards surer and more mature methods of expressing that sentiment continuous. But his professed disciples did not share this temper; they are in love with his strength only, and seem not to feel his grave and temperate sweetness. Theatricality is their chief characteristic; and that is a quality as little attributable to Michelangelo as to Mino or Luca Signorelli. With him, as with them, all is serious, passionate, impulsive.

This discipleship of Michelangelo, this dependence of his on the tradition of the Florentine schools, is nowhere seen more clearly than in his treatment of the *Creation*. The *Creation of Man* had haunted the mind of the middle age like a dream; and weaving it into a hundred carved ornaments of capital or doorway, the Italian sculptors had early impressed upon it that pregnancy of expression which seems to give it many veiled meanings. As with other artistic conceptions of the middle age, its treatment became almost conventional, handed on from artist to artist, with slight changes, till it came to have almost an independent and abstract existence of its own. It was characteristic of the medieval mind thus to give an independent traditional existence to a special pictorial conception, or to a legend, like that of *Tristram* or *Tannhäuser*, or even to the very thoughts and substance of a book, like the *Imitation*, so that no single workman could claim it as his own, and the book, the image, the legend, had itself a legend, and its fortunes, and a personal history; and it is a sign of the medievalism of Michelangelo, that he thus receives from tradition his central

conception, and does but add the last touches, in transferring it to the frescoes of the Sistine Chapel.

But there was another tradition of those earlier, more serious Florentines, of which Michelangelo is the inheritor, to which he gives the final expression, and which centres in the sacristy of *San Lorenzo,* as the tradition of the *Creation* centres in the Sistine Chapel. It has been said that all the great Florentines were preoccupied with death. *Outre-tombe! Outre-tombe!*—is the burden of their thoughts, from Dante to Savonarola. Even the gay and licentious Boccaccio gives a keener edge to his stories by putting them in the mouths of a party of people who had taken refuge in a country-house from the danger of death by plague. It was to this inherited sentiment, this practical decision that to be preoccupied with the thought of death was in itself dignifying, and a note of high quality, that the seriousness of the great Florentines of the fifteenth century was partly due; and it was reinforced in them by the actual sorrows of their times. How often, and in what various ways, had they seen life stricken down, in their streets and houses. *La bella Simonetta* dies in early youth, and is borne to the grave with uncovered face. The young Cardinal Jacopo di Portogallo dies on a visit to Florence—*insignis formâ fui et mirabili modestiâ*—his epitaph dares to say. Antonio Rossellino carves his tomb in the church of San Miniato, with care for the shapely hands and feet, and sacred attire; Luca della Robbia puts his skyiest works there; and the tomb of the youthful and princely prelate became the strangest and most beautiful thing in that strange and beautiful place. After the execution of the Pazzi conspirators, Botticelli is employed to paint their portraits. This preoccupation with serious thoughts and sad images might easily have resulted, as it did, for instance, in the gloomy villages of the Rhine, or in the overcrowded parts of medieval Paris, as it still does in many a village of the Alps, in something merely morbid or grotesque, in the *Danse Macabre* of many French and German painters, or the grim inventions of Dürer. From such a result the Florentine masters of the fifteenth century were saved by the nobility of their Italian culture, and still more by their tender pity for the thing itself. They must often have leaned over the

lifeless body, when all was at length quiet and smoothed out.
After death, it is said, the traces of slighter and more superficial
dispositions disappear; the lines become more simple and dig-
nified; only the abstract lines remain, in a great indifference.
They came thus to see death in its distinction. Then following
it perhaps one stage further, dwelling for a moment on the
point where all this transitory dignity must break up, and dis-
cerning with no clearness a new body, they paused just in time,
and abstained, with a sentiment of profound pity.

Of all this sentiment Michelangelo is the achievement; and,
first of all, of pity. *Pietà*, pity, the pity of the Virgin Mother over
the dead body of Christ, expanded into the pity of all mothers
over all dead sons, the entombment, with its cruel "hard
stones":—this is the subject of his predilection. He has left it in
many forms, sketches, half-finished designs, finished and unfin-
ished groups of sculpture; but always as a hopeless, rayless,
almost heathen sorrow—no divine sorrow, but mere pity and
awe at the stiff limbs and colourless lips. There is a drawing of
his at Oxford, in which the dead body has sunk to the earth
between the mother's feet, with the arms extended over her
knees. The tombs in the sacristy of *San Lorenzo* are memorials,
not of any of the nobler and greater Medici, but of Giuliano, and
Lorenzo the younger, noticeable chiefly for their somewhat
early death. It is mere human nature therefore which has
prompted the sentiment here. The titles assigned traditionally
to the four symbolical figures, *Night* and *Day, The Twilight* and
The Dawn, are far too definite for them; for these figures come
much nearer to the mind and spirit of their author, and are a
more direct expression of his thoughts, than any merely sym-
bolical conceptions could possibly have been. They concentrate
and express, less by way of definite conceptions than by the
touches, the promptings of a piece of music, all those vague fan-
cies, misgivings, presentiments, which shift and mix and are
defined and fade again, whenever the thoughts try to fix them-
selves with sincerity on the conditions and surroundings of the
disembodied spirit. I suppose no one would come to the sacristy
of San Lorenzo for consolation; for seriousness, for solemnity,
for dignity of impression, perhaps, but not for consolation. It is

a place neither of consoling nor of terrible thoughts, but of vague and wistful speculation. Here, again, Michelangelo is the disciple not so much of Dante as of the Platonists. Dante's belief in immortality is formal, precise, and firm, almost as much so as that of a child, who thinks the dead will hear if you cry loud enough. But in Michelangelo you have maturity, the mind of the grown man, dealing cautiously and dispassionately with serious things; and what hope he has is based on the consciousness of ignorance—ignorance of man, ignorance of the nature of the mind, its origin and capacities. Michelangelo is so ignorant of the spiritual world, of the new body and its laws, that he does not surely know whether the consecrated Host may not be the body of Christ. And of all that range of sentiment he is the poet, a poet still alive, and in possession of our inmost thoughts— dumb inquiry over the relapse after death into the formlessness which preceded life, the change, the revolt from that change, then the correcting, hallowing, consoling rush of pity; at last, far off, thin and vague, yet not more vague than the most definite thoughts men have had through three centuries on a matter that has been so near their hearts, the new body—a passing light, a mere intangible, external effect, over those too rigid, or too formless faces; a dream that lingers a moment, retreating in the dawn, incomplete, aimless, helpless; a thing with faint hearing, faint memory, faint power of touch; a breath, a flame in the doorway, a feather in the wind.

The qualities of the great masters in art or literature, the combination of those qualities, the laws by which they moderate, support, relieve each other, are not peculiar to them; but most often typical standards, or revealing instances of the laws by which certain æsthetic effects are produced. The old masters indeed are simpler; their characteristics are written larger, and are easier to read, than the analogues of them in all the mixed, confused productions of the modern mind. But when once we have succeeded in defining for ourselves those characteristics, and the law of their combination, we have acquired a standard or measure which helps us to put in its right place many a vagrant genius, many an unclassified talent, many precious though imperfect products of art. It is so with the components

of the true character of Michelangelo. That strange interfusion of sweetness and strength is not to be found in those who claimed to be his followers; but it is found in many of those who worked before him, and in many others down to our own time, in William Blake, for instance, and Victor Hugo, who, though not of his school, and unaware, are his true sons, and help us to understand him, as he in turn interprets and justifies them. Perhaps this is the chief use in studying old masters.

1871.

LEONARDO DA VINCI

[Homo Minister et Interpres Naturæ]

IN Vasari's life of Leonardo da Vinci as we now read it there are some variations from the first edition. There, the painter who has fixed the outward type of Christ for succeeding centuries was a bold speculator, holding lightly by other men's beliefs, setting philosophy above Christianity. Words of his, trenchant enough to justify this impression, are not recorded, and would have been out of keeping with a genius of which one characteristic is the tendency to lose itself in a refined and graceful mystery. The suspicion was but the time-honoured mode in which the world stamps its appreciation of one who has thoughts for himself alone, his high indifference, his intolerance of the common forms of things; and in the second edition the image was changed into something fainter and more conventional. But it is still by a certain mystery in his work, and something enigmatical beyond the usual measure of great men, that he fascinates, or perhaps half repels. His life is one of sudden revolts, with intervals in which he works not at all, or apart from the main scope of his work. By a strange fortune the pictures on which his more popular fame rested disappeared early from the world, like the *Battle of the Standard;* or are mixed obscurely with the product of meaner hands, like the *Last Supper.* His type of beauty is so exotic that it fascinates a larger number than it delights, and seems more than that of any other artist to reflect ideas and views and some scheme of the world within; so that he seemed to his contemporaries to be the possessor of some unsanctified and sacred wisdom; as to Michelet and others to have anticipated modern ideas. He trifles with his genius, and crowds all his chief work into a few tormented years of later life; yet he is so possessed by his genius that he passes unmoved

67

through the most tragic events, overwhelming his country and friends, like one who comes across them by chance on some secret errand.

His *legend,* as the French say, with the anecdotes which every one remembers, is one of the most brilliant chapters of Vasari. Later writers merely copied it, until, in 1804, Carlo Amoretti applied to it a criticism which left hardly a date fixed, and not one of those anecdotes untouched. The various questions thus raised have since that time become, one after another, subjects of special study, and mere antiquarianism has in this direction little more to do. For others remain the editing of the thirteen books of his manuscripts, and the separation by technical criticism of what in his reputed works is really his, from what is only half his, or the work of his pupils. But a lover of strange souls may still analyse for himself the impression made on him by those works, and try to reach through it a definition of the chief elements of Leonardo's genius. The *legend,* as corrected and enlarged by its critics, may now and then intervene to support the results of this analysis.

His life has three divisions—thirty years at Florence, nearly twenty years at Milan, then nineteen years of wandering, till he sinks to rest under the protection of Francis the First at the *Château de Clou.* The dishonour of illegitimacy hangs over his birth. Piero Antonio, his father, was of a noble Florentine house, of Vinci in the *Val d'Arno,* and Leonardo, brought up delicately among the true children of that house, was the love-child of his youth, with the keen, puissant nature such children often have. We see him in his boyhood fascinating all men by his beauty, improvising music and songs, buying the caged birds and setting them free, as he walked the streets of Florence, fond of odd bright dresses and spirited horses.

From his earliest years he designed many objects, and constructed models in relief, of which Vasari mentions some of women smiling. His father, pondering over this promise in the child, took him to the workshop of Andrea del Verrocchio, then the most famous artist in Florence. Beautiful objects lay about there—reliquaries, pyxes, silver images for the pope's chapel at Rome, strange fancy-work of the middle age, keeping odd com-

pany with fragments of antiquity, then but lately discovered. Another student Leonardo may have seen there—a lad into whose soul the level light and aerial illusions of Italian sunsets had passed, in after days famous as Perugino. Verrocchio was an artist of the earlier Florentine type, carver, painter, and worker in metals, in one; designer, not of pictures only, but of all things for sacred or household use, drinking-vessels, ambries, instruments of music, making them all fair to look upon, filling the common ways of life with the reflexion of some far-off brightness; and years of patience had refined his hand till his work was now sought after from distant places.

It happened that Verrocchio was employed by the brethren of Vallombrosa to paint the Baptism of Christ, and Leonardo was allowed to finish an angel in the left-hand corner. It was one of those moments in which the progress of a great thing—here, that of the art of Italy—presses hard on the happiness of an individual, through whose discouragement and decrease, humanity, in more fortunate persons, comes a step nearer to its final success.

For beneath the cheerful exterior of the mere well-paid craftsman, chasing brooches for the copes of *Santa Maria Novella,* or twisting metal screens for the tombs of the Medici, lay the ambitious desire to expand the destiny of Italian art by a larger knowledge and insight into things, a purpose in art not unlike Leonardo's still unconscious purpose; and often, in the modelling of drapery, or of a lifted arm, or of hair cast back from the face, there came to him something of the freer manner and richer humanity of a later age. But in this *Baptism* the pupil had surpassed the master; and Verrocchio turned away as one stunned, and as if his sweet earlier work must thereafter be distasteful to him, from the bright animated angel of Leonardo's hand.

The angel may still be seen in Florence, a space of sunlight in the cold, laboured old picture; but the legend is true only in sentiment, for painting had always been the art by which Verrocchio set least store. And as in a sense he anticipates Leonardo, so, to the last Leonardo recalls the studio of Verrocchio, in the love of beautiful toys, such as the vessel of

water for a mirror, and lovely needlework about the implicated hands in the *Modesty and Vanity,* and of reliefs, like those cameos which in the *Virgin of the Balances* hang all round the girdle of Saint Michael, and of bright variegated stones, such as the agates in the *Saint Anne,* and in a hieratic preciseness and grace, as of a sanctuary swept and garnished. Amid all the cunning and intricacy of his Lombard manner this never left him. Much of it there must have been in that lost picture of *Paradise,* which he prepared as a cartoon for tapestry, to be woven in the looms of Flanders. It was the perfection of the older Florentine style of miniature-painting, with patient putting of each leaf upon the trees and each flower in the grass, where the first man and woman were standing.

And because it was the perfection of that style, it awoke in Leonardo some seed of discontent which lay in the secret places of his nature. For the way to perfection is through a series of disgusts; and this picture—all that he had done so far in his life at Florence—was after all in the old slight manner. His art, if it was to be something in the world, must be weighted with more of the meaning of nature and purpose of humanity. Nature was "the true mistress of higher intelligences." He plunged, then, into the study of nature. And in doing this he followed the manner of the older students; he brooded over the hidden virtues of plants and crystals, the lines traced by the stars as they moved in the sky, over the correspondences which exist between the different orders of living things, through which, to eyes opened, they interpret each other; and for years he seemed to those about him as one listening to a voice, silent for other men.

He learned here the art of going deep, of tracking the sources of expression to their subtlest retreats, the power of an intimate presence in the things he handled. He did not at once or entirely desert his art; only he was no longer the cheerful, objective painter, through whose soul, as through clear glass, the bright figures of Florentine life, only made a little mellower and more pensive by the transit, passed on to the white wall. He wasted many days in curious tricks of design, seeming to lose himself in the spinning of intricate devices of line and colour. He was smitten with a love of the impossible—the perforation

of mountains, changing the course of rivers, raising great buildings, such as the church of *San Giovanni*, in the air; all those feats for the performance of which natural magic professed to have the key. Later writers, indeed, see in these efforts an anticipation of modern mechanics; in him they were rather dreams, thrown off by the overwrought and labouring brain. Two ideas were especially confirmed in him, as reflexes of things that had touched his brain in childhood beyond the depth of other impressions—the smiling of women and the motion of great waters.

And in such studies some interfusion of the extremes of beauty and terror shaped itself, as an image that might be seen and touched, in the mind of this gracious youth, so fixed that for the rest of his life it never left him. As if catching glimpses of it in the strange eyes or hair of chance people, he would follow such about the streets of Florence till the sun went down, of whom many sketches of his remain. Some of these are full of a curious beauty, that remote beauty which may be apprehended only by those who have sought it carefully; who, starting with acknowledged types of beauty, have refined as far upon these, as these refine upon the world of common forms. But mingled inextricably with this there is an element of mockery also; so that, whether in sorrow or scorn, he caricatures Dante even. Legions of grotesques sweep under his hand; for has not nature too her grotesques—the rent rock, the distorting lights of evening on lonely roads, the unveiled structure of man in the embryo, or the skeleton?

All these swarming fancies unite in the *Medusa* of the *Uffizii*. Vasari's story of an earlier Medusa, painted on a wooden shield, is perhaps an invention; and yet, properly told, has more of the air of truth about it than anything else in the whole legend. For its real subject is not the serious work of a man, but the experiment of a child. The lizards and glow-worms and other strange small creatures which haunt an Italian vineyard bring before one the whole picture of a child's life in a Tuscan dwelling—half castle, half farm—and are as true to nature as the pretended astonishment of the father for whom the boy has prepared a surprise. It was not in play that he painted that other Medusa, the

one great picture which he left behind him in Florence. The subject has been treated in various ways; Leonardo alone cuts to its centre; he alone realises it as the head of a corpse, exercising its powers through all the circumstances of death. What may be called the fascination of corruption penetrates in every touch its exquisitely finished beauty. About the dainty lines of the cheek the bat flits unheeded. The delicate snakes seem literally strangling each other in terrified struggle to escape from the Medusa brain. The hue which violent death always brings with it is in the features; features singularly massive and grand, as we catch them inverted, in a dexterous foreshortening, crown foremost, like a great calm stone against which the wave of serpents breaks.

The science of that age was all divination, clairvoyance, unsubjected to our exact modern formulas, seeking in an instant of vision to concentrate a thousand experiences. Later writers, thinking only of the well-ordered treatise on painting which a Frenchman, Raffaelle du Fresne, a hundred years afterwards, compiled from Leonardo's bewildered manuscripts, written strangely, as his manner was, from right to left, have imagined a rigid order in his inquiries. But this rigid order would have been little in accordance with the restlessness of his character; and if we think of him as the mere reasoner who subjects design to anatomy, and composition to mathematical rules, we shall hardly have that impression which those around Leonardo received from him. Poring over his crucibles, making experiments with colour, trying, by a strange variation of the alchemist's dream, to discover the secret, not of an elixir to make man's natural life immortal, but of giving immortality to the subtlest and most delicate effects of painting, he seemed to them rather the sorcerer or the magician, possessed of curious secrets and a hidden knowledge, living in a world of which he alone possessed the key. What his philosophy seems to have been most like is that of Paracelsus or Cardan; and much of the spirit of the older alchemy still hangs about it, with its confidence in short cuts and odd byways to knowledge. To him philosophy was to be something giving strange swiftness and double sight, divining the sources of springs beneath the earth or of expression

beneath the human countenance, clairvoyant of occult gifts in common or uncommon things, in the reed at the brook-side, or the star which draws near to us but once in a century. How, in this way, the clear purpose was overclouded, the fine chaser's hand perplexed, we but dimly see; the mystery which at no point quite lifts from Leonardo's life is deepest here. But it is certain that at one period of his life he had almost ceased to be an artist.

The year 1483—the year of the birth of Raphael and the thirty-first of Leonardo's life—is fixed as the date of his visit to Milan by the letter in which he recommends himself to Ludovico Sforza, and offers to tell him, for a price, strange secrets in the art of war. It was that Sforza who murdered his young nephew by slow poison, yet was so susceptible of religious impressions that he blended mere earthly passion with a sort of religious sentimentalism, and who took for his device the mulberry-tree—symbol, in its long delay and sudden yielding of flowers and fruit together, of a wisdom which economises all forces for an opportunity of sudden and sure effect. The fame of Leonardo had gone before him, and he was to model a colossal statue of Francesco, the first Duke of Milan. As for Leonardo himself, he came not as an artist at all, or careful of the fame of one; but as a player on the harp, a strange harp of silver of his own construction, shaped in some curious likeness to a horse's skull. The capricious spirit of Ludovico was susceptible also to the power of music, and Leonardo's nature had a kind of spell in it. Fascination is always the word descriptive of him. No portrait of his youth remains; but all tends to make us believe that up to this time some charm of voice and aspect, strong enough to balance the disadvantage of his birth, had played about him. His physical strength was great; it was said that he could bend a horse-shoe like a coil of lead.

The *Duomo*, work of artists from beyond the Alps, so fantastic to the eye of a Florentine used to the mellow, unbroken surfaces of Giotto and Arnolfo, was then in all its freshness; and below, in the streets of Milan, moved a people as fantastic, changeful, and dreamlike. To Leonardo least of all men could there be anything poisonous in the exotic flowers of sentiment which grew there. It was a life of brilliant sins and exquisite

amusements: Leonardo became a celebrated designer of pageants; and it suited the quality of his genius, composed, in almost equal parts, of curiosity and the desire of beauty, to take things as they came.

Curiosity and the desire of beauty—these are the two elementary forces in Leonardo's genius; curiosity often in conflict with the desire of beauty, but generating, in union with it, a type of subtle and curious grace.

The movement of the fifteenth century was two-fold; partly the Renaissance, partly also the coming of what is called the "modern spirit," with its realism, its appeal to experience. It comprehended a return to antiquity, and a return to nature. Raphael represents the return to antiquity, and Leonardo the return to nature. In this return to nature, he was seeking to satisfy a boundless curiosity by her perpetual surprises, a microscopic sense of finish by her *finesse,* or delicacy of operation, that *subtilitas naturæ* which Bacon notices. So we find him often in intimate relations with men of science,—with Fra Luca Paccioli the mathematician, and the anatomist Marc Antonio della Torre. His observations and experiments fill thirteen volumes of manuscript; and those who can judge describe him as anticipating long before, by rapid intuition, the later ideas of science. He explained the obscure light of the unilluminated part of the moon, knew that the sea had once covered the mountains which contain shells, and of the gathering of the equatorial waters above the polar.

He who thus penetrated into the most secret parts of nature preferred always the more to the less remote, what, seeming exceptional, was an instance of law more refined, the construction about things of a peculiar atmosphere and mixed lights. He paints flowers with such curious felicity that different writers have attributed to him a fondness for particular flowers, as Clement the cyclamen, and Rio the jasmin; while, at Venice, there is a stray leaf from his portfolio dotted all over with studies of violets and the wild rose. In him first appears the taste for what is *bizarre* or *recherché* in landscape; hollow places full of the green shadow of bituminous rocks, ridged reefs of trap-rock which cut the water into quaint sheets of light,—their exact anti-

type is in our own western seas; all the solemn effects of moving water. You may follow it springing from its distant source among the rocks on the heath of the *Madonna of the Balances,* passing, as a little fall, into the treacherous calm of the *Madonna of the Lake,* as a goodly river next, below the cliffs of the *Madonna of the Rocks,* washing the white walls of its distant villages, stealing out in a network of divided streams in *La Gioconda* to the seashore of the *Saint Anne*—that delicate place, where the wind passes like the point of some fine etcher over the surface, and the untorn shells are lying thick upon the sand, and the tops of the rocks, to which the waves never rise, are green with grass, grown fine as hair. It is the landscape, not of dreams or of fancy, but of places far withdrawn, and hours selected from a thousand with a miracle of *finesse.* Through Leonardo's strange veil of sight things reach him so; in no ordinary night or day, but as in faint light of eclipse, or in some brief interval of falling rain at daybreak, or through deep water.

And not into nature only; but he plunged also into human personality, and became above all a painter of portraits; faces of a modelling more skilful than has been seen before or since, embodied with a reality which almost amounts to illusion, on the dark air. To take a character as it was, and delicately sound its stops, suited one so curious in observation, curious in invention. He painted thus the portraits of Ludovico's mistresses, Lucretia Crivelli and Cecilia Galerani the poetess, of Ludovico himself, and the Duchess Beatrice. The portrait of Cecilia Galerani is lost, but that of Lucretia Crivelli has been identified with *La Belle Feronnière* of the Louvre, and Ludovico's pale, anxious face still remains in the Ambrosian library. Opposite is the portrait of Beatrice d'Este, in whom Leonardo seems to have caught some presentiment of early death, painting her precise and grave, full of the refinement of the dead, in sad earth-coloured raiment, set with pale stones.

Sometimes this curiosity came in conflict with the desire of beauty; it tended to make him go too far below that outside of things in which art really begins and ends. This struggle between the reason and its ideas, and the senses, the desire of beauty, is the key to Leonardo's life at Milan—his restlessness,

his endless re-touchings, his odd experiments with colour. How much must he leave unfinished, how much recommence! His problem was the transmutation of ideas into images. What he had attained so far had been the mastery of that earlier Florentine style, with its naïve and limited sensuousness. Now he was to entertain in this narrow medium those divinations of a humanity too wide for it, that larger vision of the opening world, which is only not too much for the great, irregular art of Shakespeare; and everywhere the effort is visible in the work of his hands. This agitation, this perpetual delay, give him an air of weariness and *ennui*. To others he seems to be aiming at an impossible effect, to do something that art, that painting, can never do. Often the expression of physical beauty at this or that point seems strained and marred in the effort, as in those heavy German foreheads—too heavy and German for perfect beauty.

For there was a touch of Germany in that genius which, as Goethe said, had "thought itself weary"—*müde sich gedacht*. What an anticipation of modern Germany, for instance, in that debate on the question whether sculpture or painting is the nobler art![1] But there is this difference between him and the German, that, with all that curious science, the German would have thought nothing more was needed. The name of Goethe himself reminds one how great for the artist may be the danger of over-much science; how Goethe, who, in the *Elective Affinities* and the first part of *Faust*, does transmute ideas into images, who wrought many such transmutations, did not invariably find the spell-word, and in the second part of *Faust* presents us with a mass of science which has almost no artistic character at all. But Leonardo will never work till the happy moment comes—that moment of *bien-être*, which to imaginative men is the moment of invention. On this he waits with a perfect patience; other moments are but a preparation, or after-taste of it. Few men distinguish between them as jealously as he. Hence, so many flaws even in the choicest work. But for

[1] How princely, how characteristic of Leonardo, the answer, *Quanto più un' arte porta seco fatica di corpo tanto più è vile!*

Leonardo the distinction is absolute, and, in the moment of *bien-être*, the alchemy complete: the idea is stricken into colour and imagery: a cloudy mysticism is refined to a subdued and graceful mystery, and painting pleases the eye while it satisfies the soul.

This curious beauty is seen above all in his drawings, and in these chiefly in the abstract grace of the bounding lines. Let us take some of these drawings, and pause over them awhile; and, first, one of those at Florence—the heads of a woman and a little child, set side by side, but each in its own separate frame. First of all, there is much pathos in the reappearance, in the fuller curves of the face of the child, of the sharper, more chastened lines of the worn and older face, which leaves no doubt that the heads are those of a little child and its mother. A feeling for maternity is indeed always characteristic of Leonardo; and this feeling is further indicated here by the half-humourous pathos of the diminutive, rounded shoulders of the child. You may note a like pathetic power in drawings of a young man, seated in a stooping posture, his face in his hands, as in sorrow; of a slave sitting in an uneasy inclined attitude, in some brief interval of rest; of a small Madonna and Child, peeping sideways in half-reassured terror, as a mighty griffin with batlike wings, one of Leonardo's finest *inventions*, descends suddenly from the air to snatch up a great wild beast wandering near them. But note in these, as that which especially belongs to art, the contour of the young man's hair, the poise of the slave's arm above his head, and the curves of the head of the child, following the little skull within, thin and fine as some seashell worn by the wind.

Take again another head, still more full of sentiment, but of a different kind, a little drawing in red chalk which every one will remember who has examined at all carefully the drawings by old masters at the Louvre. It is a face of doubtful sex, set in the shadow of its own hair, the cheek-line in high light against it, with something voluptuous and full in the eyelids and the lips. Another drawing might pass for the same face in childhood, with parched and feverish lips, but much sweetness in the loose, short-waisted childish dress, with necklace and *bulla,* and in the daintily bound hair. We might take the thread of suggestion

which these two drawings offer, when thus set side by side, and, following it through the drawings at Florence, Venice, and Milan, construct a sort of series, illustrating better than anything else Leonardo's type of womanly beauty. Daughters of Herodias, with their fantastic head-dresses knotted and folded so strangely to leave the dainty oval of the face disengaged, they are not of the Christian family, or of Raphael's. They are the clairvoyants, through whom, as through delicate instruments, one becomes aware of the subtler forces of nature, and the modes of their action, all that is magnetic in it, all those finer conditions wherein material things rise to that subtlety of operation which constitutes them spiritual, where only the finer nerve and the keener touch can follow. It is as if in certain significant examples we actually saw those forces at their work on human flesh. Nervous, electric, faint always with some inexplicable faintness, these people seem to be subject to exceptional conditions, to feel powers at work in the common air unfelt by others, to become, as it were, the receptacle of them, and pass them on to us in a chain of secret influences.

But among the more youthful heads there is one at Florence which Love chooses for its own—the head of a young man, which may well be the likeness of Andréa Salaino, beloved of Leonardo for his curled and waving hair—*belli capelli ricci e inanellati*—and afterwards his favourite pupil and servant. Of all the interests in living men and women which may have filled his life at Milan, this attachment alone is recorded. And in return Salaino identified himself so entirely with Leonardo, that the picture of *St. Anne,* in the Louvre, has been attributed to him. It illustrates Leonardo's usual choice of pupils, men of some natural charm of person or intercourse like Salaino, or men of birth and princely habits of life like Francesco Melzi—men with just enough genius to be capable of initiation into his secret, for the sake of which they were ready to efface their own individuality. Among them, retiring often to the villa of the Melzi at *Canonica al Vaprio,* he worked at his fugitive manuscripts and sketches, working for the present hour, and for a few only, perhaps chiefly for himself. Other artists have been as careless of present or future applause, in self-forgetfulness, or because they set moral

or political ends above the ends of art; but in him this solitary culture of beauty seems to have hung upon a kind of self-love, and a carelessness in the work of art of all but art itself. Out of the secret places of a unique temperament he brought strange blossoms and fruits hitherto unknown; and for him, the novel impression conveyed, the exquisite effect woven, counted as an end in itself—a perfect end.

And these pupils of his acquired his manner so thoroughly, that though the number of Leonardo's authentic works is very small indeed, there is a multitude of other men's pictures through which we undoubtedly see him, and come very near to his genius. Sometimes, as in the little picture of the *Madonna of the Balances,* in which, from the bosom of His mother, Christ weighs the pebbles of the brook against the sins of men, we have a hand, rough enough by contrast, working upon some fine hint or sketch of his. Sometimes, as in the subjects of the *Daughter of Herodias* and the *Head of John the Baptist,* the lost originals have been re-echoed and varied upon again and again by Luini and others. At other times the original remains, but has been a mere theme or motive, a type of which the accessories might be modified or changed; and these variations have but brought out the more the purpose, or expression of the original. It is so with the so-called *Saint John the Baptist* of the Louvre—one of the few naked figures Leonardo painted—whose delicate brown flesh and woman's hair no one would go out into the wilderness to seek, and whose treacherous smile would have us understand something far beyond the outward gesture or circumstance. But the long, reedlike cross in the hand, which suggests Saint John the Baptist, becomes faint in a copy at the Ambrosian Library, and disappears altogether in another version, in the *Palazzo Rosso* at Genoa. Returning from the latter to the original, we are no longer surprised by Saint John's strange likeness to the *Bacchus* which hangs near it, and which set Théophile Gautier thinking of Heine's notion of decayed gods, who, to maintain themselves, after the fall of paganism, took employment in the new religion. We recognise one of those symbolical inventions in which the ostensible subject is used, not as matter for definite pictorial realisation, but as the starting-point of a train of senti-

ment, subtle and vague as a piece of music. No one ever ruled over the mere *subject* in hand more entirely than Leonardo, or bent it more dexterously to purely artistic ends. And so it comes to pass that though he handles sacred subjects continually, he is the most profane of painters; the given person or subject, Saint John in the Desert, or the Virgin on the knees of Saint Anne, is often merely the pretext for a kind of work which carried one altogether beyond the range of its conventional associations.

About the *Last Supper,* its decay and restorations, a whole literature has risen up, Goethe's pensive sketch of its sad fortunes being perhaps the best. The death in child-birth of the Duchess Beatrice was followed in Ludovico by one of those paroxysms of religious feeling which in him were constitutional. The low, gloomy Dominican church of *Saint Mary of the Graces* had been the favourite oratory of Beatrice. She had spent her last days there, full of sinister presentiments; at last it had been almost necessary to remove her from it by force; and now it was here that mass was said a hundred times a day for her repose. On the damp wall of the refectory, oozing with mineral salts, Leonardo painted the *Last Supper.* Effective anecdotes were told about it, his retouchings and delays. They show him refusing to work except at the moment of invention, scornful of anyone who supposed that art could be a work of mere industry and rule, often coming the whole length of Milan to give a single touch. He painted it, not in fresco, where all must be *impromptu,* but in oils, the new method which he had been one of the first to welcome, because it allowed of so many afterthoughts, so refined a working-out of perfection. It turned out that on a plastered wall no process could have been less durable. Within fifty years it had fallen into decay. And now we have to turn back to Leonardo's own studies, above all to one drawing of the central head at the *Brera,* which, in a union of tenderness and severity in the face-lines, reminds one of the monumental work of Mino da Fiesole, to trace it as it was.

Here was another effort to lift a given subject out of the range of its traditional associations. Strange, after all the mystic developments of the middle age, was the effort to see the Eucharist, not as the pale Host of the altar, but as one taking leave of his

friends. Five years afterwards the young Raphael, at Florence, painted it with sweet and solemn effect in the refectory of Saint Onofrio; but still with all the mystical unreality of the school of Perugino. Vasari pretends that the central head was never finished. But finished or unfinished, or owing part of its effect to a mellowing decay, the head of Jesus does but consummate the sentiment of the whole company—ghosts through which you see the wall, faint as the shadows of the leaves upon the wall on autumn afternoons. This figure is but the faintest, the most spectral of them all.

The *Last Supper* was finished in 1497; in 1498 the French entered Milan, and whether or not the Gascon bowmen used it as a mark for their arrows, the model of Francesco Sforza certainly did not survive. What, in that age, such work was capable of being of what nobility, amid what racy truthfulness to fact— we may judge from the bronze statue of Bartolomeo Colleoni on horseback, modelled by Leonardo's master, Verrocchio, (he died of grief, it was said, because, the mould accidentally failing, he was unable to complete it), still standing in the *piazza* of Saint John and Saint Paul at Venice. Some traces of the thing may remain in certain of Leonardo's drawings, and perhaps also, by a singular circumstance, in a far-off town of France. For Ludovico became a prisoner, and ended his days at Loches in Touraine. After many years of captivity in the dungeons below, where all seems sick with barbarous feudal memories, he was allowed at last, it is said, to breathe fresher air for awhile in one of the rooms of the great tower still shown, its walls covered with strange painted arabesques, ascribed by tradition to his hand, amused a little, in this way, through the tedious years. In those vast helmets and human faces and pieces of armour, among which, in great letters, the motto *Infelix Sum* is woven in and out, it is perhaps not too fanciful to see the fruit of a wistful after-dreaming over Leonardo's sundry experiments on the armed figure of the great duke, which had occupied the two so much during the days of their good fortune at Milan.

The remaining years of Leonardo's life are more or less years of wandering. From his brilliant life at court he had saved nothing, and he returned to Florence a poor man. Perhaps necessity

kept his spirit excited: the next four years are one prolonged
rapture or ecstasy of invention. He painted now the pictures of
the Louvre, his most authentic works, which came there straight
from the cabinet of Francis the First, at Fontainebleau. One
picture of his, the *Saint Anne*—not the *Saint Anne* of the
Louvre, but a simple cartoon, now in London—revived for a
moment a sort of appreciation more common in an earlier time,
when good pictures had still seemed miraculous. For two days a
crowd of people of all qualities passed in naïve excitement
through the chamber where it hung, and gave Leonardo a taste
of the "triumph" of Cimabue. But his work was less with the
saints than with the living women of Florence. For he lived still
in the polished society that he loved, and in the houses of
Florence, left perhaps a little subject to light thoughts by the
death of Savonarola—the latest gossip (1869) is of an undraped
Monna Lisa, found in some out-of-the-way corner of the late
Orleans collection—he saw Ginevra di Benci, and Lisa, the
young third wife of Francesco del Giocondo. As we have seen
him using incidents of sacred story, not for their own sake, or as
mere subjects for pictorial realisation, but as a cryptic language
for fancies all his own, so now he found a vent for his thought in
taking one of these languid women, and raising her, as Leda or
Pomona, as Modesty or Vanity, to the seventh heaven of sym-
bolical expression.

La Gioconda is, in the truest sense, Leonardo's masterpiece,
the revealing instance of his mode of thought and work. In sug-
gestiveness, only the *Melancholia* of Dürer is comparable to it;
and no crude symbolism disturbs the effect of its subdued and
graceful mystery. We all know the face and hands of the figure,
set in its marble chair, in that circle of fantastic rocks, as in some
faint light under sea. Perhaps of all ancient pictures time has
chilled it least.[2] As often happens with works in which invention
seems to reach its limit, there is an element in it given to, not
invented by, the master. In that inestimable folio of drawings,

[2] Yet for Vasari there was some further magic of crimson in the lips and cheeks,
lost for us.

once in the possession of Vasari, were certain designs by Verrocchio, faces of such impressive beauty that Leonardo in his boyhood copied them many times. It is hard not to connect with these designs of the elder, by-past master, as with its germinal principle, the unfathomable smile, always with a touch of something sinister in it, which plays over all Leonardo's work. Besides, the picture is a portrait. From childhood we see this image defining itself on the fabric of his dreams; and but for express historical testimony, we might fancy that this was but his ideal lady, embodied and beheld at last. What was the relationship of a living Florentine to this creature of his thought? By what strange affinities had the dream and the person grown up thus apart, and yet so closely together? Present from the first incorporeally in Leonardo's brain, dimly traced in the designs of Verrocchio, she is found present at last in *Il Giocondo's* house. That there is much of mere portraiture in the picture is attested by the legend that by artificial means, the presence of mimes and flute-players, that subtle expression was protracted on the face. Again, was it in four years and by renewed labour never really completed, or in four months and as by stroke of magic, that the image was projected?

The presence that rose thus so strangely beside the waters, is expressive of what in the ways of a thousand years men had come to desire. Hers is the head upon which all "the ends of the world are come," and the eyelids are a little weary. It is a beauty wrought out from within upon the flesh, the deposit, little cell by cell, of strange thoughts and fantastic reveries and exquisite passions. Set it for a moment beside one of those white Greek goddesses or beautiful women of antiquity, and how would they be troubled by this beauty, into which the soul with all its maladies has passed! All the thoughts and experience of the world have etched and moulded there, in that which they have of power to refine and make expressive the outward form, the animalism of Greece, the lust of Rome, the mysticism of the middle age with its spiritual ambition and imaginative loves, the return of the Pagan world, the sins of the Borgias. She is older than the rocks among which she sits; like the vampire, she has been dead many times, and learned the secrets of the grave; and

has been a diver in deep seas, and keeps their fallen day about her; and trafficked for strange webs with Eastern merchants: and, as Leda, was the mother of Helen of Troy, and, as Saint Anne, the mother of Mary; and all this has been to her but as the sound of lyres and flutes, and lives only in the delicacy with which it has moulded the changing lineaments, and tinged the eyelids and the hands. The fancy of a perpetual life, sweeping together ten thousand experiences, is an old one; and modern philosophy has conceived the idea of humanity as wrought upon by, and summing up in itself, all modes of thought and life. Certainly Lady Lisa might stand as the embodiment of the old fancy, the symbol of the modern idea.

During these years at Florence Leonardo's history is the history of his art; for himself, he is lost in the bright cloud of it. The outward history begins again in 1502, with a wild journey through central Italy, which he makes as the chief engineer of Cæsar Borgia. The biographer, putting together the stray jottings of his manuscripts, may follow him through every day of it, up the strange tower of Siena, elastic like a bent bow, down to the seashore at Piombino, each place appearing as fitfully as in a fever dream.

One other great work was left for him to do, a work all trace of which soon vanished, *The Battle of the Standard,* in which he had Michelangelo for his rival. The citizens of Florence, desiring to decorate the walls of the great council-chamber, had offered the work for competition, and any subject might be chosen from the Florentine wars of the fifteenth century. Michelangelo chose for his cartoon an incident of the war with Pisa, in which the Florentine soldiers, bathing in the Arno, are surprised by the sound of trumpets, and run to arms. His design has reached us only in an old engraving, which helps us less perhaps than our remembrance of the background of his *Holy Family* in the *Uffizii* to imagine in what superhuman form, such as might have beguiled the heart of an earlier world, those figures ascended out of the water. Leonardo chose an incident from the battle of Anghiari, in which two parties of soldiers fight for a standard. Like Michelangelo's, his cartoon is lost, and has come to us only in sketches, and in a fragment of Rubens.

Through the accounts given we may discern some lust of terrible things in it, so that even the horses tore each other with their teeth. And yet one fragment of it, in a drawing of his at Florence, is far different—a waving field of lovely armour, the chased edgings running like lines of sunlight from side to side. Michelangelo was twenty-seven years old; Leonardo more than fifty; and Raphael, then nineteen years of age, visiting Florence for the first time, came and watched them as they worked.

We catch a glimpse of Leonardo again, at Rome in 1514, surrounded by his mirrors and vials and furnaces, making strange toys that seemed alive of wax and quicksilver. The hesitation which had haunted him all through life, and made him like one under a spell, was upon him now with double force. No one had ever carried political indifferentism further; it had always been his philosophy to "fly before the storm"; he is for the Sforzas, or against them, as the tide of their fortune turns. Yet now, in the political society of Rome, he came to be suspected of secret French sympathies. It paralysed him to find himself among enemies; and he turned wholly to France, which had long courted him.

France was about to become an Italy more Italian than Italy itself. Francis the First, like Lewis the Twelfth before him, was attracted by the *finesse* of Leonardo's work; *La Gioconda* was already in his cabinet, and he offered Leonardo the little *Château de Clou,* with its vineyards and meadows, in the pleasant valley of the Masse, just outside the walls of the town of Amboise, where, especially in the hunting season, the court then frequently resided. A *Monsieur Lyonard, peinteur du Roy pour Amboyse:*— so the letter of Francis the First is headed. It opens a prospect, one of the most interesting in the history of art, where, in a peculiarly blent atmosphere, Italian art dies away as a French exotic.

Two questions remain, after much busy antiquarianism, concerning Leonardo's death—the question of the exact form of his religion, and the question whether Francis the First was present at the time. They are of about equally little importance in the estimate of Leonardo's genius. The directions in his will concerning the thirty masses and the great candles for the church

of Saint Florentin are things of course, their real purpose being immediate and practical; and on no theory of religion could these hurried offices be of much consequence. We forget them in speculating how one who had been always so desirous of beauty, but desired it always in such precise and definite forms, as hands or flowers or hair, looked forward now into the vague land, and experienced the last curiosity.

1869.

THE SCHOOL OF GIORGIONE

IT is the mistake of much popular criticism to regard poetry, music, and painting—all the various products of art as but translations into different languages of one and the same fixed quantity of imaginative thought, supplemented by certain technical qualities of colour, in painting; of sound, in music; of rhythmical words, in poetry. In this way, the sensuous element in art, and with it almost everything in art that is essentially artistic, is made a matter of indifference; and a clear apprehension of the opposite principle—that the sensuous material of each art brings with it a special phase or quality of beauty, untranslatable into the forms of any other, an order off impressions distinct in kind—is the beginning of all true æsthetic criticism. For, as art addresses not pure sense, still less the pure intellect, but the "imaginative reason" through the senses, there are differences of kind in æsthetic beauty, corresponding to the differences in kind of the gifts of sense themselves. Each art, therefore, having its own peculiar and untranslatable sensuous charm, has its own special mode of reaching the imagination, its own special responsibilities to its material. One of the functions of æsthetic criticism is to define these limitations; to estimate the degree in which a given work of art fulfils its responsibilities to its special material; to note in a picture that true pictorial charm, which is neither a mere poetical thought or sentiment, on the one hand, nor a mere result of communicable technical skill in colour or design, on the other; to define in a poem that true poetical quality, which is neither descriptive nor meditative merely, but comes of an inventive handling of rhythmical language, the element of song in the singing; to note in music the musical charm, that essential music, which presents no words, no matter of sentiment or thought, separable from the special form in which it is conveyed to us.

To such a philosophy of the variations of the beautiful, Lessing's analysis of the spheres of sculpture and poetry, in the *Laocoon,* was an important contribution. But a true appreciation of these things is possible only in the light of a whole system of such art-casuistries. Now painting is the art in the criticism of which this truth most needs enforcing, for it is in popular judgments on pictures that the false generalisation of all art into forms of poetry is most prevalent. To suppose that all is mere technical acquirement in delineation or touch, working through and addressing itself to the intelligence, on the one side, or a merely poetical, or what may be called literary interest, addressed also to the pure intelligence, on the other:—this is the way of most spectators, and of many critics, who have never caught sight all the time of that true pictorial quality which lies between, unique pledge, as it is, of the possession of the pictorial gift, that inventive or creative handling of pure line and colour, which, as almost always in Dutch painting, as often also in the works of Titian or Veronese, is quite independent of anything definitely poetical in the subject it accompanies. It is the *drawing*—the design projected from that peculiar pictorial temperament or constitution, in which, while it may possibly be ignorant of true anatomical proportions, all things whatever, all poetry, all ideas however abstract or obscure, float up as visible scene or image: it is the *colouring*—that weaving of light, as of just perceptible gold threads, through the dress, the flesh, the atmosphere, in Titian's *Lace-girl,* that staining of the whole fabric of the thing with a new, delightful physical quality. This *drawing,* then—the arabesque traced in the air by Tintoret's flying figures, by Titian's forest branches; this colouring—the magic conditions of light and hue in the atmosphere of Titian's *Lace-girl,* or Rubens's *Descent from the Cross:*—these essential pictorial qualities must first of all delight the sense, delight it as directly and sensuously as a fragment of Venetian glass; and through this delight alone become the vehicle of whatever poetry or science may lie beyond them in the intention of the composer. In its primary aspect, a great picture has no more definite message for us than an accidental play of sunlight and shadow for a few moments on the wall or floor: is itself, in truth,

a space of such fallen light, caught as the colours are in an Eastern carpet, but refined upon, and dealt with more subtly and exquisitely than by nature itself. And this primary and essential condition fulfilled, we may trace the coming of poetry into painting, by fine gradations upwards; from Japanese fan-painting, for instance, where we get, first, only abstract colour; then, just a little interfused sense of the poetry of flowers; then, sometimes, perfect flower-painting; and so, onwards, until in Titian we have, as his poetry in the *Ariadne,* so actually a touch of true childlike humour in the diminutive, quaint figure with its silk gown, which ascends the temple stairs, in his picture of the *Presentation of the Virgin,* at Venice.

But although each art has thus its own specific order of impressions, and an untranslatable charm, while a just apprehension of the ultimate differences of the arts is the beginning of æsthetic criticism; yet it is noticeable that, in its special mode of handling its given material, each art may be observed to pass into the condition of some other art, by what German critics term an *Anders-streben*—a partial alienation from its own limitations, through which the arts are able, not indeed to supply the place of each other, but reciprocally to lend each other new forces.

Thus, some of the most delightful music seems to be always approaching to figure, to pictorial definition. Architecture, again, though it has its own laws—laws esoteric enough, as the true architect knows only too well—yet sometimes aims at fulfilling the conditions of a picture, as in the *Arena* chapel; or of sculpture, as in the flawless unity of Giotto's tower at Florence; and often finds a true poetry, as in those strangely twisted staircases of the *châteaux* of the country of the Loire, as if it were intended that among their odd turnings the actors in a theatrical mode of life might pass each other unseen; there being a poetry also of memory and of the mere effect of time, by which architecture often profits greatly. Thus, again, sculpture aspires out of the hard limitation of pure form towards colour, or its equivalent; poetry also, in many ways, finding guidance from the other arts, the analogy between a Greek tragedy and a work of Greek sculpture, between a sonnet and a relief, of French poetry generally with the art of engraving, being more than

mere figures of speech; and all the arts in common aspiring towards the principle of music; music being the typical, or ideally consummate art, the object of the great *Anders-streben* of all art, of all that is artistic, or partakes of artistic qualities. *All art constantly aspires towards the condition of music.* For while in all other kinds of art it is possible to distinguish the matter from the form, and the understanding can always make this distinction, yet it is the constant effort of art to obliterate it. That the mere matter of a poem, for instance, its subject, namely, its given incidents or situation—that the mere matter of a picture, the actual circumstances of an event, the actual topography of a landscape—should be nothing without the form, the spirit, of the handling, that this form, this mode of handling, should become an end in itself, should penetrate every part of the matter: this is what all art constantly strives after, and achieves in different degrees.

This abstract language becomes clear enough, if we think of actual examples. In an actual landscape we see a long white road, lost suddenly on the hill-verge. That is the matter of one of the etchings of M. Alphonse Legros: only, in this etching, it is informed by an indwelling solemnity of expression, seen upon it or half-seen, within the limits of an exceptional moment, or caught from his own mood perhaps, but which he maintains as the very essence of the thing, throughout his work. Sometimes a momentary hint of stormy light may invest a homely or too familiar scene with a character which might well have been drawn from the deep places of the imagination. Then we might say that this particular effect of light, this sudden inweaving of gold thread through the texture of the haystack, and the poplars, and the grass, gives the scene artistic qualities, that it is like a picture. And such tricks of circumstance are commonest in landscape which has little salient character of its own; because, in such scenery, all the material details are so easily absorbed by that informing expression of passing light, and elevated, throughout their whole extent, to a new and delightful effect by it. And hence the superiority, for most conditions of the picturesque, of a river-side in France to a Swiss valley, because, on the French river-side, mere topography, the simple material,

counts for so little, and, all being very pure, untouched, and tranquil in itself, mere light and shade have such easy work in modulating it to one dominant tone. The Venetian landscape, on the other hand, has in its material conditions much which is hard, or harshly definite; but the masters of the Venetian school have shown themselves little burdened by them. Of its Alpine background they retain certain abstracted elements only, of cool colour and tranquillising line; and they use its actual details, the brown windy turrets, the straw-coloured fields, the forest arabesques, but as the notes of a music which duly accompanies the presence of their men and women, presenting us with the spirit or essence only of a certain sort of landscape—a country of the pure reason or half-imaginative memory.

Poetry, again, works with words addressed in the first instance to the pure intelligence; and it deals, most often, with a definite subject or situation. Sometimes it may find a noble and quite legitimate function in the conveyance of moral or political aspiration, as often in the poetry of Victor Hugo. In such instances it is easy enough for the understanding to distinguish between the matter and the form, however much the matter, the subject, the element which is addressed to the mere intelligence, has been penetrated by the informing, artistic spirit. But the ideal types of poetry are those in which this distinction is reduced to its *minimum;* so that lyrical poetry, precisely because in it we are least able to detach the matter from the form, without a deduction of something from that matter itself, is, at least artistically, the highest and most complete form of poetry. And the very perfection of such poetry often appears to depend, in part, on a certain suppression or vagueness of mere subject, so that the meaning reaches us through ways not distinctly traceable by the understanding, as in some of the most imaginative compositions of William Blake, and often in Shakespeare's songs, as preeminently in that song of Mariana's page in *Measure for Measure,* in which the kindling force and poetry of the whole play seems to pass for a moment into an actual strain of music.

And this principle holds good of all things that partake in any degree of artistic qualities, of the furniture of our houses, and of dress, for instance, of life itself, of gesture and speech, and the

details of daily intercourse; these also, for the wise, being susceptible of a suavity and charm, caught from the way in which they are done, which gives them a worth in themselves. Herein, again, lies what is valuable and justly attractive, in what is called the fashion of a time, which elevates the trivialities of speech, and manner, and dress, into "ends in themselves," and gives them a mysterious grace and attractiveness in the doing of them.

Art, then, is thus always striving to be independent of the mere intelligence, to become a matter of pure perception, to get rid of its responsibilities to its subject or material; the ideal examples of poetry and painting being those in which the constituent elements of the composition are so welded together, that the material or subject no longer strikes the intellect only; nor the form, the eye or the ear only; but form and matter, in their union or identity, present one single effect to the "imaginative reason," that complex faculty for which every thought and feeling is twin-born with its sensible analogue or symbol.

It is the art of music which most completely realises this artistic ideal, this perfect identification of matter and form. In its consummate moments, the end is not distinct from the means, the form from the matter, the subject from the expression; they inhere in and completely saturate each other; and to it, therefore, to the condition of its perfect moments, all the arts may be supposed constantly to tend and aspire. In music, then, rather than in poetry, is to be found the true type or measure of perfected art. Therefore, although each art has its incommunicable element, its untranslatable order of impressions, its unique mode of reaching the "imaginative reason," yet the arts may be represented as continually struggling after the law or principle of music, to a condition which music alone completely realises, and one of the chief functions of æsthetic criticism, dealing with the products of art, new or old, is to estimate the degree in which each of those products approaches, in this sense, to musical law.

By no school of painters have the necessary limitations of the art of painting been so unerringly though instinctively apprehended, and the essence of what is pictorial in a picture so justly

conceived, as by the school of Venice; and the train of thought suggested in what has been now said is, perhaps, a not unfitting introduction to a few pages about Giorgione, who, though much has been taken by recent criticism from what was reputed to be his work, yet, more entirely than any other painter, sums up, in what we know of himself and his art, the spirit of the Venetian school.

The beginnings of Venetian painting link themselves to the last, stiff, half-barbaric splendours of Byzantine decoration, and are but the introduction into the crust of marble and gold on the walls of the *Duomo* of Murano, or of *Saint Mark's,* of a little more of human expression. And throughout the course of its later development, always subordinate to architectural effect, the work of the Venetian school never escaped from the influence of its beginnings. Unassisted, and therefore unperplexed, by naturalism, religious mysticism, philosophical theories, it had no Giotto, no Angelico, no Botticelli. Exempt from the stress of thought and sentiment, which taxed so severely the resources of the generations of Florentine artists, those earlier Venetian painters, down to Carpaccio and the Bellini, seem never for a moment to have been so much as tempted to lose sight of the scope of their art in its strictness, or to forget that painting must be before all things decorative, a thing for the eye, a space of colour on the wall, only more dexterously blent than the marking of its precious stone or the chance interchange of sun and shade upon it:—this, to begin and end with; whatever higher matter of thought, or poetry, or religious reverie might play its part therein, between. At last, with final mastery of all the technical secrets of his art, and with somewhat more than "a spark of the divine fire" to his share, comes Giorgione. He is the inventor of *genre,* of those easily movable pictures which serve neither for uses of devotion, nor of allegorical or historic teaching— little groups of real men and women, amid congruous furniture or landscape—morsels of actual life, conversation or music or play, but refined upon or idealised, till they come to seem like glimpses of life from afar. Those spaces of more cunningly blent colour, obediently filling their places, hitherto, in a mere architectural scheme, Giorgione detaches from the wall. He frames

them by the hands of some skilful carver, so that people may move them readily and take with them where they go, as one might a poem in manuscript, or a musical instrument, to be used, at will, as a means of self-education, stimulus or solace, coming like an animated presence, into one's cabinet, to enrich the air as with some choice aroma, and, like persons, live with us, for a day or a lifetime. Of all art such as this, art which has played so large a part in men's culture since that time, Giorgione is the initiator. Yet in him too that old Venetian clearness or justice, in the apprehension of the essential limitations of the pictorial art, is still undisturbed. While he interfuses his painted work with a high-strung sort of poetry, caught directly from a singularly rich and high-strung sort of life, yet in his selection of subject, or phase of subject, in the subordination of mere subject to pictorial design, to the main purpose of a picture, he is typical of that aspiration of all the arts towards music, which I have endeavoured to explain,—towards the perfect identification of matter and form.

Born so near to Titian, though a little before him, that these two companion pupils of the aged Giovanni Bellini may almost be called contemporaries, Giorgione stands to Titian in something like the relationship of Sordello to Dante, in Browning's poem. Titian, when he leaves Bellini, becomes, in turn, the pupil of Giorgione. He lives in constant labour more than sixty years after Giorgione is in his grave; and with such fruit, that hardly one of the greater towns of Europe is without some fragment of his work. But the slightly older man, with his so limited actual product (what remains to us of it seeming, when narrowly explained, to reduce itself to almost one picture, like Sordello's one fragment of lovely verse) yet expresses, in elementary motive and principle, that spirit—itself the final acquisition of all the long endeavours of Venetian art—which Titian spreads over his whole life's activity.

And, as we might expect, something fabulous and illusive has always mingled itself in the brilliancy of Giorgione's fame. The exact relationship to him of many works—drawings, portraits, painted idylls—often fascinating enough, which in various collections went by his name, was from the first uncertain. Still, six

or eight famous pictures at Dresden, Florence and the Louvre, were with no doubt attributed to him, and in these, if anywhere, something of the splendour of the old Venetian humanity seemed to have been preserved. But of those six or eight famous pictures it is now known that only one is certainly from Giorgione's hand. The accomplished science of the subject has come at last, and, as in other instances, has not made the past more real for us, but assured us only that we possess less of it than we seemed to possess. Much of the work on which Giorgione's immediate fame depended, work done for instantaneous effect, in all probability passed away almost within his own age, like the frescoes on the façade of the *fondaco dei Tedeschi* at Venice, some crimson traces of which, however, still give a strange additional touch of splendour to the scene of the *Rialto*. And then there is a barrier or borderland, a period about the middle of the sixteenth century, in passing through which the tradition miscarries, and the true outlines of Giorgione's work and person are obscured. It became fashionable for wealthy lovers of art, with no critical standard of authenticity, to collect so-called works of Giorgione, and a multitude of imitations came into circulation. And now, in the "new Vasari,"[1] the great traditional reputation, woven with so profuse demand on men's admiration, has been scrutinised thread by thread; and what remains of the most vivid and stimulating of Venetian masters, a live flame, as it seemed, in those old shadowy times, has been reduced almost to a name by his most recent critics.

Yet enough remains to explain why the legend grew up above the name, why the name attached itself, in many instances, to the bravest work of other men. The *Concert* in the *Pitti* Palace, in which a monk, with cowl and tonsure, touches the keys of a harpsichord, while a clerk, placed behind him, grasps the handle of a viol, and a third, with cap and plume, seems to wait upon the true interval for beginning to sing, is undoubtedly Giorgione's. The outline of the lifted finger, the trace of the plume, the very threads of the fine linen, which fasten them-

[1] Crowe and Cavalcaselle: *History of Painting in North Italy.*

selves on the memory, in the moment before they are lost altogether in that calm unearthly glow, the skill which has caught the waves of wandering sound, and fixed them for ever on the lips and hands—these are indeed the master's own; and the criticism which, while dismissing so much hitherto believed to be Giorgione's, has established the claims of this one picture, has left it among the most precious things in the world of art.

It is noticeable that the "distinction" of this *Concert*, its sustained evenness of perfection, alike in design, in execution, and in choice of personal type, becomes for the "new Vasari" the standard of Giorgione's genuine work. Finding here sufficient to explain his influence, and the true seal of mastery, its authors assign to Pellegrino da San Daniele the *Holy Family* in the Louvre, in consideration of certain points where it comes short of this standard. Such shortcoming however will hardly diminish the spectator's enjoyment of a singular charm of liquid air, with which the whole picture seems instinct, filling the eyes and lips, the very garments, of its sacred personages, with some wind-searched brightness and energy; of which fine air the blue peak, clearly defined in the distance, is, as it were, the visible pledge. Similarly, another favourite picture in the Louvre, subject of a delightful sonnet by a poet[2] whose own painted work often comes to mind as one ponders over these precious things—the *Fête Champêtre*, is assigned to an imitator of Sebastian del Piombo; and the *Tempest*, in the Academy at Venice, to Paris Bordone, or perhaps to "some advanced craftsman of the sixteenth century." From the gallery at Dresden, the *Knight embracing a Lady*, where the knight's broken gauntlet seems to mark some well-known pause in a story we would willingly hear the rest of, is conceded to "a Brescian hand," and *Jacob meeting Rachel* to a pupil of Palma. And then, whatever their charm, we are called on to give up the *Ordeal*, and the *Finding of Moses* with its jewel-like pools of water, perhaps to Bellini.

Nor has the criticism, which thus so freely diminishes the

[2] Dante Gabriel Rossetti.

number of his authentic works, added anything important to the well-known outline of the life and personality of the man: only, it has fixed one or two dates, one or two circumstances, a little more exactly. Giorgione was born before the year 1477, and spent his childhood at Castelfranco, where the last crags of the Venetian Alps break down romantically, with something of park-like grace, to the plain. A natural child of the family of the Barbarelli by a peasant-girl of Vedelago, he finds his way early into the circle of notable persons—people of courtesy. He is initiated into those differences of personal type, manner, and even of dress, which are best understood there—that "distinction" of the *Concert* of the *Pitti* Palace. Not far from his home lives Catherine of Cornara, formerly Queen of Cyprus; and, up in the towers which still remain, Tuzio Costanzo, the famous *condottière*, a picturesque remnant of mediceval manners, amid a civilisation rapidly changing. Giorgione paints their portraits; and when Tuzio's son, Matteo, dies in early youth, adorns in his memory a chapel in the church of Castelfranco, painting on this occasion, perhaps, the altarpiece, foremost among his authentic works, still to be seen there, with the figure of the warrior-saint, Liberale, of which the original little study in oil, with the delicately gleaming, silver-grey armour, is one of the greater treasures of the National Gallery. In that figure, as in some other knightly personages attributed to him, people have supposed the likeness of the painter's own presumably gracious presence. Thither, at last, he is himself brought home from Venice, early dead, but celebrated. It happened, about his thirty-fourth year, that in one of those parties at which he entertained his friends with music, he met a certain lady of whom he became greatly enamoured, and "they rejoiced greatly," says Vasari, "the one and the other, in their loves."And two quite different legends concerning it agree in this, that it was through this lady he came by his death; Ridolfi relating that, being robbed of her by one of his pupils, he died of grief at the double treason; Vasari, that she being secretly stricken of the plague, and he making his visits to her as usual, Giorgione took the sickness from her mortally, along with her kisses, and so briefly departed.

But, although the number of Giorgione's extant works has

been thus limited by recent criticism, all is not done when the real and the traditional elements in what concerns him have been discriminated; for, in what is connected with a great name, much that is not real is often very stimulating. For the æsthetic philosopher, therefore, over and above the real Giorgione and his authentic extant works, there remains the *Giorgionesque* also—an influence, a spirit or type in art, active in men so different as those to whom many of his supposed works are really assignable. A veritable school, in fact, grew together out of all those fascinating works rightly or wrongly attributed to him; out of many copies from, or variations on him, by unknown or uncertain workmen, whose drawings and designs were, for various reasons, prized as his; out of the immediate impression he made upon his contemporaries, and with which he continued in men's minds; out of many traditions of subject and treatment, which really descend from him to our own time, and by retracing which we fill out the original image. Giorgione thus becomes a sort of impersonation of Venice itself, its projected reflex or ideal, all that was intense or desirable in it crystallising about the memory of this wonderful young man.

And now, finally, let me illustrate some of the characteristics of this *School of Giorgione,* as we may call it, which, for most of us, notwithstanding all that negative criticism of the "new Vasari," will still identify itself with those famous pictures at Florence, at Dresden and Paris. A certain artistic ideal is there defined for us—the conception of a peculiar aim and procedure in art, which we may understand as the *Giorgionesque,* wherever we find it, whether in Venetian work generally, or in work of our own time. Of this the *Concert,* that undoubted work of Giorgione in the *Pitti* Palace, is the typical instance, and a pledge authenticating the connexion of the school, and the spirit of the school, with the master.

I have spoken of a certain interpretation of the matter or subject of a work of art with the form of it, a condition realised absolutely only in music, as the condition to which every form of art is perpetually aspiring. In the art of painting, the attainment of this ideal condition, this perfect interpenetration of the sub-

ject with the elements of colour and design, depends, of course, in great measure, on dexterous choice of that subject, or phase of subject; and such choice is one of the secrets of Giorgione's school. It is the school of *genre,* and employs itself mainly with "painted idylls," but, in the production of this pictorial poetry, exercises a wonderful tact in the selecting of such matter as lends itself most readily and entirely to pictorial form, to complete expression by drawing and colour. For although its productions are painted poems, they belong to a sort of poetry which tells itself without an articulated story. The master is preeminent for the resolution, the ease and quickness, with which he reproduces instantaneous motion—the lacing-on of armour, with the head bent back so stately—the fainting lady—the embrace, rapid as the kiss, caught with death itself from dying lips—some momentary conjunction of mirrors and polished armour and still water, by which all the sides of a solid image are exhibited at once, solving that casuistical question whether painting can present an object as completely as sculpture. The sudden act, the rapid transition of thought, the passing expression—these he arrests with that vivacity which Vasari has attributed to him, *il fuoco Giorgionesco,* as he terms it. Now it is part of the ideality of the highest sort of dramatic poetry, that it presents us with a kind of profoundly significant and animated instants, a mere gesture, a look, a smile, perhaps—some brief and wholly concrete moment—into which, however, all the motives, all the interests and effects of a long history, have condensed themselves, and which seem to absorb past and future in an intense consciousness of the present. Such ideal instants the school of Giorgione selects, with its admirable tact, from that feverish, tumultuously coloured world of the old citizens of Venice—exquisite pauses in time, in which, arrested thus, we seem to be spectators of all the fulness of existence, and which are like some consummate extract or quintessence of life.

It is to the law or condition of music, as I said, that all art like this is really aspiring; and, in the school of Giorgione, the perfect moments of music itself, the making or hearing of music, song or its accompaniment, are themselves prominent as subjects. On that background of the silence of Venice, so impressive

to the modern visitor, the world of Italian music was then form-
ing. In choice of subject, as in all besides, the *Concert* of the
Pitti Palace is typical of everything that Giorgione, himself an
admirable musician, touched with his influence. In sketch or
finished picture, in various collections, we may follow it through
many intricate variations—men fainting at music; music at the
pool-side while people fish, or mingled with the sound of the
pitcher in the well, or heard across running water, or among the
flocks; the tuning of instruments; people with intent faces, as if
listening, like those described by Plato in an ingenious passage
of the Republic, to detect the smallest interval of musical sound,
the smallest undulation in the air, or feeling for music in thought
on a stringless instrument, ear and finger refining themselves
infinitely, in the appetite for sweet sound; a momentary touch of
an instrument in the twilight, as one passes through some unfa-
miliar room, in a chance company.

In these then, the favourite incidents of Giorgione's school,
music or the musical intervals in our existence, life itself is con-
ceived as a sort of listening—listening to music, to the reading
of Bandello's novels, to the sound of water, to time as it flies.
Often such moments are really our moments of play, and we are
surprised at the unexpected blessedness of what may seem our
least important part of time; not merely because play is in many
instances that to which people really apply their own best pow-
ers, but also because at such times, the stress of our servile,
everyday attentiveness being relaxed, the happier powers in
things without are permitted free passage, and have their way
with us. And so, from music, the school of Giorgione passes
often to the play which is like music; to those masques in which
men avowedly do but play at real life, like children "dressing-
up," disguised in the strange old Italian dresses, particoloured,
or fantastic with embroidery and furs, of which the master was
so curious a designer, and which, above all the spotless white
linen at wrist and throat, he painted so dexterously.

But when people are happy in this thirsty land water will not
be far off; and in the school of Giorgione, the presence of
water—the well, or marble-rimmed pool, the drawing or pour-
ing of water, as the woman pours it from a pitcher with her jew-

elled hand in the *Fête Champêter*, listening, perhaps, to the cool sound as it falls, blent with the music of the pipes—is as characteristic, and almost as suggestive, as that of music itself. And the landscape feels, and is glad of it also—a landscape full of clearness, of the effects of water, of fresh rain newly passed through the air, and collected into the grassy channels. The air, moreover, in the school of Giorgione, seems as vivid as the people who breathe it, and literally empyrean, all impurities being burnt out of it, and no taint, no floating particle of anything but its own proper elements allowed to subsist within it.

Its scenery is such as in England we call "park scenery," with some elusive refinement felt about the rustic buildings, the choice grass, the grouped trees, the undulations deftly economised for graceful effect. Only, in Italy all natural things are as it were woven through and through with gold thread, even the cypress revealing it among the folds of its blackness. And it is with gold dust, or gold thread, that these Venetian painters seem to work, spinning its fine filaments, through the solemn human flesh, away into the white plastered walls of the thatched huts. The harsher details of the mountains recede to a harmonious distance, the one peak of rich blue above the horizon remaining but as the sensible warrant of that due coolness which is all we need ask here of the Alps, with their dark rains and streams. Yet what real, airy space, as the eye passes from level to level, through the long-drawn valley in which Jacob embraces Rachel among the flocks! Nowhere is there a truer instance of that balance, that modulated unison of landscape and persons —of the human image and its accessories— already noticed as characteristic of the Venetian school, so that, in it, neither personage nor scenery is ever a mere pretext for the other.

Something like this seems to me to be the *vraie vérité* about Giorgione, if I may adopt a serviceable expression, by which the French recognise those more liberal and durable impressions which, in respect of any really considerable person or subject, anything that has at all intricately occupied men's attention, lie beyond, and must supplement, the narrower range of the strictly ascertained facts about it. In this, Giorgione is but an

illustration of a valuable general caution we may abide by in all criticism. As regards Giorgione himself, we have indeed to take note of all those negations and exceptions, by which, at first sight, a "new Vasari" seems merely to have confused our apprehension of a delightful object, to have explained away in our inheritance from past time what seemed of high value there. Yet it is not with a full understanding even of those exceptions that one can leave off just at this point. Properly qualified, such exceptions are but a salt of genuineness in our knowledge; and beyond all those strictly ascertained facts, we must take note of that indirect influence by which one like Giorgione, for instance, enlarges his permanent efficacy and really makes himself felt in our culture. In a just impression of that, is the essential truth, the *vraie vérité,* concerning him.

1877.

JOACHIM DU BELLAY

IN the middle of the sixteenth century, when the spirit of the Renaissance was everywhere, and people had begun to look back with distaste on the works of the middle age, the old Gothic manner had still one chance more, in borrowing something from the rival which was about to supplant it. In this way there was produced, chiefly in France, a new and peculiar phase of taste with qualities and a charm of its own, blending the somewhat attenuated grace of Italian ornament with the general outlines of northern design. It created the *Château de Gaillon*, as you may still see it in the delicate engravings of Israël Silvestre—a Gothic donjon veiled faintly by a surface of dainty Italian traceries—Chenonceaux, Blois, Chambord, and the church of Brou. In painting, there came from Italy workmen like *Maître Roux* and the masters of the school of Fontainebleau, to have their later Italian voluptuousness attempered by the naïve and silvery qualities of the native style; and it was characteristic of these painters that they were most successful in painting on glass, an art so essentially medieval. Taking it up where the middle age had left it, they found their whole work among the last subtleties of colour and line; and keeping within the true limits of their material, they got quite a new order of effects from it, and felt their way to refinements on colour never dreamed of by those older workmen, the glass-painters of Chartres or Le Mans. What is called the *Renaissance in France* is thus not so much the introduction of a wholly new taste ready-made from Italy, but rather the finest and subtlest phase of the middle age itself, its last fleeting splendour and temperate Saint Martin's summer. In poetry, the Gothic spirit in France had produced a thousand songs; so in the Renaissance, French poetry too did but borrow something to blend with a native growth, and the poems of Ronsard, with their ingenuity, their delicately fig-

103

ured surfaces, their slightness, their fanciful combinations of rhyme, are the correlative of the traceries of the house of Jacques Cœur at Bourges, or the *Maison de Justice* at Rouen. There was indeed something in the native French taste naturally akin to that Italian *finesse*. The characteristic of French work had always been a certain nicety, a remarkable daintiness of hand, *une netteté remarquable d'exécution*. In the paintings of François Clouet, for example, or rather of the Clouets—for there was a whole family of them—painters remarkable for their resistance to Italian influences, there is a silveriness of colour and a clearness of expression which distinguish them very definitely from their Flemish neighbours, Hemling or the Van Eycks. And this nicety is not less characteristic of old French poetry. A light, aerial delicacy, a simple elegance—*une netteté remarquable d'exécution:* these are essential characteristics alike of Villon's poetry, and of the *Hours of Anne of Brittany.* They are characteristic too of a hundred French Gothic carvings and traceries. Alike in the old Gothic cathedrals, and in their counterpart, the old Gothic *chansons de geste,* the rough and ponderous mass becomes, as if by passing for a moment into happier conditions, or through a more gracious stratum of air, graceful and refined, like the carved ferneries on the granite church at Folgoat, or the lines which describe the fair priestly hands of Archbishop Turpin, in the song of Roland; although below both alike there is a fund of mere Gothic strength, or heaviness.[1]

Now Villon's songs and Clouet's paintings are like these. It is the higher touch making itself felt here and there, betraying itself, like nobler blood in a lower stock, by a fine line or gesture or expression, the turn of a wrist, the tapering of a finger. In Ronsard's time that rougher element seemed likely to predominate. No one can turn over the pages of Rabelais without feeling how much need there was of softening, of castigation. To effect this softening is the object of the revolution in poetry which is connected with Ronsard's name. Casting about for the means of thus refining upon

[1] The purely artistic aspects of this subject have been interpreted, in a work of great taste and learning, by Mrs. Mark Pattison.—*The Renaissance of Art in France.*

and saving the character of French literature, he accepted that influx of Renaissance taste, which, leaving the buildings, the language, the art, the poetry of France, at bottom, what they were, old French Gothic still, gilds their surfaces with a strange, delightful, foreign aspect passing over all that northern land, in itself neither deeper nor more permanent than a chance effect of light. He reinforces, he doubles the French daintiness by Italian *finesse*. Thereupon, nearly all the force and all the seriousness of French work disappear; only the elegance, the aerial touch, the perfect manner remain. But this elegance, this manner, this daintiness of execution are consummate, and have an unmistakable æsthetic value.

So the old French *chanson,* which, like the old northern Gothic ornament, though it sometimes refined itself into a sort of weird elegance, was often, in its essence, something rude and formless, became in the hands of Ronsard a Pindaric ode. He gave it structure, a sustained system, *strophe* and *antistrophe,* and taught it a changefulness and variety of metre which keep the curiosity always excited, so that the very aspect of it, as it lies written on the page, carried the eye lightly onwards, and of which this is a good instance:—

> Avril, la grace, et le lis
> De Cypris,
> Le flair et la douce haleine;
> Avril, le parfum des dieux,
> Qui, des cieux,
> Sentent l'odeur de la plaine;
>
> C'est toy, courtois et gentil,
> Qui, d'exil
> Retire ces passageres,
> Ces arondelles qui vont,
> Et qui sont
> Du printemps les messageres.

That is not by Ronsard, but by Remy Belleau, for Ronsard soon came to have a school. Six other poets threw in their lot with him in his literary revolution,—this Remy Belleau, Antoine de Baif,

Pontus de Tyard, Étienne Jodelle, Jean Daurat, and lastly
Joachim du Bellay; and with that strange love of emblems which
is characteristic of the time, which covered all the works of Francis
the First with the salamander, and all the works of Henry the
Second with the double crescent, and all the works of Anne of
Brittany with the knotted cord, they called themselves the
Pleiad, seven in all, although, as happens with the celestial
Pleiad, if you scrutinise this constellation of poets more carefully
you may find there a great number of minor stars.

The first note of this literary revolution was struck by Joachim
du Bellay in a little tract written at the early age of twenty-four,
which coming to us through three centuries seems of yesterday,
so full is it of those delicate critical distinctions which are some-
times supposed peculiar to modern writers. The piece has for its
title *La Deffense et Illustration de la langue Françoyse;* and its
problem is how to illustrate or ennoble the French language, to
give it lustre. We are accustomed to speak of the varied critical
and creative movement of the fifteenth and sixteenth centuries as
the *Renaissance,* and because we have a single name for it we may
sometimes fancy that there was more unity in the thing itself than
there really was. Even the Reformation, that other great move-
ment of the fifteenth and sixteenth centuries, had far less unity,
far less of combined action, than is at first sight supposed; and the
Renaissance was infinitely less united, less conscious of combined
action, than the Reformation. But if anywhere the Renaissance
became conscious, as a German philosopher might say, if ever it
was understood as a systematic movement by those who took part
in it, it is in this little book of Joachim du Bellay's, which it is
impossible to read without feeling the excitement, the animation,
of change, of discovery. "It is a remarkable fact," says M. Sainte-
Beuve, "and an inversion of what is true of other languages, that,
in French, prose has always had the precedence over poetry." Du
Bellay's prose is perfectly transparent, flexible, and chaste. In
many ways it is a more characteristic example of the culture of the
Pleiad than any of its verse; and those who love the whole move-
ment of which the *Pleiad* is a part, for a weird foreign grace in it,
and may be looking about for a true specimen of it, cannot have a
better than Joachim du Bellay and this little treatise of his.

Du Bellay's object is to adjust the existing French culture to

the rediscovered classical culture; and in discussing this problem, and developing the theories of the *Pleiad,* he has lighted upon many principles of permanent truth and applicability. There were some who despaired of the French language altogether, who thought it naturally incapable of the fulness and elegance of Greek and Latin—*cette élégance et copie qui est en la langue Greque et Romaine*—that science could be adequately discussed, and poetry nobly written, only in the dead languages. "Those who speak thus," says du Bellay, "make me think of the relics which one may only see through a little pane of glass, and must not touch with one's hands. That is what these people do with all branches of culture, which they keep shut up in Greek and Latin books, not permitting one to see them otherwise, or transport them out of dead words into those which are alive, and wing their way daily through the mouths of men." "Languages," he says again, "are not born like plants and trees, some naturally feeble and sickly, others healthy and strong and apter to bear the weight of men's conceptions, but all their virtue is generated in the world of choice and men's freewill concerning them. Therefore, I cannot blame too strongly the rashness of some of our countrymen, who being anything rather than Greeks or Latins, depreciate and reject with more than stoical disdain everything written in French; nor can I express my surprise at the odd opinion of some learned men who think that our vulgar tongue is wholly incapable of erudition and good literature."

It was an age of translations. du Bellay himself translated two books of the *Æneid,* and other poetry, old and new, and there were some who thought that the translation of the classical literature was the true means of *ennobling* the French language:—strangers are ever favourites with us—*nous favorisons toujours les étrangers.* Du Bellay moderates their expectations. "I do not believe that one can learn the right use of them"—he is speaking of figures and ornament in language— "from translations, because it is impossible to reproduce them with the same grace with which the original author used them. For each language has I know not what peculiarity of its own; and if you force yourself to express the naturalness *(le naif)* of this in another language, observing the law of translation,—not to expatiate beyond the limits of the author himself, your words

will be constrained, cold and ungraceful." Then he fixes the test of all good translation:—"To prove this, read me Demosthenes and Homer in Latin, Cicero and Virgil in French, and see whether they produce in you the same affections which you experience in reading those authors in the original."

In this effort to ennoble the French language, to give it grace, number, perfection, and as painters do to their pictures, that last, so desirable, touch—*cette dernière main que nous désirons*—what du Bellay is really pleading for is his mother-tongue, the language, that is, in which one will have the utmost degree of what is moving and passionate. He recognised of what force the music and dignity of languages are, how they enter into the inmost part of things; and in pleading for the cultivation of the French language, he is pleading for no merely scholastic interest, but for freedom, impulse, reality, not in literature only, but in daily communion of speech. After all, it was impossible to have this impulse in Greek and Latin, dead languages shut up in books as in reliquaries—*péris et mises en reliquaires de livres*. By aid of this starveling stock—*pauvre plante et vergette*—of the French language, he must speak delicately, movingly, if he is ever to speak so at all: that, or none, must be for him the medium of what he calls, in one of his great phrases, *le discours fatal des choses mondaines*—that discourse about affairs which decide men's fates. And it is his patriotism not to despair of it; he sees it already perfect in all elegance and beauty of words— *parfait en toute élégance et vénusté de paroles*.

Du Bellay was born in the disastrous year 1525, the year of the battle of Pavia, and the captivity of Francis the First. His parents died early, and to him, as the younger son, his mother's little estate, *ce petit Liré*, the beloved place of his birth, descended. He was brought up by a brother only a little older than himself; and left to themselves, the two boys passed their lives in day-dreams of military glory. Their education was neglected; "The time of my youth," says du Bellay, "was lost, like the flower which no shower waters, and no hand cultivates." He was just twenty years old when the elder brother died, leaving Joachim to be the guardian of his child. It was with regret, with a shrinking sense of incapacity, that he took upon him the burden of this responsibility.

Hitherto he had looked forward to the profession of a soldier, hereditary in his family. But at this time a sickness attacked him which brought him cruel sufferings, and seemed likely to be mortal. It was then for the first time that he read the Greek and Latin poets. These studies came too late to make him what he so much desired to be, a trifler in Greek and Latin verse, like so many others of his time now forgotten; instead, they made him a lover of his own homely native tongue, that poor starveling stock of the French language. It was through this fortunate shortcoming in his education that he became national and modern; and he learned afterwards to look back on that wild garden of his youth with only a half-regret. A certain Cardinal du Bellay was the successful member of the family, a man often employed in high official business. To him the thoughts of Joachim turned when it became necessary to choose a profession, and in 1552 he accompanied the Cardinal to Rome. He remained there nearly five years, burdened with the weight of affairs, and languishing with home-sickness. Yet it was under these circumstances that his genius yielded its best fruits. From Rome, so full of pleasurable sensation for men of an imaginative temperament such as his, with all the curiosities of the Renaissance still fresh in it, his thoughts went back painfully, longingly, to the country of the Loire, with its wide expanse of waving corn, its homely pointed roofs of grey slate, and its far-off scent of the sea. He reached home at last, but only to die there, quite suddenly, one wintry day, at the early age of thirty-five.

Much of du Bellay's poetry illustrates rather the age and school to which he belonged than his own temper and genius. As with the writings of Ronsard and the other poets of the *Pleiad,* its interest depends not so much on the impress of individual genius upon it, as on the circumstance that it was once poetry *à la mode,* that it is part of the manner of a time—a time which made much of manner, and carried it to a high degree of perfection. It is one of the decorations of an age which threw a large part of its energy into the work of decoration. We feel a pensive pleasure in gazing on these faded adornments, and observing how a group of actual men and women pleased themselves long ago. Ronsard's poems are a kind of epitome of his

age. Of one side of that age, it is true, of the strenuous, the progressive, the serious movement, which was then going on, there is little; but of the catholic side, the losing side, the forlorn hope, hardly a figure is absent. The Queen of Scots, at whose desire Ronsard published his Odes, reading him in her northern prison, felt that he was bringing back to her the true flavour of her early days in the court of Catherine at the Louvre, with its exotic Italian gaieties. Those who disliked that poetry, disliked it because they found that age itself distasteful. The poetry of Malherbe came, with its sustained style and weighty sentiment, but with nothing that set people singing; and the lovers of such poetry saw in the poetry of the *Pleiad* only the latest trumpery of the middle age. But the time arrived when the school of Malherbe also had had its day; and the *Romanticists*, who in their eagerness for excitement, for strange music and imagery, went back to the works of the middle age, accepted the *Pleiad* too with the rest; and in that new middle age which their genius has evoked, the poetry of the *Pleiad* has found its place. At first, with Malherbe, you may think it, like the architecture, the whole mode of life, the very dresses of that time, fantastic, faded, *rococo.* But if you look long enough to understand it, to conceive its sentiment, you will find that those wanton lines have a spirit guiding their caprices. For there is *style* there; one temper has shaped the whole; and everything that has style, that has been done as no other man or age could have done it, as it could never, for all our trying, be done again, has its true value and interest. Let us dwell upon it for a moment, and try to gather from it that special flower, *ce fleur particulier,* which Ronsard himself tells us every garden has.

It is poetry not for the people, but for a confined circle, for courtiers, great lords and erudite persons, people who desire to be humoured, to gratify a certain refined voluptuousness they have in them. Ronsard loves, or dreams that he loves, a rare and peculiar type of beauty, *la petite pucelle Angevine,* with golden hair and dark eyes. But he has the ambition not only of being a courtier and a lover, but a great scholar also; he is anxious about orthography, about the letter *è Grecque,* the true spelling of Latin names in French writing, and the restoration of the letter

i to its primitive liberty—*del' i voyelle en sa première liberté.* His poetry is full of quaint, remote learning. He is just a little pedantic, true always to his own express judgment, that to be natural is not enough for one who in poetry desires to produce work worthy of immortality. And therewithal a certain number of Greek words, which charmed Ronsard and his circle by their gaiety and daintiness, and a certain air of foreign elegance about them, crept into the French language; as there were other strange words which the poets of the *Pleiad* forged for themselves, and which had only an ephemeral existence.

With this was united the desire to taste a more exquisite and various music than that of the older French verse, or of the classical poets. The music of the measured, scanned verse of Latin and Greek poetry is one thing; the music of the rhymed, unscanned verse of Villon and the old French poets, *la poésie chantée,* is another. To combine these two kinds of music in a new school of French poetry, to make verse which should scan and rhyme as well, to search out and harmonise the measure of every syllable, and unite it to the swift, flitting, swallow-like motion of rhyme, to penetrate their poetry with a double music—this was the ambition of the *Pleiad.* They are insatiable of music, they cannot have enough of it; they desire a music of greater compass perhaps than words can possibly yield, to drain out the last drops of sweetness which a certain note or accent contains.

It was Goudimel, the serious and protestant Goudimel, who set Ronsard's songs to music; but except in this eagerness for music the poets of the *Pleiad* seem never quite in earnest. The old Greek and Roman mythology, which the great Italians had found a motive so weighty and severe, becomes with them a mere toy. That "Lord of terrible aspect," *Amor,* has become Love the boy, or the babe. They are full of fine railleries; they delight in diminutives, *ondelette, fontelette, doucelette, Cassandrette.* Their loves are only half real, a vain effort to prolong the imaginative loves of the middle age beyond their natural lifetime. They write love-poems for hire. Like that party of people who tell the tales in Boccaccio's *Decameron,* they form a circle which in an age of great troubles, losses, anxieties, can amuse itself with art, poetry, intrigue. But they amuse them-

selves with wonderful elegance. And sometimes their gaiety becomes satiric, for, as they play, real passions insinuate themselves, and at least the reality of death. Their dejection at the thought of leaving this fair abode of our common daylight—*le beau sejour du commun jour*—is expressed by them with almost wearisome reiteration. But with this sentiment too they are able to trifle. The imagery of death serves for delicate ornament, and they weave into the airy nothingness of their verses their trite reflexions on the vanity of life. Just so the grotesque details of the charnel-house nest themselves, together with birds and flowers and the fancies of the pagan mythology, in the traceries of the architecture of that time, which wantons in its graceful arabesques with the images of old age and death.

Ronsard became deaf at sixteen; and it was this circumstance which finally determined him to be a man of letters instead of a diplomatist, significantly, one might fancy, of a certain premature agedness, and of the tranquil, temperate sweetness appropriate to that, in the school of poetry which he founded. Its charm is that of a thing not vigorous or original, but full of the grace which comes of long study and reiterated refinements, and many steps repeated, and many angles worn down, with an exquisite faintness, *une fadeur exquise,* a certain tenuity and caducity, as for those who can bear nothing vehement or strong; for princes weary of love, like Francis the First, or of pleasure, like Henry the Third, or of action, like Henry the Fourth. Its merits are those of the old,—grace and finish, perfect in minute detail. For these people are a little jaded, and have a constant desire for a subdued and delicate excitement, to warm their creeping fancy a little. They love a constant change of rhyme in poetry, and in their houses that strange, fantastic interweaving of thin, reed-like lines, which are a kind of rhetoric in architecture.

But the poetry of the *Pleiad* is true not only to the physiognomy of its age, but also to its country, *ce pays du Vendomois,* the names and scenery of which so often recur in it:—the great Loire, with its long spaces of white sand; the little river Loir; the heathy, upland country, with its scattered pools of water and waste roadsides, and retired manors, with their crazy old feudal defences half fallen into decay; *La Beauce,* where the vast

rolling fields seem to anticipate the great western sea itself. It is full of the traits of that country. We see du Bellay and Ronsard gardening, or hunting with their dogs, or watch the pastimes of a rainy day; and with all this is connected a domesticity, a homeliness and simple goodness, by which the northern country gains upon the south. They have the love of the aged for warmth, and understand the poetry of winter; for they are not far from the Atlantic, and the west wind which comes up from it, turning the poplars white, spares not this new Italy in France. So the fireside often appears, with the pleasures of the frosty season, about the vast emblazoned chimneys of the time, and with a *bonhomie* as of little children, or old people.

It is in du Bellay's *Olive,* a collection of sonnets in praise of a half-imaginary lady, *Sonnetz a la louange d'Olive,* that these characteristics are most abundant. Here is a perfectly crystallised example;—

> D'amour, de grace, et de haulte valeur
> Les feux divins estoient ceinctz et les cieulx
> S'estoient vestuz d'un manteau precieux
> A raiz ardens de diverse couleur:
> Tout estoit plein de beauté, de bonheur,
> La mer tranquille, et le vent gracieulx,
> Quand celle la nasquit en ces bas lieux
> Qui a pillé du monde tout l'honneur.
> Ell' prist son teint des beux lyz blanchissans,
> Son chef de l'or, ses deux levres des rozes,
> Et du soleil ses yeux resplandissans:
> Le ciel usant de liberalite,
> Mist en l'esprit ses semences encloses,
> Son nom des Dieux prist l'immortalité.

That he is thus a characteristic specimen of the poetical taste of that age, is indeed du Bellay's chief interest. But if his work is to have the highest sort of interest, if it is to do something more than satisfy curiosity, if it is to have an æsthetic as distinct from an historical value, it is not enough for a poet to have been the true child of his age, to have conformed to its æsthetic conditions, and by so conforming have charmed and stimulated that

age; it is necessary that there should be perceptible in his work something individual, inventive, unique, the impress there of the writer's own temper and personality. This impress M. Sainte-Beuve thought he found in the *Antiquités de Rome,* and the *Regrets,* which he ranks as what has been called *poésie intime,* that intensely modern sort of poetry in which the writer has for his aim the portraiture of his own most intimate moods, and to take the reader into his confidence. That age had other instances of this intimacy of sentiment; Montaigne's *Essays* are full of it, the carvings of the church of Brou are full of it. M. Sainte-Beuve has perhaps exaggerated the influence of this quality in du Bellay's *Regrets;* but the very name of the book has a touch of Rousseau about it, and reminds one of a whole generation of self-pitying poets in modern times. It was in the atmosphere of Rome, to him so strange and mournful, that these pale flowers grew up. For that journey to Italy, which he deplored as the greatest misfortune of his life, put him in full possession of his talent, and brought out all its originality. And in effect you do find intimacy, *intimité,* here. The trouble of his life is analysed, and the sentiment of it conveyed directly to our minds; not a great sorrow or passion, but only the sense of loss in passing days, the *ennui* of a dreamer who must plunge into the world's affairs, the opposition between actual life and the ideal, a longing for rest, nostalgia, homesickness—that pre-eminently childish, but so suggestive sorrow, as significant of the final regret of all human creatures for the familiar earth and limited sky.

The feeling for landscape is often described as a modern one; still more so is that for antiquity, the sentiment of ruins. Du Bellay has this sentiment. The duration of the hard, sharp outlines of things is a grief to him, and passing his wearisome days among the ruins of ancient Rome, he is consoled by the thought that all must one day end, by the sentiment of the grandeur of nothingness—*la grandeur du rien.* With a strange touch of far-off mysticism, he thinks that the great whole—*le grand tout*—into which all other things pass and lose themselves, ought itself sometimes to perish and pass away. Nothing less can relieve his weariness. From the stately aspects of Rome his thoughts went back continually to France, to the smoking chimneys of his little

village, the longer twilight of the north, the soft climate of
Anjou—*la douceur Angevine;* yet not so much to the real
France, we may be sure, with its dark streets and roofs of rough-
hewn slate, as to that other country, with slenderer towers, and
more winding rivers, and trees like flowers, and with softer sun-
shine on more gracefully-proportioned fields and ways, which
the fancy of the exile, and the pilgrim, and of the schoolboy far
from home, and of those kept at home unwillingly, everywhere
builds up before or behind them.

He came home at last, through the *Grisons*, by slow journeys;
and there, in the cooler air of his own country, under its skies of
milkier blue, the sweetest flower of his genius sprang up. There
have been poets whose whole fame has rested on one poem, as
Gray's on the *Elegy in a Country Churchyard*, or Ronsard's, as
many critics have thought, on the eighteen lines of one famous
ode. Du Bellay has almost been the poet of one poem; and this
one poem of his is an Italian product transplanted into that
green country of Anjou; out of the Latin verses of Andrea
Navagero, into French. But it is a composition in which the mat-
ter is almost nothing, and the form almost everything; and the
form of the poem as it stands, written in old French, is all du
Bellay's own. It is a song which the winnowers are supposed to
sing as they winnow the corn, and they invoke the winds to lie
lightly on the grain.

D'UN VANNEUR DE BLE AUX VENTS [2]

> A vous trouppe legère
> Qui d'aile passagère
> Par le monde volez,
> Et d'un sifflant murmure
> L'ombrageuse verdure
> Doulcement esbranlez.

[2] A graceful translation of this and some other poems of the *Pleiad* may be
found in *Ballads and Lyrics of Old France*, by Mr. Andrew Lang.

J'offre ces violettes,
 Ces lis & ces fleurettes,
 Et ces roses icy,
 Ces vermeillettes roses
 Sont freschement écloses,
 Et ces œlliets aussi.

De vostre doulce haleine
 Eventez ceste plaine
 Eventez ce sejour;
 Ce pendant que j'ahanne
 A mon blé que je vanne
 A la chaleur du jour.

That has, in the highest degree, the qualities, the value, of the whole Pleiad school of poetry, of the whole phase of taste from which that school derives—a certain silvery grace of fancy, nearly all the pleasure of which is in the surprise at the happy and dexterous way in which a thing slight in itself is handled. The sweetness of it is by no means to be got at by crushing, as you crush wild herbs to get at their perfume. One seems to hear the measured motion of the fans, with a child's pleasure on coming across the incident for the first time, in one of those great barns of du Bellay's own country, *La Beauce*, the granary of France. A sudden light transfigures some trivial thing, a weather-vane, a windmill, a winnowing-fan, the dust in the barn door. A moment—and the thing has vanished, because it was pure effect; but it leaves a relish behind it, a longing that the accident may happen again.

1872.

WINCKELMANN

Et Ego in Arcadia Fui

GOETHE'S fragments of art-criticism contain a few pages of strange pregnancy on the character of Winckelmann. He speaks of the teacher who had made his career possible, but whom he had never seen, as of an abstract type of culture, consummate, tranquil, withdrawn already into the region of ideals, yet retaining colour from the incidents of a passionate intellectual life. He classes him with certain works of art, possessing an inexhaustible gift of suggestion, to which criticism may return again and again with renewed freshness. Hegel, in his lectures on the *Philosophy of Art*, estimating the work of his predecessors, has also passed a remarkable judgment on Winckelmann's writings:—"Winckelmann, by contemplation of the ideal works of the ancients, received a sort of inspiration, through which he opened a new sense for the study of art. He is to be regarded as one of those who, in the sphere of art, have known how to initiate a new organ for the human spirit." That is has given a new sense, that it has laid open a new organ, is the highest that can be said of any critical effort. It is interesting then to ask what kind of man it was who thus laid open a new organ. Under what conditions was that effected?

Johann Joachim Winckelmann was born at Stendal, in Brandenburg, in the year 1717. The child of a poor tradesman, he passed through many struggles in early youth, the memory of which ever remained in him as a fitful cause of dejection. In 1763, in the full emancipation of his spirit, looking over the beautiful Roman prospect, he writes—"One gets spoiled here; but God owed me this; in my youth I suffered too much." Destined to assert and interpret the charm of the Hellenic

spirit, he served first a painful apprenticeship in the tarnished intellectual world of Germany in the earlier half of the eighteenth century. Passing out of that into the happy light of the antique, he had a sense of exhilaration almost physical. We find him as a child in the dusky precincts of a German school, hungrily feeding on a few colourless books. The master of this school grows blind; Winckelmann becomes his *famulus*. The old man would have had him study theology. Winckelmann, free of the master's library, chooses rather to become familiar with the Greek classics. Herodotus and Homer win, with their "vow-elled" Greek, his warmest enthusiasm; whole nights of fever are devoted to them; disturbing dreams of an Odyssey of his own come to him. "He felt in himself," says Madame de Staël, "an ardent attraction towards the south. In German imaginations even now traces are often to be found of that love of the sun, that weariness of the north *(cette fatigue du nord)* which carried the northern peoples away into the countries of the south. A fine sky brings to birth sentiments not unlike the love of one's Fatherland."

To most of us, after all our steps towards it, the antique world, in spite of its intense outlines, its own perfect self-expression, still remains faint and remote. To him, closely limited except on the side of the ideal, building for his dark poverty "a house not made with hands," it early came to seem more real than the present. In the fantastic plans of foreign travel continually passing through his mind, to Egypt, for instance, and to France, there seems always to be rather a wistful sense of something lost to be regained, than the desire of discovering anything new. Goethe has told us how, in his eagerness actually to handle the antique, he became interested in the insignificant vestiges of it which the neighbourhood of Strasburg afforded. So we hear of Winckelmann's boyish antiquarian wanderings among the ugly Brandenburg sandhills. Such a conformity between himself and Winckelmann, Goethe would have gladly noted.

At twenty-one he enters the University of Halle, to study theology, as his friends desire; instead, he becomes the enthusiastic translator of Herodotus, The condition of Greek learning in German schools and universities had fallen, and there were

no professors at Halle who could satisfy his sharp, intellectual craving. Of his professional education he always speaks with scorn, claiming to have been his own teacher from first to last. His appointed teachers did not perceive that a new source of culture was within their hands. *Homo vagus et inconstans!*—one of them pedantically reports of the future pilgrim to Rome, unaware on which side his irony was whetted. When professional education confers nothing but irritation on a Schiller, no one ought to be surprised; for Schiller, and such as he, are primarily spiritual adventurers. But that Winckelmann, the votary of the gravest of intellectual traditions, should get nothing but an attempt at suppression from the professional guardians of learning, is what may well surprise us.

In 1743 he became master of a school at Seehausen. This was the most wearisome period of his life. Notwithstanding a success in dealing with children, which seems to testify to something simple and primeval in his nature, he found the work of teaching very depressing. Engaged in this work, he writes that he still has within him a longing desire to attain to the knowledge of beauty—*sehnlich wünschte zur Kenntniss des Schönen zu gelangen*. He had to shorten his nights, sleeping only four hours, to gain time for reading. And here Winckelmann made a step forward in culture. He multiplied his intellectual force by detaching from it all flaccid interests. He renounced mathematics and law, in which his reading had been considerable, all but the literature of the arts. Nothing was to enter into his life unpenetrated by its central enthusiasm. At this time he undergoes the charm of Voltaire. Voltaire belongs to that flimsier, more artificial, classical tradition, which Winckelmann was one day to supplant, by the clear ring, the eternal outline, of the genuine antique. But it proves the authority of such a gift as Voltaire's that it allures and wins even those born to supplant it. Voltaire's impression on Winckelmann was never effaced; and it gave him a consideration for French literature which contrasts with his contempt for the literary products of Germany. German literature transformed, side-realised, as we see it in Goethe, reckons Winckelmann among its initiators. But Germany at that time presented nothing in which he could have anticipated

Iphigenie, and the formation of an effective classical tradition in German literature.

Under this purely literary influence, Winckelmann protests against Christian Wolff and the philosophers. Goethe, in speaking of this protest, alludes to his own obligations to Emmanuel Kant. Kant's influence over the culture of Goethe, which he tells us could not have been resisted by him without loss, consisted in a severe limitation to the concrete. But he adds, that in born antiquaries, like Winckelmann, a constant handling of the antique, with its eternal outline, maintains that limitation as effectually as a critical philosophy. Plato, however, saved so often for his redeeming literary manner, is excepted from Winckelmann's proscription of the philosophers. The modern student most often meets Plato on that side which seems to pass beyond Plato into a world no longer pagan, and based upon the conception of a spiritual life. But the element of affinity which he presents to Winckelmann is that which is wholly Greek, and alien from the Christian world, represented by that group of brilliant youths in the *Lysis,* still uninfected by any spiritual sickness, finding the end of all endeavour in the aspects of the human form, the continual stir and motion of a comely human life.

This new-found interest in Plato's dialogues could not fail to increase his desire to visit the countries of the classical tradition. "It is my misfortune," he writes, "that I was not born to great place, wherein I might have had cultivation, and the opportunity of following my instinct and forming myself." A visit to Rome probably was already designed, and he silently preparing for it. Count Bünau, the author of a historical work then of note, had collected at Nöthenitz a valuable library, now part of the library of Dresden. In 1784 Winckelmann wrote to Bünau in halting French:—He is emboldened, he says, by Bünau's indulgence for needy men of letters. He desires only to devote himself to study, having never allowed himself to be dazzled by favourable prospects in the Church. He hints at his doubtful position "in a metaphysical age, by which humane literature is trampled under foot. At present," he goes on, "little value is set on Greek literature, to which I have devoted myself so far as I could penetrate, when good books are so scarce and expensive."

Finally, he desires a place in some corner of Bünau's library. "Perhaps, at some future time, I shall become more useful to the public, if, drawn from obscurity in whatever way, I can find means to maintain myself in the capital." Soon afterwards we find Winckelmann in the library at Nöthenitz. Thence he made many visits to the collection of antiquities at Dresden. He became acquainted with many artists, above all with Oeser, Goethe's future friend and master, who, uniting a high culture with the practical knowledge of art, was fitted to minister to Winckelmann's culture. And now a new channel of communion with the Greek life was opened for him. Hitherto he had handled the words only of Greek poetry, stirred indeed and roused by them, yet divining beyond the words some unexpressed pulsation of sensuous life. Suddenly he is in contact with that life, still fervent in the relics of plastic art. Filled as our culture is with the classical spirit, we can hardly imagine how deeply the human mind was moved, when, at the Renaissance, in the midst of a frozen world, the buried fire of ancient art rose up from under the soil. Winckelmann here reproduces for us the earlier sentiment of the Renaissance. On a sudden the imagination feels itself free. How facile and direct, it seems to say, is this life of the senses and the understanding, when once we have apprehended it! Here, surely, is that more liberal mode of life we have been seeking so long, so near to us all the while. How mistaken and round-about have been our efforts to reach it by mystic passion, and monastic reverie; how they have deflowered the flesh; how little have they really emancipated us! Hermione melts from her stony posture, and the lost proportions of life right themselves. Here, then, in vivid realisation, we see the native tendency of Winckelmann to escape from abstract theory to intuition, to the exercise of sight and touch. Lessing, in the *Laocoon*, has theorised finely on the relation of poetry to sculpture; and philosophy may give us theoretical reasons why not poetry but sculpture should be the most sincere and exact expression of the Greek ideal. By a happy, unperplexed dexterity, Winckelmann solves the question in the concrete. It is what Goethe calls his *Gewahrwerden der griechischen Kunst*, his *finding* of Greek art.

Through the tumultuous richness of Goethe's culture, the influence of Winckelmann is always discernible, as the strong, regulative under-current of a clear, antique motive. "One learns nothing from him," he says to Eckermann, "but one becomes something." If we ask what the secret of this influence was, Goethe himself will tell us—wholeness, unity with one's self, intellectual integrity. And yet these expressions, because they fit Goethe, with his universal culture, so well, seem hardly to describe the narrow, exclusive interest of Winckelmann. Doubtless Winckelmann's perfection is a narrow perfection: his feverish nursing of the one motive of his life is a contrast to Goethe's various energy. But what affected Goethe, what instructed him and ministered to his culture, was the integrity, the truth to its type, of the given force. The development of this force was the single interest of Winckelmann, unembarrassed by anything else in him. Other interests, practical or intellectual, those slighter talents and motives not supreme, which in most men are the waste part of nature, and drain away their vitality, he plucked out and cast from him. The protracted longing of his youth is not a vague, romantic longing: he knows what he longs for, what he wills. Within its severe limits his enthusiasm burns like lava. "You know," says Lavater, speaking of Winckelmann's countenance, "that I consider ardour and indifference by no means incompatible in the same character. If ever there was a striking instance of that union, it is in the countenance before us." "A lowly childhood," says Goethe, "insufficient instruction in youth, broken, distracted studies in early manhood, the bur-den of school-keeping! He was thirty years old before he enjoyed a single favour of fortune: but so soon as he had attained to an adequate condition of freedom, he appears before us consummate and entire, complete in the ancient sense."

But his hair is turning grey, and he has not yet reached the south. The Saxon court had become Roman Catholic, and the way to favour at Dresden was through Roman ecclesiastics. Probably the thought of a profession of the papal religion was not new to Winckelmann. At one time he had thought of beg-ging his way to Rome, from cloister to cloister, under the pre-tence of a disposition to change his faith. In 1751, the papal

nuncio, Archinto, was one of the visitors at Nöthenitz. He suggested Rome as the fitting stage for Winckelmann's accomplishments, and held out the hope of a place in the pope's library. Cardinal Passionei, charmed with Winckelmann's beautiful Greek writing, was ready to play the part of Mæcenas, if the indispensable change were made. Winckelmann accepted the bribe, and visited the *nuncio* at Dresden. Unquiet still at the word "profession," not without a struggle, he joined the Roman Church, July the 11th, 1754.

Goethe boldly pleads that Winckelmann was a pagan, that the landmarks of Christendom meant nothing to him. It is clear that he intended to deceive no one by his disguise; fears of the inquisition are sometimes visible during his life in Rome; he entered Rome notoriously with the works of Voltaire in his possession; the thought of what Count Bünau might be thinking of him seems to have been his greatest difficulty. On the other hand, he may have had a sense of a certain antique and as it were pagan grandeur in the Roman Catholic religion. Turning from the crabbed Protestantism, which had been the *ennui* of his youth, he might reflect that while Rome had reconciled itself to the Renaissance, the Protestant principle in art had cut off Germany from the supreme tradition of beauty. And yet to that transparent nature, with its simplicity as of the earlier world, the loss of absolute sincerity must have been a real loss. Goethe understands that Winckelmann had made this sacrifice. Yet at the bar of the highest criticism, perhaps, Winckelmann may be absolved. The insincerity of his religious profession was only one incident of a culture in which the moral instinct, like the religious or political, was merged in the artistic. But then the artistic interest was that, by desperate faithfulness to which Winckelmann was saved from a mediocrity, which, breaking through no bounds, moves ever in a bloodless routine, and misses its one chance in the life of the spirit and the intellect. There have been instances of culture developed by every high motive in turn, and yet intense at every point; and the aim of our culture should be to attain not only as intense but as complete a life as possible. But often the higher life is only possible at all, on condition of the selection of that in which one's motive is native and strong; and this selection

involves the renunciation of a crown reserved for others. Which
is better?—to lay open a new sense, to initiate a new organ for
the human spirit, or to cultivate many types of perfection up to a
point which leaves us still beyond the range of their transform-
ing power? Savonarola is one type of success; Winckelmann is
another; criticism can reject neither, because each is true to
itself. Winckelmann himself explains the motive of his life when
he says, "It will be my highest reward, if posterity acknowledges
that I have written worthily."

For a time he remained at Dresden. There his first book
appeared, *Thoughts on the Imitation of Greek Works of Art in
Painting and Sculpture.* Full of obscurities as it was, obscurities
which baffled but did not offend Goethe when he first turned
to art-criticism, its purpose was direct—an appeal from the
artificial classicism of the day to the study of the antique. The
book was well received, and a pension supplied through the
king's confessor. In September 1755 he started for Rome, in the
company of a young Jesuit. He was introduced to Raphael
Mengs, a painter then of note, and found a home near him, in
the artists' quarter, in a place where he could "overlook, far and
wide, the eternal city." At first he was perplexed with the sense
of being a stranger on what was to him, spiritually, native soil.
"Unhappily," he cries in French, often selected by him as the
vehicle of strong feeling, "I am one of those whom the Greeks
call ὀψιμαθεῖς.—I have come into the world and into Italy too
late." More than thirty years afterwards, Goethe also, after
many aspirations and severe preparation of mind, visited Italy.
In early manhood, just as he too was *finding* Greek art, the
rumour of that true artist's life of Winckelmann in Italy had
strongly moved him. At Rome, spending a whole year drawing
from the antique, in preparation for *Iphigenie,* he finds the
stimulus of Winckelmann's memory ever active. Winckelmann's
Roman life was simple, primeval, Greek. His delicate constitu-
tion permitted him the use only of bread and wine.
Condemned by many as a renegade, he had no desire for places
of honour, but only to see his merits acknowledged, and exis-
tence assured to him. He was simple without being niggardly;
he desired to be neither poor nor rich.

Winckelmann's first years in Rome present all the elements of an intellectual situation of the highest interest. The beating of the soul against its bars, the sombre aspect, the alien traditions, the still barbarous literature of Germany, are afar off. Before him are adequate conditions of culture, the sacred soil itself, the first tokens of the advent of the new German literature, with its broad horizons, its boundless intellectual promise. Dante, passing from the darkness of the *Inferno*, is filled with a sharp and joyful sense of light, which makes him deal with it, in the opening of the *Purgatorio*, in a wonderfully touching and penetrative way. Hellenism, which is the principle pre-eminently of intellectual light, (our modern culture may have more colour, the medieval spirit greater heat and profundity, but Hellenism is pre-eminent for light), has always been most effectively conceived by those who have crept into it out of an intellectual world in which the sombre elements predominate. So it had been in the ages of the Renaissance. This repression, removed at last, gave force and glow to Winckelmann's native affinity to the Hellenic spirit. "There had been known before him," says Madame de Staël, "learned men who might be consulted like books; but no one had, if I may say so, made himself a pagan for the purpose of penetrating antiquity." "One is always a poor executant of conceptions not one's own."—*On exécute mal ce qu'on n'a pas conçu soi-même*[1]—are true in their measure of every genuine enthusiasm. Enthusiasm,—that, in the broad Platonic sense of the *Phaedrus*, was the secret of his divinatory power over the Hellenic world. This enthusiasm, dependent as it is to a great degree on bodily temperament, has a power of reinforcing the purer emotions of the intellect with an almost physical excitement. That his affinity with Hellenism was not merely intellectual, that the subtler threads of temperament were inwoven in it, is proved by his romantic, fervent friendships with young men. He has known, he says, many young men more beautiful than Guido's archangel. These friendships, bringing him into contact with the pride of human form, and staining the

[1] Words of Charlotte Corday before the *Convention*.

thoughts with its bloom, perfected his reconciliation to the spirit of Greek sculpture. A letter on taste, addressed from Rome to a young nobleman, Friedrich von Berg, is the record of such a friendship.

"I shall excuse my delay," he begins, "in fulfilling my promise of an essay on the taste for beauty in works of art, in the words of Pindar. He says to Agesidamus, a youth of Locri—ἰδέᾳ τε καλὸν, ὥρᾳ τε κεκραμένον—whom he had kept waiting for an intended ode, that a debt paid with usury is the end of reproach. This may win your good-nature on behalf of my present essay, which has turned out far more detailed and circumstantial than I had at first intended.

"It is from yourself that the subject is taken. Our intercourse has been short, too short both for you and me; but the first time I saw you, the affinity of our spirits was revealed to me: your culture proved that my hope was not groundless; and I found in a beautiful body a soul created for nobleness, gifted with the sense of beauty. My parting from you was therefore one of the most painful in my life; and that this feeling continues our common friend is witness, for your separation from me leaves me no hope of seeing you again. Let this essay be a memorial of our friendship, which, on my side, is free from every selfish motive, and ever remains subject and dedicate to yourself alone."

The following passage is characteristic—

"As it is confessedly the beauty of man which is to be conceived under one general idea, so I have noticed that those who are observant of beauty only in women, and are moved little or not at all by the beauty of men, seldom have an impartial, vital, inborn instinct for beauty in art. To such persons the beauty of Greek art will ever seem wanting, because its supreme beauty is rather male than female. But the beauty of art demands a higher sensibility than the beauty of nature, because the beauty of art, like tears shed at a play, gives no pain, is without life, and must be awakened and repaired by culture. Now, as the spirit of culture is much more ardent in youth than in manhood, the instinct of which I am speaking must be exercised and directed to what is beautiful, before that age is reached, at which one would be afraid to confess that one had no taste for it."

Certainly, of that beauty of living form which regulated Winckelmann's friendships, it could not be said that it gave no pain. One notable friendship, the fortune of which we may trace through his letters, begins with an antique, chivalrous letter in French, and ends noisily in a burst of angry fire. Far from reaching the quietism, the bland indifference of art, such attachments are nevertheless more susceptible than any others of equal strength of a purely intellectual culture. Of passion, of physical excitement, they contain only just so much as stimulates the eye to the finest delicacies of colour and form. These friendships, often the caprices of a moment, make Winckelmann's letters, with their troubled colouring, an instructive but bizarre addition to the *History of Art*, that shrine of grave and mellow light around the mute Olympian family. The impression which Winckelmann's literary life conveyed to those about him, was that of excitement, intuition, inspiration, rather than the contemplative evolution of general principles. The quick, susceptible enthusiast, betraying his temperament even in appearance, by his olive complexion, his deep-seated, piercing eyes, his rapid movements, apprehended the subtlest principles of the Hellenic manner, not through the understanding, but by instinct or touch. A German biographer of Winckelmann has compared him to Columbus. That is not the aptest of comparisons; but it reminds one of a passage in which Edgar Quinet describes the great discoverer's famous voyage. His science was often at fault; but he had a way of estimating at once the slightest indication of land, in a floating weed or passing bird; he seemed actually to come nearer to nature than other men. And that world in which others had moved with so much embarrassment, seems to call out in Winckelmann new senses fitted to deal with it. He is in touch with it; it penetrates him, and becomes part of his temperament. He remodels his writings with constant renewal of insight; he catches the thread of a whole sequence of laws in some hollowing of the hand, or dividing of the hair; he seems to realise that fancy of the reminiscence of a forgotten knowledge hidden for a time in the mind itself; as if the mind of one, lover and philosopher at once in some phase of pre-existence— φιλοσοφήσαζ πότε μέτ᾽ ἔρωτοζ—fallen into a new cycle, were

beginning its intellectual career over again, yet with a certain power of anticipating its results. And so comes the truth of Goethe's judgments on his works; they are a life, a living thing, designed for those who are alive—*ein Lebendiges für die Lebendigen geschrieben, ein Leben selbst.*

In 1758 Cardinal Albani, who had formed in his Roman villa a precious collection of antiquities, became Winckelmann's patron. Pompeii had just opened its treasures; Winckelmann gathered its first-fruits. But his plan of a visit to Greece remained unfulfilled. From his first arrival in Rome he had kept the *History of Ancient Art* ever in view. All his other writings were a preparation for that. It appeared, finally, in 1764; but even after its publication Winckelmann was still employed in perfecting it. It is since his time that many of the most significant examples of Greek art have been submitted to criticism. He had seen little or nothing of what we ascribe to the age of Pheidias; and his conception of Greek art tends, therefore, to put the mere elegance of the imperial society of ancient Rome in place of the severe and chastened grace of the *palaestra*. For the most part he had to penetrate to Greek art through copies, imitations, and later Roman art itself; and it is not surprising that this turbid medium has left in Winckelmann's actual results much that a more privileged criticism can correct.

He had been twelve years in Rome. Admiring Germany had made many calls to him. At last, in 1768, he set out to revisit the country of his birth; and as he left Rome, a strange, inverted home-sickness, a strange reluctance to leave it at all, came over him. He reached Vienna. There he was loaded with honours and presents: other cities were awaiting him. Goethe, then nineteen years old, studying art at Leipsic, was expecting his coming, with that wistful eagerness which marked his youth, when the news of Winckelmann's murder arrived. All his "weariness of the north" had revived with double force. He left Vienna, intending to hasten back to Rome, and at Trieste a delay of a few days occurred. With characteristic openness, Winckelmann had confided his plans to a fellow-traveller, a man named Arcangeli, and had shown him the gold medals received at Vienna. Arcangeli's avarice was roused. One morning he entered Winckelmann's

room, under pretence of taking leave. Winckelmann was then writing "memoranda for the future editor of the *History of Art,*" still seeking the perfection of his great work. Arcangeli begged to see the medals once more. As Winckelmann stooped down to take them from the chest, a cord was thrown round his neck. Some time afterwards, a child with whose companionship Winckelmann had beguiled his delay, knocked at the door, and receiving no answer, gave the alarm. Winckelmann was found dangerously wounded, and died a few hours later, after receiving the last sacraments. It seemed as if the gods, in reward for his devotion to them, had given him a death which, for its swiftness and its opportunity, he might well have desired. "He has," says Goethe, "the advantage of figuring in the memory of posterity, as one eternally able and strong; for the image in which one leaves the world, is that in which one moves among the shadows." Yet, perhaps, it is not fanciful to regret that his proposed meeting with Goethe never took place. Goethe, then in all the pregnancy of his wonderful youth, still unruffled by the "press and storm" of his earlier manhood, was awaiting Winckelmann with a curiosity of the worthiest kind. As it was, Winckelmann became to him something like what Virgil was to Dante. And Winckelmann, with his fiery friendships, had reached that age and that period of culture at which emotions hitherto fitful, sometimes concentrate themselves in a vital, unchangeable relationship. German literary history seems to have lost the chance of one of those famous friendships, the very tradition of which becomes a stimulus to culture, and exercises an imperishable influence.

In one of the frescoes of the Vatican, Raphael has commemorated the tradition of the Catholic religion. Against a space of tranquil sky, broken in upon by the beatific vision, are ranged the great personages of Christian history, with the Sacrament in the midst. Another fresco of Raphael in the same apartment presents a very different company, Dante alone appearing in both. Surrounded by the muses of Greek mythology, under a thicket of laurel, sits Apollo, with the sources of Castalia at his feet. On either side are grouped those on whom the spirit of Apollo descended, the classical and Renaissance poets,

to whom the waters of Castalia come down, a river making glad this other "City of God." In this fresco it is the classical tradition, the orthodoxy of taste, that Raphael commemorates. Winckelmann's intellectual history authenticates the claims of this tradition in human culture. In the countries where that tradition arose, where it still lurked about its own artistic relics, and changes of language had not broken its continuity, national pride might sometimes light up anew an enthusiasm for it. Aliens might imitate that enthusiasm, and classicism become from time to time an intellectual fashion. But Winckelmann was not further removed by language, than by local aspects and associations, from those vestiges of the classical spirit; and he lived at a time when, in Germany classical studies were out of favour. Yet, remote in time and place, he feels after the Hellenic world, divines those channels of ancient art, in which its life still circulates, and, like Scyles, the half-barbarous yet Hellenising king, in the beautiful story of Herodotus, is irresistibly attracted by it. This testimony to the authority of the Hellenic tradition, its fitness to satisfy some vital requirement of the intellect, which Winckelmann contributes as a solitary man of genius, is offered also by the general history of the mind. The spiritual forces of the past, which have prompted and informed the culture of a succeeding age, live, indeed, within that culture, but with an absorbed, underground life. The Hellenic element alone has not been so absorbed, or content with this underground life; from time to time it has started to the surface; culture has been drawn back to its sources to be clarified and corrected. Hellenism is not merely an absorbed element in our intellectual life; it is a conscious tradition in it.

Again, individual genius works ever under conditions of time and place: its products are coloured by the varying aspects of nature, and type of human form, and outward manners of life. There is thus an element of change in art; criticism must never for a moment forget that "the artist is the child of his time." But besides these conditions of time and place, and independent of them, there is also an element of permanence, a standard of taste, which genius confesses. This standard is maintained in a purely intellectual tradition. It acts upon the artist, not as one of

the influences of his own age, but through those artistic prod-
ucts of the previous generation which first excited, while they
directed into a particular channel, his sense of beauty. The
supreme artistic products of succeeding generations thus form a
series of elevated points, taking each from each the reflexion of
a strange light, the source of which is not in the atmosphere
around and above them, but in a stage of society remote from
ours. The standard of taste, then, was fixed in Greece, at a def-
inite historical period. A tradition for all succeeding generations,
it originates in a spontaneous growth out of the influences of
Greek society. What were the conditions under which this ideal,
this standard of artistic orthodoxy, was generated? How was
Greece enabled to force its thought upon Europe?

Greek art, when we first catch sight of it, is entangled with
Greek religion. We are accustomed to think of Greek religion as
the religion of art and beauty, the religion of which the
Olympian Zeus and the Athene Polias are the idols, the poems
of Homer the sacred books. Thus Cardinal Newman speaks of
"the classical polytheism which was gay and graceful, as was nat-
ural in a civilised age." Yet such a view is only a partial one. In it
the eye is fixed on the sharp, bright edge of high Hellenic cul-
ture, but loses sight of the sombre world across which it strikes
Greek religion, where we can observe it most distinctly, is at
once a magnificent ritualistic system, and a cycle of poetical
conceptions. Religions, as they grow by natural laws out of man's
life, are modified by whatever modifies his life. They brighten
under a bright sky, they become liberal as the social range
widens, they grow intense and shrill in the clefts of human life,
where the spirit is narrow and confined, and the stars are visible
at noonday; and a fine analysis of these differences is one of the
gravest functions of religious criticism. Still, the broad founda-
tion, in mere human nature, of all religions as they exist for the
greatest number, is a universal pagan sentiment, a paganism
which existed before the Greek religion, and has lingered far
onward into the Christian world, ineradicable, like some persis-
tent vegetable growth, because its seed is an element of the very
soil out of which it springs.

This pagan sentiment measures the sadness with which the

human mind is filled, whenever its thoughts wander far from what is here, and now. It is beset by notions of irresistible natural powers, for the most part ranged against man, but the secret also of his fortune, making the earth golden and the grape fiery for him. He makes gods in his own image, gods smiling and flower-crowned, or bleeding by some sad fatality, to console him by their wounds, never closed from generation to generation. It is with a rush of home-sickness that the thought of death presents itself. He would remain at home for ever on the earth if he could. As it loses its colour and the senses fail, he clings ever closer to it; but since the mouldering of bones and flesh must go on to the end, he is careful for charms and talismans, which may chance to have some friendly power in them, when the inevitable shipwreck comes. Such sentiment is a part of the eternal basis of all religions, modified indeed by changes of time and place, but indestructible, because its root is so deep in the earth of man's nature. The breath of religious initiators passes over them; a few "rise up with wings as eagles," but the broad level of religious life is not permanently changed. Religious progress, like all purely spiritual progress, is confined to a few. This sentiment attaches itself in the earliest times to certain usages of patriarchal life, the kindling of fire, the washing of the body, the slaughter of the flock, the gathering of harvest, holidays and dances. Here are the beginnings of a ritual, at first as occasional and unfixed as the sentiment which it expresses, but destined to become the permanent element of religious life. The usages of patriarchal life change; but this germ of ritual remains, promoted now with a consciously religious motive, losing its domestic character, and therefore becoming more and more inexplicable with each generation. Such pagan worship, in spite of local variations, essentially one, is an element in all religions. It is the anodyne which the religious principle, like one administering opiates to the incurable, has added to the law which makes life sombre for the vast majority of mankind.

More definite religious conceptions come from other sources, and fix themselves upon this ritual in various ways, changing it, and giving it new meanings. In Greece they were derived from mythology, itself not due to a religious source at all, but devel-

oping in the course of time into a body of religious conceptions, entirely human in form and character. To the unprogressive ritual element it brought these conceptions, itself—ἡ πτεροῦ δύναμιϛ, the power of the wing—an element of refinement, of ascension, with the promise of an endless destiny. While the ritual remains unchanged, the æsthetic element, only accidentally connected with it, expands with the freedom and mobility of the things of the intellect. Always, the fixed element is the religious observance; the fluid, unfixed element is the myth, the religious conception. This religion is itself pagan, and has in any broad view of it the pagan sadness. It does not at once, and for the majority, become the higher Hellenic religion. The country people, of course, cherish the unlovely idols of an earlier time, such as those which Pausanias found still devoutly preserved in Arcadia. Athenæus tells the story of one who, coming to a temple of Latona, had expected to find some worthy presentment of the mother of Apollo, and laughed on seeing only a shapeless wooden figure. The wilder people have wilder gods, which, however, in Athens, or Corinth, or Lacedæmon, changing ever with the worshippers in whom they live and move and have their being, borrow something of the lordliness and distinction of human nature there. Greek religion too has its mendicants, its purifications, its antinomian mysticism, its garments offered to the gods, its statues worn with kissing, its exaggerated superstitions for the vulgar only, its worship of sorrow, its *addolorata*, its mournful mysteries. Scarcely a wild or melancholy note of the medieval church but was anticipated by Greek polytheism! What should we have thought of the vertiginous prophetess at the very centre of Greek religion? The supreme Hellenic culture is a sharp edge of light across this gloom. The fiery, stupefying wine becomes in a happier climate clear and exhilarating. The Dorian worship of Apollo, rational, chastened, debonair, with his unbroken daylight, always opposed to the sad Chthonian divinities, is the aspiring element, by force and spring of which Greek religion sublimes itself. Out of Greek religion, under happy conditions, arises Greek art, to minister to human culture. It was the privilege of Greek religion to be able to transform itself into an artistic ideal.

For the thoughts of the Greeks about themselves, and their relation to the world generally, were ever in the happiest readiness to be transformed into objects for the senses. In this lies the main distinction between Greek art and the mystical art of the Christian middle age, which is always struggling to express thoughts beyond itself. Take, for instance, a characteristic work of the middle age, Angelico's *Coronation of the Virgin,* in the cloister of *Saint Mark's* at Florence. In some strange halo of a moon Jesus and the Virgin Mother are seated, clad in mystical white raiment, half shroud, half priestly linen. Jesus, with rosy nimbus and the long pale hair—*tanquam lana alba et tanquam nix*—of the figure in the Apocalypse, with slender finger-tips is setting a crown of pearl on the head of Mary, who, corpse-like in her refinement, is bending forward to receive it, the light lying like snow upon her forehead. Certainly, it cannot be said of Angelico's fresco that it throws into a sensible form our highest thoughts about man and his relation to the world; but it did not do this adequately even for Angelico. For him, all that is outward or sensible in his work—the hair like wool, the rosy nimbus, the crown of pearl—is only the symbol or type of a really inexpressible world, to which he wishes to direct the thoughts; he would have shrunk from the notion that what the eye apprehended was all. Such forms of art, then, are inadequate to the matter they clothe; they remain ever below its level. Something of this kind is true also of oriental art. As in the middle age from an exaggerated inwardness, so in the East from a vagueness, a want of definition, in thought, the matter presented to art is unmanageable, and the forms of sense struggle vainly with it. The many-headed gods of the East, the orientalised, many-breasted Diana of Ephesus, like Angelico's fresco, are at best overcharged symbols, a means of hinting at an idea which art cannot fitly or completely express, which still remains in the world of shadows.

But take a work of Greek art,—the Venus of Melos. That is in no sense a symbol, a suggestion, of anything beyond its own victorious fairness. The mind begins and ends with the finite image, yet loses no part of the spiritual motive. This motive is not lightly and loosely attached to the sensuous form, as its

meaning to an allegory, but saturates and is identical with it. The Greek mind had advanced to a particular stage of self-reflexion, but was careful not to pass beyond it. In oriental thought there is a vague conception of life everywhere, but no true appreciation of itself by the mind, no knowledge of the distinction of man's nature: in its consciousness of itself, humanity is still confused with the fantastic, indeterminate life of the animal and vegetable world. In Greek thought, on the other hand, the "lordship of the soul" is recognised; that lordship gives authority and divinity to human eyes and hands and feet; inanimate nature is thrown into the background. But just there Greek thought finds its happy limit; it has not yet become too inward; the mind has not yet learned to boast its independence of the flesh; the spirit has not yet absorbed everything with its emotions, nor reflected its own colour everywhere. It has indeed committed itself to a train of reflexion which must end in defiance of form, of all that is outward, in an exaggerated idealism. But that end is still distant; it has not yet plunged into the depths of religious mysticism.

This ideal art, in which the thought does not outstrip or lie beyond the proper range of its sensible embodiment, could not have arisen out of a phase of life that was uncomely or poor. That delicate pause in Greek reflexion was joined, by some supreme good luck, to the perfect animal nature of the Greeks. Here are the two conditions of an artistic ideal. The influences which perfected the animal nature of the Greeks are part of the process by which "the ideal" was evolved. Those "Mothers" who, in the second part of *Faust*, mould and remould the typical forms that appear in human history, preside, at the beginning of Greek culture, over such a concourse of happy physical conditions as ever generates by natural laws some rare type of intellectual or spiritual life. That delicate air, "nimbly and sweetly recommending itself" to the senses, the finer aspects of nature, the finer lime and clay of the human form, and modelling of the dainty framework of the human countenance:—these are the good luck of the Greek when he enters upon life. Beauty becomes a distinction, like genius, or noble place.

"By no people," says Winckelmann, "has beauty been so

highly esteemed as by the Greeks. The priests of a youthful
Jupiter at Ægæ, of the Ismenian Apollo, and the priest who at
Tanagra led the procession of Mercury, bearing a lamb upon his
shoulders, were always youths to whom the prize of beauty had
been awarded. The citizens of Egesta erected a monument to a
certain Philip who was not their fellow-citizen, but of Croton, for
his distinguished beauty; and the people made offerings at it. In
an ancient song, ascribed to Simonides or Epicharmus, of four
wishes, the first was health, the second beauty. And as beauty was
so longed for and prized by the Greeks, every beautiful person
sought to become known to the whole people by this distinction,
and above all to approve himself to the artists, because they
awarded the prize; and this was for the artists an occasion for hav-
ing supreme beauty ever before their eyes. Beauty even gave a
right to fame; and we find in Greek histories the most beautiful
people distinguished. Some were famous for the beauty of one
single part of their form; as Demetrius Phalereus, for his beauti-
ful eyebrows, was called *Charitoblepharos.* It seems even to have
been thought that the procreation of beautiful children might be
promoted by prizes. This is shown by the existence of contests for
beauty, which in ancient times were established by Cypselus,
King of Arcadia, by the river Alpheus; and, at the feast of Apollo
of Philæ, a prize was offered to the youths for the deftest kiss.
This was decided by an umpire; as also at Megara, by the grave of
Diocles. At Sparta, and at Lesbos, in the temple of Juno, and
among the Parrhasii, there were contests for beauty among
women. The general esteem for beauty went so far, that the
Spartan women set up in their bedchambers a Nireus, a
Narcissus, or a Hyacinth, that they might bear beautiful children."

So, from a few stray antiquarianisms, a few faces cast up
sharply from the waves, Winckelmann, as his manner was,
divines the temperament of the antique world, and that in which
it had delight. It has passed away with that distant age, and we
may venture to dwell upon it. What sharpness and reality it has
is the sharpness and reality of suddenly arrested life. The Greek
system of gymnastics originated as part of a religious ritual. The
worshipper was to recommend himself to the gods by becoming
fleet and fair, white and red, like them. The beauty of the

palaestra, and the beauty of the artist's workshop, reacted on one another. The youth tried to rival his gods; and his increased beauty passed back into them.—"I take the gods to witness, I had rather have a fair body than a king's crown"— Ὄμνυμι πάντας θεοὺς μὴ ἐλέσθαι ἂν τὴν βασιλέως ἀρχὴν ἀντὶ τοῦ καλὸς εἶναι—that is the form in which one age of the world chose the higher life.—A perfect world, if the gods could have seemed for ever only fleet and fair, white and red! Let us not regret that this unperplexed youth of humanity, satisfied with the vision of itself, passed, at the due moment, into a mournful maturity, for already the deep joy was in store for the spirit, of finding the ideal of that youth still red with life in the grave.

It followed that the Greek ideal expressed itself pre-eminently in sculpture. All art has a sensuous element, colour, form, sound— in poetry a dexterous recalling of these, together with the profound, joyful sensuousness of motion, and each of them may be a medium for the ideal: it is partly accident which in any individual case makes the born artist, poet, or painter rather than sculptor. But as the mind itself has had an historical development, one form of art, by the very limitations of its material, may be more adequate than another for the expression of any one phase of that development. Different attitudes of the imagination have a native affinity with different types of sensuous form, so that they combine together, with completeness and ease. The arts may thus be ranged in a series, which corresponds to a series of developments in the human mind itself. Architecture, which begins in a practical need, can only express by vague hint or symbol, the spirit or mind of the artist. He closes his sadness over him, or wanders in the perplexed intricacies of things, or projects his purpose from him clean-cut and sincere, or bares himself to the sunlight. But these spiritualities, felt rather than seen, can but lurk about architectural form as volatile effects, to be gathered from it by reflexion. Their expression is, indeed, not really sensuous at all. As human form is not the subject with which it deals, architecture is the mode in which the artistic effort centres, when the thoughts of man concerning himself are still indistinct, when he is still little pre-occupied with those harmonies, storms, victories, of the unseen

and intellectual world, which, wrought out into the bodily form, give it an interest and significance communicable to it alone. The art of Egypt, with its supreme architectural effects, is, according to Hegel's beautiful comparison, a Memnon waiting for the day, the day of the Greek spirit, the humanistic spirit, with its power of speech.

Again, painting, music, and poetry, with their endless power of complexity, are the special arts of the romantic and modern ages. Into these, with the utmost attenuation of detail, may be translated every delicacy of thought and feeling, incidental to a consciousness brooding with delight over itself. Through their gradations of shade, their exquisite intervals, they project in an external form that which is most inward in passion or sentiment. Between architecture and those romantic arts of painting, music, and poetry, comes sculpture, which, unlike architecture, deals immediately with man, while it contrasts with the romantic arts, because it is not self-analytical. It has to do more exclusively than any other art with the human form, itself one entire medium of spiritual expression, trembling, blushing, melting into dew, with inward excitement. That spirituality which only lurks about architecture as a volatile effect, in sculpture takes up the whole given material, and penetrates it with an imaginative motive; and at first sight sculpture, with its solidity of form, seems a thing more real and full than the faint, abstract world of poetry or painting. Still the fact is the reverse. Discourse and action show man as he is, more directly than the play of the muscles and the moulding of the flesh; and over these poetry has command. Painting, by the flushing of colour in the face and dilatation of light in the eye—music, by its subtle range of tones—can refine most delicately upon a single moment of passion, unravelling its subtlest threads.

But why should sculpture thus limit itself to pure form? Because, by this limitation, it becomes a perfect medium of expression for one peculiar motive of the imaginative intellect. It therefore renounces all those attributes of its material which do not forward that motive. It has had, indeed, from the beginning an unfixed claim to colour; but this element of colour in it has always been more or less conventional, with no melting or

modulation of tones, never permitting more than a very limited realism. It was maintained chiefly as a religious tradition. In proportion as the art of sculpture ceased to be merely decorative, and subordinate to architecture, it threw itself upon pure form. It renounces the power of expression by lower or heightened tones. In it, no member of the human form is more significant than the rest; the eye is wide, and without pupil; the lips and brow are hardly less significant than hands, and breasts, and feet. But the limitation of its resources is part of its pride: it has no backgrounds, no sky or atmosphere, to suggest and interpret a train of feeling; a little of suggested motion, and much of pure light on its gleaming surfaces, with pure form—only these. And it gains more than it loses by this limitation to its own distinguishing motives; it unveils man in the repose of his unchanging characteristics. That white light purged from the angry, blood-like stains of action and passion, reveals, not what is accidental in man, but the tranquil godship in him, as opposed to the restless accidents of life. The art of sculpture records the first naïve, unperplexed recognition of man by himself; and it is a proof of the high artistic capacity of the Greeks, that they apprehended and remained true to these exquisite limitations, yet, in spite of them, gave to their creations a mobile, a vital, individuality.

Heiterkeit—blithenoss or repose, and *Allgemeinheit*—generality or breadth, are, then, the supreme characteristics of the Hellenic ideal. But that generality or breadth has nothing in common with the lax observation, the unlearned thought, the flaccid execution, which have sometimes claimed superiority in art, on the plea of being "broad" or "general." Hellenic breadth and generality come of a culture minute, severe, constantly renewed, rectifying and concentrating its impressions into certain pregnant types.

The basis of all artistic genius lies in the power of conceiving humanity in a new and striking way, of putting a happy world of its own creation in place of the meaner world of our common days, generating around itself an atmosphere with a novel power of refraction, selecting, transforming, recombining the images it transmits, according to choice of the imaginative intellect. In exercising this power, painting and poetry have a variety of sub-

ject almost unlimited. The range of characters or persons open
to them is as various as life itself; no character, however trivial,
misshapen, or unlovely, can resist their magic. That is because
those arts can accomplish their function in the choice and devel-
opment of some special situation, which lifts or glorifies a char-
acter, in itself not poetical. To realise this situation, to define, in
a chill and empty atmosphere, the focus where rays, in them-
selves pale and impotent, unite and begin to burn, the artist may
have, indeed, to employ the most cunning detail, to complicate
and refine upon thought and passion a thousand-fold. Let us
take a brilliant example from the poems of Robert Browning.
His poetry is pre-eminently the poetry of situations. The char-
acters themselves are always of secondary importance; often
they are characters in themselves of little interest; they seem to
come to him by strange accidents from the ends of the world.
His gift is shown by the way in which he accepts such a charac-
ter, throws it into some situation, or apprehends it in some del-
icate pause of life, in which for a moment it becomes ideal. In
the poem entitled *Le Byron de nos Jours,* in his *Dramatis
Personae,* we have a single moment of passion thrown into relief
after this exquisite fashion. Those two jaded Parisians are not
intrinsically interesting: they begin to interest us only when
thrown into a choice situation. But to discriminate that moment,
to make it appreciable by us, that we may "find" it, what a cob-
web of allusions, what double and treble reflexions of the mind
upon itself, what an artificial light is constructed and broken
over the chosen situation: on how fine a needle's point that little
world of passion is balanced! Yet, in spite of this intricacy, the
poem has the clear ring of a central motive. We receive from it
the impression of one imaginative tone, of a single creative act.

 To produce such effects at all requires all the resources of
painting, with its power of indirect expression, of subordinate
but significant detail, its atmosphere, its foregrounds and back-
grounds. To produce them in a pre-eminent degree requires all
the resources of poetry, language in its most purged form, its
remote associations and suggestions, its double and treble lights.
These appliances sculpture cannot command. In it, therefore,
not the special situation, but the type, the general character of

the subject to be delineated, is all-important. In poetry and painting, the situation predominates over the character; in sculpture, the character over the situation. Excluded by the proper limitation of its material from the development of exquisite situations, it has to choose from a select number of types intrinsically interesting—interesting, that is, independently of any special situation into which they may be thrown. Sculpture finds the secret of its power in presenting these types, in their broad, central, incisive lines. This it effects not by accumulation of detail, but by abstracting from it. All that is accidental, all that distracts the simple effect upon us of the supreme types of humanity, all traces in them of the commonness of the world, it gradually purges away.

Works of art produced under this law, and only these, are really characterised by Hellenic generality or breadth. In every direction it is a law of restraint. It keeps passion always below that degree of intensity at which it must necessarily be transitory, never winding up the features to one note of anger, or desire, or surprise. In some of the feebler allegorical designs of the middle age, we find isolated qualities portrayed as by so many masks; its religious art has familiarised us with faces fixed immovably into blank types of placid reverie. Men and women, again, in the hurry of life, often wear the sharp impress of one absorbing motive, from which it is said death sets their features free. All such instances may be ranged under the *grotesque;* and the Hellenic ideal has nothing in common with the grotesque. It allows passion to play lightly over the surface of the individual form, losing thereby nothing of its central impassivity, its depth and repose. To all but the highest culture, the reserved faces of the gods will ever have something of insipidity.

Again, in the best Greek sculpture, the archaic immobility has been stirred, its forms are in motion; but it is a motion ever kept in reserve, and very seldom committed to any definite action. Endless as are the attitudes of Greek sculpture, exquisite as is the invention of the Greeks in this direction, the actions or situations it permits are simple and few. There is no Greek Madonna; the goddesses are always childless. The actions selected are those which would be without significance, except

in a divine person—binding on a sandal, or preparing for the bath. When a more complex and significant action is permitted, it is most often represented as just finished, so that eager expectancy is excluded, as in the image of Apollo just after the slaughter of the Python, or of Venus with the apple of Paris already in her hand. The *Laocoon*, with all that patient science through which it has triumphed over an almost unmanageable subject, marks a period in which sculpture has begun to aim at effects legitimate, because delightful, only in painting.

The hair, so rich a source of expression in painting, because, relatively to the eye or the lip, it is mere drapery, is withdrawn from attention; its texture, as well as its colour, is lost, its arrangement but faintly and severely indicated, with no broken or enmeshed light. The eyes are wide and directionless, not fixing anything with their gaze, nor riveting the brain to any special external object, the brows without hair. Again, Greek sculpture deals almost exclusively with youth, where the moulding of the bodily organs is still as if suspended between growth and completion, indicated but not emphasised; where the transition from curve to curve is so delicate and elusive, that Winckelmann compares it to a quiet sea, which, although we understand it to be in motion, we nevertheless regard as an image of repose; where, therefore, the exact degree of development is so hard to apprehend. If a single product only of Hellenic art were to be saved in the wreck of all beside, one might choose perhaps from the "beautiful multitude" of the Panathenaic frieze, that line of youths on horseback, with their level glances, their proud, patient lips, their chastened reins, their whole bodies in exquisite service. This colourless, unclassified purity of life, with its blending and interpenetration of intellectual, spiritual, and physical elements, still folded together, pregnant with the possibilities of a whole world closed within it, is the highest expression of the indifference which lies beyond all that is relative or partial. Everywhere there is the effect of an awaking, of a child's sleep just disturbed. All these effects are united in a single instance—the *adorante* of the museum of Berlin, a youth who has gained the wrestler's prize, with hands lifted and open, in praise for the victory. Fresh,

unperplexed, it is the image of man as he springs first from the sleep of nature, his white light taking no colour from any one-sided experience. He is characterless, so far as *character* involves subjection to the accidental influences of life.

"This sense," says Hegel, "for the consummate modelling of divine and human forms was pre-eminently at home in Greece. In its poets and orators, its historians and philosophers, Greece cannot be conceived from a central point, unless one brings, as a key to the understanding of it, an insight into the ideal forms of sculpture, and regards the images of statesmen and philosophers, as well as epic and dramatic heroes, from the artistic point of view. For those who act, as well as those who create and think, have, in those beautiful days of Greece, this plastic character. They are great and free, and have grown up on the soil of their own individuality, creating themselves out of themselves, and moulding themselves to what they were, and willed to be. The age of Pericles was rich in such characters; Pericles himself, Pheidias, Plato, above all Sophocles, Thucydides also, Xenophon and Socrates, each in his own order, the perfection of one remaining undiminished by that of the others. They are ideal artists of themselves, cast each in one flawless mould, works of art, which stand before us as an immortal presentment of the gods. Of this modelling also are those bodily works of art, the victors in the Olympic games; yes! and even Phryne, who, as the most beautiful of women, ascended naked out of the water, in the presence of assembled Greece."

This key to the understanding of the Greek spirit, Winckelmann possessed in his own nature, itself like a relic of classical antiquity, laid open by accident to our alien, modern atmosphere. To the criticism of that consummate Greek modelling he brought not only his culture but his temperament. We have seen how definite was the leading motive of that culture; how, like some central root-fibre, it maintained the well-rounded unity of his life through a thousand distractions. Interests not his, nor meant for him, never disturbed him. In morals, as in criticism, he followed the clue of instinct, of an unerring instinct. Penetrating into the antique world by his passion, his temperament, he enunciated no formal principles,

always hard and one-sided. Minute and anxious as his culture was, he never became one-sidedly self-analytical. Occupied ever with himself, perfecting himself and developing his genius, he was not content, as so often happens with such natures, that the atmosphere between him and other minds should be thick and clouded; he was ever jealously refining his meaning into a form, express, clear, objective. This temperament he nurtured and invigorated by friendships which kept him always in direct contact with the spirit of youth. The beauty of the Greek statues was a sexless beauty: the statues of the gods had the least traces of sex. Here there is a moral sexlessness, a kind of ineffectual wholeness of nature, yet with a true beauty and significance of its own.

One result of this temperament is a serenity—*Heiterkeit*—which characterises Winckelmann's handling of the sensuous side of Greek art. This serenity is, perhaps, in great measure, a negative quality: it is the absence of any sense of want, or corruption, or shame. With the sensuous element in Greek art he deals in the pagan manner; and what is implied in that? It has been sometimes said that art is a means of escape from "the tyranny of the senses." It may be so for the spectator: he may find that the spectacle of supreme works of art takes from the life of the senses something of its turbid fever. But this is possible for the spectator only because the artist, in producing those works, has gradually sunk his intellectual and spiritual ideas in sensuous form. He may live, as Keats lived, a pure life; but his soul, like that of Plato's false astronomer, becomes more and more immersed in sense, until nothing which lacks the appeal to sense has interest for him. How could such an one ever again endure the greyness of the ideal or spiritual world? The spiritualist is satisfied as he watches the escape of the sensuous elements from his conceptions; his interest grows, as the dyed garment bleaches in the keener air. But the artist steeps his thought again and again into the fire of colour. To the Greek this immersion in the sensuous was, religiously, at least, indifferent. Greek sensuousness, therefore, does not fever the conscience: it is shameless and childlike. Christian asceticism, on the other hand, discrediting the slightest touch of sense, has from time to

time provoked into strong emphasis the contrast or antagonism to itself, of the artistic life, with its inevitable sensuousness.—*I did but taste a little honey with the end of the rod that was in mine hand, and lo! I must die.*—It has sometimes seemed hard to pursue that life without something of conscious disavowel of a spiritual world; and this imparts to genuine artistic interests a kind of intoxication. From this intoxication Winckelmann is free: he fingers those pagan marbles with unsinged hands, with no sense of shame or loss. That is to deal with the sensuous side of art in the pagan manner.

The longer we contemplate that Hellenic ideal, in which man is at unity with himself, with his physical nature, with the outward world, the more we may be inclined to regret that he should ever have passed beyond it, to contend for a perfection that makes the blood turbid, and frets the flesh, and discredits the actual world about us. But if he was to be saved from the *ennui* which ever attaches itself to realisation, even the realisation of the perfect life, it was necessary that a conflict should come, that some sharper note should grieve the existing harmony, and the spirit chafed by it beat out at last only a larger and profounder music. In Greek tragedy this conflict has begun: man finds himself face to face with rival claims. Greek tragedy shows how such a conflict may be treated with serenity, how the evolution of it may be a spectacle of the dignity, not of the impotence, of the human spirit. But it is not only in tragedy that the Greek spirit showed itself capable of thus bringing joy out of matter in itself full of discouragements. Theocritus too strikes often a note of romantic sadness. But what a blithe and steady poise, above these discouragements, in a clear and sunny stratum of the air!

Into this stage of Greek achievement Winckelmann did not enter. Supreme as he is where his true interest lay, his insight into the typical unity and repose of the highest sort of sculpture seems to have involved limitation in another direction. His conception of art excludes that bolder type of it which deals confidently and serenely with life, conflict, evil. Living in a world of exquisite but abstract and colourless form, he could hardly have conceived of the subtle and penetrative, yet somewhat

grotesque art of the modern world. What would he have thought of Gilliatt, in Victor Hugo's *Travailleurs de la Mer,* or of the bleeding mouth of Fantine in the first part of *Les Misérables,* penetrated as those books are with a sense of beauty, as lively and transparent as that of a Greek? Nay, a sort of preparation for the romantic temper is noticeable even within the limits of the Greek ideal itself, which for his part Winckelmann failed to see. For Greek religion has not merely its mournful mysteries of Adonis, of Hyacinthus, of Demeter, but it is conscious also of the fall of earlier divine dynasties. Hyperion gives way to Apollo, Oceanus to Poseidon. Around the feet of that tranquil Olympian family still crowd the weary shadows of an earlier, more formless, divine world. The placid minds even of Olympian gods are troubled with thoughts of a limit to duration, of inevitable decay, of dispossession. Again, the supreme and colourless abstraction of those divine forms, which is the secret of their repose, is also a premonition of the fleshless, consumptive refinements of the pale, medieval artists. That high indifference to the outward, that impassivity, has already a touch of the corpse in it: we see already Angelico and the *Master of the Passion* in the artistic future. The suppression of the sensuous, the shutting of the door upon it, the ascetic interest, may be even now foreseen. Those abstracted gods, "ready to melt out their essence fine into the winds," who can fold up their flesh as a garment, and still remain themselves, seem already to feel that bleak air, in which, like Helen of Troy, they wander as the spectres of the middle age.

Gradually, as the world came into the church, an artistic interest, native in the human soul, reasserted its claims. But Christian art was still dependent on pagan examples, building the shafts of pagan temples into its churches, perpetuating the form of the *basilica,* in later times, working the disused amphitheatres as stone-quarries. The sensuous expression of ideas which unreservedly discredit the world of sense, was the delicate problem which Christian art had before it. If we think of medieval painting, as it ranges from the early German schools, still with something of the air of the charnel-house about them, to the clear

loveliness of Perugino, we shall see how that problem was solved. In the very "worship of sorrow" the native blitheness of art asserted itself. The religious spirit, as Hegel says, "smiled through its tears." So perfectly did the young Raphael infuse that *Heiterkeit*, that pagan blitheness, into religious works, that his picture of Saint Agatha at Bologna became to Goethe a step in the evolution of *Iphigenie*.[2] But in proportion as the gift of smiling was found once more, there came also an aspiration towards that lost antique art, some relics of which Christian art had buried in itself, ready to work wonders when their day came.

The history of art has suffered as much as any history by trenchant and absolute divisions. Pagan and Christian art are sometimes harshly opposed, and the Renaissance is represented as a fashion which set in at a definite period. That is the superficial view: the deeper view is that which preserves the identity of European culture. The two are really continuous; and there is a sense in which it may be said that the Renaissance was an uninterrupted effort of the middle age, that it was ever taking place. When the actual relics of the antique were restored to the world, in the view of the Christian ascetic it was as if an ancient plague-pit had been opened. All the world took the contagion of the life of nature and of the senses. And now it was seen that the medieval spirit too had done something for the new fortunes of the antique. By hastening the decline of art, by withdrawing interest from it and yet keeping unbroken the thread of its traditions, it had suffered the human mind to repose itself, that when day came it might awake, with eyes refreshed, to those ancient, ideal forms.

The aim of a right criticism is to place Winckelmann in an intellectual perspective, of which Goethe is the foreground. For, after all, he is infinitely less than Goethe; and it is chiefly because at certain points he comes in contact with Goethe, that criticism entertains consideration of him. His relation to modern culture is a peculiar one. He is not of the modern world; nor

[2] *Italiänische Reise. Bologna*, 19 *Oct.* 1776.

is he wholly of the eighteenth century, although so much of his outer life is characteristic of it. But that note of revolt against the eighteenth century, which we detect in Goethe, was struck by Winckelmann. Goethe illustrates a union of the Romantic spirit, in its adventure, its variety, its profound subjectivity of soul, with Hellenism, in its transparency, its rationality, its desire of beauty—that marriage of Faust and Helena, of which the art of the nineteenth century is the child, the beautiful lad Euphorion, as Goethe conceives him, on the crags, in the "splendour of battle and in harness as for victory," his brows bound with light.[3] Goethe illustrates, too, the preponderance in this marriage of the Hellenic element; and that element, in its true essence, was made known to him by Winckelmann.

Breadth, centrality, with blitheness and repose, are the marks of Hellenic culture. Is such culture a lost art? The local, accidental colouring of its own age has passed from it; and the greatness that is dead looks greater when every link with what is slight and vulgar has been severed. We can only see it at all in the reflected, refined light which a great education creates for us. Can we bring down that ideal into the gaudy, perplexed light of modern life?

Certainly, for us of the modern world, with its conflicting claims, its entangled interests, distracted by so many sorrows, with many preoccupations, so bewildering an experience, the problem of unity with ourselves, in blitheness and repose, is far harder than it was for the Greek within the simple terms of antique life. Yet, not less than ever, the intellect demands completeness, centrality. It is this which Winckelmann imprints on the imagination of Goethe, at the beginning of life, in its original and simplest form, as in a fragment of Greek art itself, stranded on that littered, indeterminate shore of Germany in the eighteenth century. In Winckelmann, this type comes to him, not as in a book or a theory, but more importunately, because in a passionate life, in a personality. For Goethe, possessing all modern interests, ready to be lost in the perplexed

[3] *Faust, Th. ii. Act.* 3.

currents of modern thought, he defines, in clearest outline, the eternal problem of culture—balance, unity with one's self, consummate Greek modelling.

It could no longer be solved, as in Phryne ascending naked out of the water, by perfection of bodily form, or any joyful union with the external world: the shadows had grown too long, the light too solemn, for that. It could hardly be solved, as in Pericles or Pheidias, by the direct exercise of any single talent: amid the manifold claims of our modern intellectual life, that could only have ended in a thin, one-sided growth. Goethe's Hellenism was of another order, the *Allgemeinheit* and *Heiterkeit,* the completeness and serenity, of a watchful, exigent intellectualism. *Im Ganzen, Guten, Wahren, resolut zu leben:* is Goethe's description of his own higher life; and what is meant by life in the whole—*im Ganzen?* It means the life of one for whom, over and over again, what was once precious has become indifferent. Every one who aims at the life of culture is met by many forms of it, arising out of the intense, laborious, one-sided development of some special talent. They are the brightest enthusiasms the world has to show: and it is not their part to weigh the claims which this or that alien form of genius makes upon them. But the proper instinct of self-culture cares not so much to reap all that those various forms of genius can give, as to find in them its own strength. The demand of the intellect is to feel itself alive. It must see into the laws, the operation, the intellectual reward of every divided form of culture; but only that it may measure the relation between itself and them. It struggles with those forms till its secret is won from each, and then lets each fall back into its place, in the supreme, artistic view of life. With a kind of passionate coldness, such natures rejoice to be away from and past their former selves, and above all, they are jealous of that abandonment to one special gift which really limits their capabilities. It would have been easy for Goethe, with the gift of a sensuous nature, to let it overgrow him. It comes easily and naturally, perhaps, to certain "otherworldly" natures to be even as the *Schöne Seele,* that ideal of gentle pietism, in *Wilhelm Meister:* but to the large vision of Goethe, this seemed to be a phase of life that a man might feel

all round, and leave behind him. Again, it is easy to indulge the commonplace metaphysical instinct. But a taste for metaphysics may be one of those things which we must renounce, if we mean to mould our lives to artistic perfection. Philosophy serves culture, not by the fancied gift of absolute or transcendental knowledge, but by suggesting questions which help one to detect the passion, and strangeness, and dramatic contrasts of life.

But Goethe's culture did not remain "behind the veil": it ever emerged in the practical functions of art, in actual production. For him the problem came to be:—Can the blitheness and universality of the antique ideal be communicated to artistic productions, which shall contain the fulness of the experience of the modern world? We have seen that the development of the various forms of art has corresponded to the development of the thoughts of man concerning humanity, to the growing revelation of the mind to itself. Sculpture corresponds to the unperplexed, emphatic outlines of Hellenic humanism; painting to the mystic depth and intricacy of the middle age; music and poetry have their fortune in the modern world.

Let us understand by poetry all literary production which attains the power of giving pleasure by its form, as distinct from its matter. Only in this varied literary form can art command that width, variety, delicacy of resources, which will enable it to deal with the conditions of modern life. What modern art has to do in the service of culture is so to rearrange the details of modern life, so to reflect it, that it may satisfy the spirit. And what does the spirit need in the face of modern life? The sense of freedom. That naïve, rough sense of freedom, which supposes man's will to be limited, if at all, only by a will stronger than his, he can never have again. The attempt to represent it in art would have so little verisimilitude that it would be flat and uninteresting. The chief factor in the thoughts of the modern mind concerning itself is the intricacy, the universality of natural law, even in the moral order. For us, necessity is not, as of old, a sort of mythological personage without us, with whom we can do warfare. It is rather a magic web woven through and through us, like that magnetic system of which modern science speaks, penetrating us with a network, subtler than our subtlest nerves, yet

bearing in it the central forces of the world. Can art represent men and women in these bewildering toils so as to give the spirit at least an equivalent for the sense of freedom? Certainly, in Goethe's romances, and even more in the romances of Victor Hugo, we have high examples of modern art dealing thus with modern life, regarding that life as the modern mind must regard it, yet reflecting upon it blitheness and repose. Natural laws we shall never modify, embarrass us as they may; but there is still something in the nobler or less noble attitude with which we watch their fatal combinations. In those romances of Goethe and Victor Hugo, in some excellent work done *after* them, this entanglement, this network of law, becomes the tragic situation, in which certain groups of noble men and women work out for themselves a supreme *dénouement*. Who, if he saw through all, would fret against the chain of circumstance which endows one at the end with those great experiences?

1867.

CONCLUSION[1]

Λέγει που Ἡράκλειτος ὅτι πάντα
χωρεῖ καὶ οὐδὲν μένει

To regard all things and principles of things as inconstant modes of fashions has more and more become the tendency of modern thought. Let us begin with that which is without— our physical life. Fix upon it in one of its more exquisite intervals, the moment, for instance, of delicious recoil from the flood of water in summer heat. What is the whole physical life in that moment but a combination of natural elements to which science gives their names? But those elements, phosphorus and lime and delicate fibres, are present not in the human body alone: we detect them in places most remote from it. Our physical life is a perpetual motion of them—the passage of the blood, the waste and repairing of the lenses of the eye, the modification of the tissues of the brain under every ray of light and sound— processes which science reduces to simpler and more elementary forces. Like the elements of which we are composed, the action of these forces extends beyond us: it rusts iron and ripens corn. Far out on every side of us those elements are broadcast, driven in many currents; and birth and gesture and death and the springing of violets from the grave are but a few out of ten thousand resultant combinations. That clear, perpetual outline of face and limb is but an image of ours, under which we group

[1] This brief "Conclusion" was omitted in the second edition of this book, as I conceived it might possibly mislead some of those young men into whose hands it might fall. On the whole, I have thought it best to reprint it here, with some slight changes which bring it closer to my original meaning. I have dealt more fully in *Marius the Epicurean* with the thoughts suggested by it.

them—a design in a web, the actual threads of which pass out beyond it. This at least of flame-like our life has, that it is but the concurrence, renewed from moment to moment, of forces parting sooner or later on their ways.

Or if we begin with the inward world of thought and feeling, the whirlpool is still more rapid, the flame more eager and devouring. There it is no longer the gradual darkening of the eye, the gradual fading of colour from the wall—movements of the shore-side, where the water flows down indeed, though in apparent rest—but the race of the mid-stream, a drift of momentary acts of sight and passion and thought. At first sight experience seems to bury us under a flood of external objects, pressing upon us with a sharp and importunate reality, calling us out of ourselves in a thousand forms of action. But when reflexion begins to play upon those objects they are dissipated under its influence; the cohesive force seems suspended like some trick of magic; each object is loosed into a group of impressions—colour, odour, texture—in the mind of the observer. And if we continue to dwell in thought on this world, not of objects in the solidity with which language invests them, but of impressions, unstable, flickering, inconsistent, which burn and are extinguished with our consciousness of them, it contracts still further: the whole scope of observation is dwarfed into the narrow chamber of the individual mind. Experience, already reduced to a group of impressions, is ringed round for each one of us by that thick wall of personality through which no real voice has ever pierced on its way to us, or from us to that which we can only conjecture to be without. Every one of those impressions is the impression of the individual in his isolation, each mind keeping as a solitary prisoner its own dream of a world. Analysis goes a step further still, and assures us that those impressions of the individual mind to which, for each one of us, experience dwindles down, are in perpetual flight; that each of them is limited by time, and that as time is infinitely divisible, each of them is infinitely divisible also; all that is actual in it being a single moment, gone while we try to apprehend it, of which it may ever be more truly said that it has ceased to be than that it is. To such a tremulous wisp constantly re-forming itself

on the stream, to a single sharp impression, with a sense in it, a relic more or less fleeting, of such moments gone by, what is real in our life fines itself down. It is with this movement, with the passage and dissolution of impressions, images, sensations, that analysis leaves off—that continual vanishing away, that strange, perpetual, weaving and unweaving of ourselves.

Philosophiren, says Novalis, *ist dephlegmatisiren, vivificiren.* The service of philosophy, of speculative culture, towards the human spirit, is to rouse, to startle it to a life of constant and eager observation. Every moment some form grows perfect in hand or face; some tone on the hills or the sea is choicer than the rest; some mood of passion or insight or intellectual excitement is irresistibly real and attractive to us,—for that moment only. Not the fruit of experience, but experience itself, is the end. A counted number of pulses only is given to us of a variegated, dramatic life. How may we see in them all that is to be seen in them by the finest senses? How shall we pass most swiftly from point to point, and be present always at the focus where the greatest number of vital forces unite in their purest energy?

To burn always with this hard, gem-like flame, to maintain this ecstasy, is success in life. In a sense it might even be said that our failure is to form habits: for, after all, habit is relative to a stereotyped world, and meantime it is only the roughness of the eye that makes any two persons, things, situations, seem alike. While all melts under our feet, we may well grasp at any exquisite passion, or any contribution to knowledge that seems by a lifted horizon to set the spirit free for a moment, or any stirring of the senses, strange dyes, strange colours, and curious odours, or work of the artist's hands, or the face of one's friend. Not to discriminate every moment some passionate attitude in those about us, and in the very brilliancy of their gifts some tragic dividing of forces on their ways, is, on this short day of frost and sun, to sleep before evening. With this sense of the splendour of our experience and of its awful brevity, gathering all we are into one desperate effort to see and touch, we shall hardly have time to make theories about the things we see and touch. What we have to do is to be for ever curiously testing new

opinions and courting new impressions, never acquiescing in a facile orthodoxy, of Comte, or of Hegel, or of our own. Philosophical theories or ideas, as points of view, instruments of criticism, may help us to gather up what might otherwise pass unregarded by us. "Philosophy is the microscope of thought." The theory or idea or system which requires of us the sacrifice of any part of this experience, in consideration of some interest into which we cannot enter, or some abstract theory we have not identified with ourselves, or of what is only conventional, has no real claim upon us.

One of the most beautiful passages of Rousseau is that in the sixth book of the *Confessions*, where he describes the awakening in him of the literary sense. An undefinable taint of death had clung always about him, and now in early manhood he believed himself smitten by mortal disease. He asked himself how he might make as much as possible of the interval that remained; and he was not biassed by anything in his previous life when he decided that it must be by intellectual excitement, which he found just then in the clear, fresh writings of Voltaire. Well! we are all *condamnés*, as Victor Hugo says: we are all under sentence of death but with a sort of indefinite reprieve— *les hommes sont tous condamnés à mort avec des sursis indéfinis:* we have an interval, and then our place knows us no more. Some spend this interval in listlessness, some in high passions, the wisest, at least among "the children of this world," in art and song. For our one chance lies in expanding that interval, in getting as many pulsations as possible into the given time. Great passions may give us this quickened sense of life, ecstasy and sorrow of love, the various forms of enthusiastic activity, disinterested or otherwise, which come naturally to many of us. Only be sure it is passion—that it does yield you this fruit of a quickened, multiplied consciousness. Of such wisdom, the poetic passion, the desire of beauty, the love of art for its own sake, has most. For art comes to you proposing frankly to give nothing but the highest quality to your moments as they pass, and simply for those moments' sake.

1868.

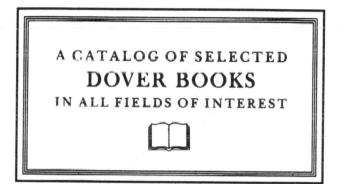

A CATALOG OF SELECTED
DOVER BOOKS
IN ALL FIELDS OF INTEREST

A CATALOG OF SELECTED DOVER BOOKS IN ALL FIELDS OF INTEREST

CONCERNING THE SPIRITUAL IN ART, Wassily Kandinsky. Pioneering work by father of abstract art. Thoughts on color theory, nature of art. Analysis of earlier masters. 12 illustrations. 80pp. of text. 5⅜ x 8½. 23411-8

ANIMALS: 1,419 Copyright-Free Illustrations of Mammals, Birds, Fish, Insects, etc., Jim Harter (ed.). Clear wood engravings present, in extremely lifelike poses, over 1,000 species of animals. One of the most extensive pictorial sourcebooks of its kind. Captions. Index. 284pp. 9 x 12. 23766-4

CELTIC ART: The Methods of Construction, George Bain. Simple geometric techniques for making Celtic interlacements, spirals, Kells-type initials, animals, humans, etc. Over 500 illustrations. 160pp. 9 x 12. (Available in U.S. only.) 22923-8

AN ATLAS OF ANATOMY FOR ARTISTS, Fritz Schider. Most thorough reference work on art anatomy in the world. Hundreds of illustrations, including selections from works by Vesalius, Leonardo, Goya, Ingres, Michelangelo, others. 593 illustrations. 192pp. 7⅛ x 10¼. 20241-0

CELTIC HAND STROKE-BY-STROKE (Irish Half-Uncial from "The Book of Kells"): An Arthur Baker Calligraphy Manual, Arthur Baker. Complete guide to creating each letter of the alphabet in distinctive Celtic manner. Covers hand position, strokes, pens, inks, paper, more. Illustrated. 48pp. 8¼ x 11. 24336-2

EASY ORIGAMI, John Montroll. Charming collection of 32 projects (hat, cup, pelican, piano, swan, many more) specially designed for the novice origami hobbyist. Clearly illustrated easy-to-follow instructions insure that even beginning papercrafters will achieve successful results. 48pp. 8¼ x 11. 27298-2

THE COMPLETE BOOK OF BIRDHOUSE CONSTRUCTION FOR WOOD-WORKERS, Scott D. Campbell. Detailed instructions, illustrations, tables. Also data on bird habitat and instinct patterns. Bibliography. 3 tables. 63 illustrations in 15 figures. 48pp. 5¼ x 8½. 24407-5

BLOOMINGDALE'S ILLUSTRATED 1886 CATALOG: Fashions, Dry Goods and Housewares, Bloomingdale Brothers. Famed merchants' extremely rare catalog depicting about 1,700 products: clothing, housewares, firearms, dry goods, jewelry, more. Invaluable for dating, identifying vintage items. Also, copyright-free graphics for artists, designers. Co-published with Henry Ford Museum & Greenfield Village. 160pp. 8¼ x 11. 25780-0

HISTORIC COSTUME IN PICTURES, Braun & Schneider. Over 1,450 costumed figures in clearly detailed engravings–from dawn of civilization to end of 19th century. Captions. Many folk costumes. 256pp. 8⅜ x 11¾. 23150-X

CATALOG OF DOVER BOOKS

STICKLEY CRAFTSMAN FURNITURE CATALOGS, Gustav Stickley and L. & J. G. Stickley. Beautiful, functional furniture in two authentic catalogs from 1910. 594 illustrations, including 277 photos, show settles, rockers, armchairs, reclining chairs, bookcases, desks, tables. 183pp. 6½ x 9¼. 23838-5

AMERICAN LOCOMOTIVES IN HISTORIC PHOTOGRAPHS: 1858 to 1949, Ron Ziel (ed.). A rare collection of 126 meticulously detailed official photographs, called "builder portraits," of American locomotives that majestically chronicle the rise of steam locomotive power in America. Introduction. Detailed captions. xi+ 129pp. 9 x 12. 27393-8

AMERICA'S LIGHTHOUSES: An Illustrated History, Francis Ross Holland, Jr. Delightfully written, profusely illustrated fact-filled survey of over 200 American lighthouses since 1716. History, anecdotes, technological advances, more. 240pp. 8 x 10¾. 25576-X

TOWARDS A NEW ARCHITECTURE, Le Corbusier. Pioneering manifesto by founder of "International School." Technical and aesthetic theories, views of industry, economics, relation of form to function, "mass-production split" and much more. Profusely illustrated. 320pp. 6¼ x 9¼. (Available in U.S. only.) 25023-7

HOW THE OTHER HALF LIVES, Jacob Riis. Famous journalistic record, exposing poverty and degradation of New York slums around 1900, by major social reformer. 100 striking and influential photographs. 233pp. 10 x 7⅞. 22012-5

FRUIT KEY AND TWIG KEY TO TREES AND SHRUBS, William M. Harlow. One of the handiest and most widely used identification aids. Fruit key covers 120 deciduous and evergreen species; twig key 160 deciduous species. Easily used. Over 300 photographs. 126pp. 5⅜ x 8½. 20511-8

COMMON BIRD SONGS, Dr. Donald J. Borror. Songs of 60 most common U.S. birds: robins, sparrows, cardinals, bluejays, finches, more–arranged in order of increasing complexity. Up to 9 variations of songs of each species.
Cassette and manual 99911-4

ORCHIDS AS HOUSE PLANTS, Rebecca Tyson Northen. Grow cattleyas and many other kinds of orchids–in a window, in a case, or under artificial light. 63 illustrations. 148pp. 5⅜ x 8½. 23261-1

MONSTER MAZES, Dave Phillips. Masterful mazes at four levels of difficulty. Avoid deadly perils and evil creatures to find magical treasures. Solutions for all 32 exciting illustrated puzzles. 48pp. 8¼ x 11. 26005-4

MOZART'S DON GIOVANNI (DOVER OPERA LIBRETTO SERIES), Wolfgang Amadeus Mozart. Introduced and translated by Ellen H. Bleiler. Standard Italian libretto, with complete English translation. Convenient and thoroughly portable–an ideal companion for reading along with a recording or the performance itself. Introduction. List of characters. Plot summary. 121pp. 5¼ x 8½. 24944-1

TECHNICAL MANUAL AND DICTIONARY OF CLASSICAL BALLET, Gail Grant. Defines, explains, comments on steps, movements, poses and concepts. 15-page pictorial section. Basic book for student, viewer. 127pp. 5⅜ x 8½. 21843-0

THE CLARINET AND CLARINET PLAYING, David Pino. Lively, comprehensive work features suggestions about technique, musicianship, and musical interpretation, as well as guidelines for teaching, making your own reeds, and preparing for public performance. Includes an intriguing look at clarinet history. "A godsend," *The Clarinet,* Journal of the International Clarinet Society. Appendixes. 7 illus. 320pp. 5⅜ x 8½. 40270-3

HOLLYWOOD GLAMOR PORTRAITS, John Kobal (ed.). 145 photos from 1926-49. Harlow, Gable, Bogart, Bacall; 94 stars in all. Full background on photographers, technical aspects. 160pp. 8⅜ x 11¼. 23352-9

THE ANNOTATED CASEY AT THE BAT: A Collection of Ballads about the Mighty Casey/Third, Revised Edition, Martin Gardner (ed.). Amusing sequels and parodies of one of America's best-loved poems: Casey's Revenge, Why Casey Whiffed, Casey's Sister at the Bat, others. 256pp. 5⅜ x 8½. 28598-7

THE RAVEN AND OTHER FAVORITE POEMS, Edgar Allan Poe. Over 40 of the author's most memorable poems: "The Bells," "Ulalume," "Israfel," "To Helen," "The Conqueror Worm," "Eldorado," "Annabel Lee," many more. Alphabetic lists of titles and first lines. 64pp. 5¹⁵⁄₁₆ x 8¼. 26685-0

PERSONAL MEMOIRS OF U. S. GRANT, Ulysses Simpson Grant. Intelligent, deeply moving firsthand account of Civil War campaigns, considered by many the finest military memoirs ever written. Includes letters, historic photographs, maps and more. 528pp. 6⅛ x 9¼. 28587-1

ANCIENT EGYPTIAN MATERIALS AND INDUSTRIES, A. Lucas and J. Harris. Fascinating, comprehensive, thoroughly documented text describes this ancient civilization's vast resources and the processes that incorporated them in daily life, including the use of animal products, building materials, cosmetics, perfumes and incense, fibers, glazed ware, glass and its manufacture, materials used in the mummification process, and much more. 544pp. 6¹/₈ x 9¹/₄. (Available in U.S. only.) 40446-3

RUSSIAN STORIES/RUSSKIE RASSKAZY: A Dual-Language Book, edited by Gleb Struve. Twelve tales by such masters as Chekhov, Tolstoy, Dostoevsky, Pushkin, others. Excellent word-for-word English translations on facing pages, plus teaching and study aids, Russian/English vocabulary, biographical/critical introductions, more. 416pp. 5⅜ x 8½. 26244-8

PHILADELPHIA THEN AND NOW: 60 Sites Photographed in the Past and Present, Kenneth Finkel and Susan Oyama. Rare photographs of City Hall, Logan Square, Independence Hall, Betsy Ross House, other landmarks juxtaposed with contemporary views. Captures changing face of historic city. Introduction. Captions. 128pp. 8¼ x 11. 25790-8

AIA ARCHITECTURAL GUIDE TO NASSAU AND SUFFOLK COUNTIES, LONG ISLAND, The American Institute of Architects, Long Island Chapter, and the Society for the Preservation of Long Island Antiquities. Comprehensive, well-researched and generously illustrated volume brings to life over three centuries of Long Island's great architectural heritage. More than 240 photographs with authoritative, extensively detailed captions. 176pp. 8¼ x 11. 26946-9

NORTH AMERICAN INDIAN LIFE: Customs and Traditions of 23 Tribes, Elsie Clews Parsons (ed.). 27 fictionalized essays by noted anthropologists examine religion, customs, government, additional facets of life among the Winnebago, Crow, Zuni, Eskimo, other tribes. 480pp. 6⅛ x 9¼. 27377-6

FRANK LLOYD WRIGHT'S DANA HOUSE, Donald Hoffmann. Pictorial essay of residential masterpiece with over 160 interior and exterior photos, plans, elevations, sketches and studies. 128pp. 9¼ x 10¾. 29120-0

THE MALE AND FEMALE FIGURE IN MOTION: 60 Classic Photographic Sequences, Eadweard Muybridge. 60 true-action photographs of men and women walking, running, climbing, bending, turning, etc., reproduced from rare 19th-century masterpiece. vi + 121pp. 9 x 12. 24745-7

1001 QUESTIONS ANSWERED ABOUT THE SEASHORE, N. J. Berrill and Jacquelyn Berrill. Queries answered about dolphins, sea snails, sponges, starfish, fishes, shore birds, many others. Covers appearance, breeding, growth, feeding, much more. 305pp. 5¼ x 8¼. 23366-9

ATTRACTING BIRDS TO YOUR YARD, William J. Weber. Easy-to-follow guide offers advice on how to attract the greatest diversity of birds. Birdhouses, feeders, water and waterers, much more. 96pp. 5³⁄₁₆ x 8¼. 28927-3

MEDICINAL AND OTHER USES OF NORTH AMERICAN PLANTS. A Historical Survey with Special Reference to the Eastern Indian Tribes, Charlotte Erichsen-Brown. Chronological historical citations document 500 years of usage of plants, trees, shrubs native to eastern Canada, northeastern U.S. Also comploto iden tifying information. 343 illustrations. 544pp. 6½ x 9¼. 25951-X

STORYBOOK MAZES, Dave Phillips. 23 stories and mazes on two-page spreads: Wizard of Oz, Treasure Island, Robin Hood, etc. Solutions. 64pp. 8¼ x 11. 23628-5

AMERICAN NEGRO SONGS: 230 Folk Songs and Spirituals, Religious and Secular, John W. Work. This authoritative study traces the African influences of songs sung and played by black Americans at work, in church, and as entertainment. The author discusses the lyric significance of such songs as "Swing Low, Sweet Chariot," "John Henry," and others and offers the words and music for 230 songs. Bibliography. Index of Song Titles. 272pp. 6½ x 9¼. 40271-1

MOVIE-STAR PORTRAITS OF THE FORTIES, John Kobal (ed.). 163 glamor, studio photos of 106 stars of the 1940s: Rita Hayworth, Ava Gardner, Marlon Brando, Clark Gable, many more. 176pp. 8⅜ x 11¼. 23546-7

BENCHLEY LOST AND FOUND, Robert Benchley. Finest humor from early 30s, about pet peeves, child psychologists, post office and others. Mostly unavailable else where. 73 illustrations by Peter Arno and others. 183pp. 5⅜ x 8½. 22410-4

YEKL and THE IMPORTED BRIDEGROOM AND OTHER STORIES OF YIDDISH NEW YORK, Abraham Cahan. Film Hester Street based on *Yekl* (1896). Novel, other stories among first about Jewish immigrants on N.Y.'s East Side. 240pp. 5⅜ x 8½. 22427-9

SELECTED POEMS, Walt Whitman. Generous sampling from *Leaves of Grass*. Twenty-four poems include "I Hear America Singing," "Song of the Open Road," "I Sing the Body Electric," "When Lilacs Last in the Dooryard Bloom'd," "O Captain! My Captain!"–all reprinted from an authoritative edition. Lists of titles and first lines. 128pp. 5³⁄₁₆ x 8¼. 26878-0

THE BEST TALES OF HOFFMANN, E. T. A. Hoffmann. 10 of Hoffmann's most important stories: "Nutcracker and the King of Mice," "The Golden Flowerpot," etc. 458pp. 5⅜ x 8½. 21793-0

FROM FETISH TO GOD IN ANCIENT EGYPT, E. A. Wallis Budge. Rich detailed survey of Egyptian conception of "God" and gods, magic, cult of animals, Osiris, more. Also, superb English translations of hymns and legends. 240 illustrations. 545pp. 5⅜ x 8½. 25803-3

FRENCH STORIES/CONTES FRANÇAIS: A Dual-Language Book, Wallace Fowlie. Ten stories by French masters, Voltaire to Camus: "Micromegas" by Voltaire; "The Atheist's Mass" by Balzac; "Minuet" by de Maupassant; "The Guest" by Camus, six more. Excellent English translations on facing pages. Also French-English vocabulary list, exercises, more. 352pp. 5⅜ x 8½. 26443-2

CHICAGO AT THE TURN OF THE CENTURY IN PHOTOGRAPHS: 122 Historic Views from the Collections of the Chicago Historical Society, Larry A. Viskochil. Rare large-format prints offer detailed views of City Hall, State Street, the Loop, Hull House, Union Station, many other landmarks, circa 1904-1913. Introduction. Captions. Maps. 144pp. 9⅜ x 12¼. 24656-6

OLD BROOKLYN IN EARLY PHOTOGRAPHS, 1865-1929, William Lee Younger. Luna Park, Gravesend race track, construction of Grand Army Plaza, moving of Hotel Brighton, etc. 157 previously unpublished photographs. 165pp. 8⅞ x 11¾. 23587-4

THE MYTHS OF THE NORTH AMERICAN INDIANS, Lewis Spence. Rich anthology of the myths and legends of the Algonquins, Iroquois, Pawnees and Sioux, prefaced by an extensive historical and ethnological commentary. 36 illustrations. 480pp. 5⅜ x 8½. 25967-6

AN ENCYCLOPEDIA OF BATTLES: Accounts of Over 1,560 Battles from 1479 B.C. to the Present, David Eggenberger. Essential details of every major battle in recorded history from the first battle of Megiddo in 1479 B.C. to Grenada in 1984. List of Battle Maps. New Appendix covering the years 1967-1984. Index. 99 illustrations. 544pp. 6½ x 9¼. 24913-1

SAILING ALONE AROUND THE WORLD, Captain Joshua Slocum. First man to sail around the world, alone, in small boat. One of great feats of seamanship told in delightful manner. 67 illustrations. 294pp. 5⅜ x 8½. 20326-3

ANARCHISM AND OTHER ESSAYS, Emma Goldman. Powerful, penetrating, prophetic essays on direct action, role of minorities, prison reform, puritan hypocrisy, violence, etc. 271pp. 5⅜ x 8½. 22484-8

MYTHS OF THE HINDUS AND BUDDHISTS, Ananda K. Coomaraswamy and Sister Nivedita. Great stories of the epics; deeds of Krishna, Shiva, taken from puranas, Vedas, folk tales; etc. 32 illustrations. 400pp. 5⅜ x 8½. 21759-0

THE TRAUMA OF BIRTH, Otto Rank. Rank's controversial thesis that anxiety neurosis is caused by profound psychological trauma which occurs at birth. 256pp. 5⅜ x 8½. 27974-X

A THEOLOGICO-POLITICAL TREATISE, Benedict Spinoza. Also contains unfinished Political Treatise. Great classic on religious liberty, theory of government on common consent. R. Elwes translation. Total of 421pp. 5⅜ x 8½. 20249-6

MY BONDAGE AND MY FREEDOM, Frederick Douglass. Born a slave, Douglass became outspoken force in antislavery movement. The best of Douglass' autobiographies. Graphic description of slave life. 464pp. 5⅜ x 8½. 22457-0

FOLLOWING THE EQUATOR: A Journey Around the World, Mark Twain. Fascinating humorous account of 1897 voyage to Hawaii, Australia, India, New Zealand, etc. Ironic, bemused reports on peoples, customs, climate, flora and fauna, politics, much more. 197 illustrations. 720pp. 5⅜ x 8½. 26113-1

THE PEOPLE CALLED SHAKERS, Edward D. Andrews. Definitive study of Shakers: origins, beliefs, practices, dances, social organization, furniture and crafts, etc. 33 illustrations. 351pp. 5⅜ x 8½. 21081-2

THE MYTHS OF GREECE AND ROME, II. A. Guerber. A classic of mythology, generously illustrated, long prized for its simple, graphic, accurate retelling of the principal myths of Greece and Rome, and for its commentary on their origins and significance. With 64 illustrations by Michelangelo, Raphael, Titian, Rubens, Canova, Bernini and others. 480pp. 5⅜ x 8½. 27584-1

PSYCHOLOGY OF MUSIC, Carl E. Seashore. Classic work discusses music as a medium from psychological viewpoint. Clear treatment of physical acoustics, auditory apparatus, sound perception, development of musical skills, nature of musical feeling, host of other topics. 88 figures. 408pp. 5⅜ x 8½. 21851-1

THE PHILOSOPHY OF HISTORY, Georg W. Hegel. Great classic of Western thought develops concept that history is not chance but rational process, the evolution of freedom. 457pp. 5⅜ x 8½. 20112-0

THE BOOK OF TEA, Kakuzo Okakura. Minor classic of the Orient: entertaining, charming explanation, interpretation of traditional Japanese culture in terms of tea ceremony. 94pp. 5⅜ x 8½. 20070-1

LIFE IN ANCIENT EGYPT, Adolf Erman. Fullest, most thorough, detailed older account with much not in more recent books, domestic life, religion, magic, medicine, commerce, much more. Many illustrations reproduce tomb paintings, carvings, hieroglyphs, etc. 597pp. 5⅜ x 8½. 22632-8

SUNDIALS, Their Theory and Construction, Albert Waugh. Far and away the best, most thorough coverage of ideas, mathematics concerned, types, construction, adjusting anywhere. Simple, nontechnical treatment allows even children to build several of these dials. Over 100 illustrations. 230pp. 5⅜ x 8½. 22947-5

THEORETICAL HYDRODYNAMICS, L. M. Milne-Thomson. Classic exposition of the mathematical theory of fluid motion, applicable to both hydrodynamics and aerodynamics. Over 600 exercises. 768pp. 6⅛ x 9¼. 68970-0

SONGS OF EXPERIENCE: Facsimile Reproduction with 26 Plates in Full Color, William Blake. 26 full-color plates from a rare 1826 edition. Includes "The Tyger," "London," "Holy Thursday," and other poems. Printed text of poems. 48pp. 5¼ x 7. 24636-1

OLD-TIME VIGNETTES IN FULL COLOR, Carol Belanger Grafton (ed.). Over 390 charming, often sentimental illustrations, selected from archives of Victorian graphics—pretty women posing, children playing, food, flowers, kittens and puppies, smiling cherubs, birds and butterflies, much more. All copyright-free. 48pp. 9¼ x 12¼. 27269-9

PERSPECTIVE FOR ARTISTS, Rex Vicat Cole. Depth, perspective of sky and sea, shadows, much more, not usually covered. 391 diagrams, 81 reproductions of drawings and paintings. 279pp. 5⅜ x 8½. 22487-2

DRAWING THE LIVING FIGURE, Joseph Sheppard. Innovative approach to artistic anatomy focuses on specifics of surface anatomy, rather than muscles and bones. Over 170 drawings of live models in front, back and side views, and in widely varying poses. Accompanying diagrams. 177 illustrations. Introduction. Index. 144pp. 8⅜ x11¼. 26723-7

GOTHIC AND OLD ENGLISH ALPHABETS: 100 Complete Fonts, Dan X. Solo. Add power, elegance to posters, signs, other graphics with 100 stunning copyright-free alphabets: Blackstone, Dolbey, Germania, 97 more—including many lower-case, numerals, punctuation marks. 104pp. 8⅛ x 11. 24695-7

HOW TO DO BEADWORK, Mary White. Fundamental book on craft from simple projects to five-bead chains and woven works. 106 illustrations. 142pp. 5⅜ x 8. 20697-1

THE BOOK OF WOOD CARVING, Charles Marshall Sayers. Finest book for beginners discusses fundamentals and offers 34 designs. "Absolutely first rate . . . well thought out and well executed."—E. J. Tangerman. 118pp. 7¾ x 10⅝. 23654-4

ILLUSTRATED CATALOG OF CIVIL WAR MILITARY GOODS: Union Army Weapons, Insignia, Uniform Accessories, and Other Equipment, Schuyler, Hartley, and Graham. Rare, profusely illustrated 1846 catalog includes Union Army uniform and dress regulations, arms and ammunition, coats, insignia, flags, swords, rifles, etc. 226 illustrations. 160pp. 9 x 12. 24939-5

WOMEN'S FASHIONS OF THE EARLY 1900s: An Unabridged Republication of "New York Fashions, 1909," National Cloak & Suit Co. Rare catalog of mail-order fashions documents women's and children's clothing styles shortly after the turn of the century. Captions offer full descriptions, prices. Invaluable resource for fashion, costume historians. Approximately 725 illustrations. 128pp. 8⅜ x 11¼. 27276-1

THE 1912 AND 1915 GUSTAV STICKLEY FURNITURE CATALOGS, Gustav Stickley. With over 200 detailed illustrations and descriptions, these two catalogs are essential reading and reference materials and identification guides for Stickley furniture. Captions cite materials, dimensions and prices. 112pp. 6½ x 9¼. 26676-1

EARLY AMERICAN LOCOMOTIVES, John H. White, Jr. Finest locomotive engravings from early 19th century: historical (1804–74), main-line (after 1870), special, foreign, etc. 147 plates. 142pp. 11⅜ x 8¼. 22772-3

THE TALL SHIPS OF TODAY IN PHOTOGRAPHS, Frank O. Braynard. Lavishly illustrated tribute to nearly 100 majestic contemporary sailing vessels: Amerigo Vespucci, Clearwater, Constitution, Eagle, Mayflower, Sea Cloud, Victory, many more. Authoritative captions provide statistics, background on each ship. 190 black-and-white photographs and illustrations. Introduction. 128pp. 8⅞ x 11¾. 27163-3

CATALOG OF DOVER BOOKS

LITTLE BOOK OF EARLY AMERICAN CRAFTS AND TRADES, Peter Stockham (ed.). 1807 children's book explains crafts and trades: baker, hatter, cooper, potter, and many others. 23 copperplate illustrations. 140pp. 4⅝ x 6. 23336-7

VICTORIAN FASHIONS AND COSTUMES FROM HARPER'S BAZAR, 1867–1898, Stella Blum (ed.). Day costumes, evening wear, sports clothes, shoes, hats, other accessories in over 1,000 detailed engravings. 320pp. 9⅜ x 12¼. 22990-4

GUSTAV STICKLEY, THE CRAFTSMAN, Mary Ann Smith. Superb study surveys broad scope of Stickley's achievement, especially in architecture. Design philosophy, rise and fall of the Craftsman empire, descriptions and floor plans for many Craftsman houses, more. 86 black-and-white halftones. 31 line illustrations. Introduction 208pp. 6½ x 9¼. 27210-9

THE LONG ISLAND RAIL ROAD IN EARLY PHOTOGRAPHS, Ron Ziel. Over 220 rare photos, informative text document origin (1844) and development of rail service on Long Island. Vintage views of early trains, locomotives, stations, passengers, crews, much more. Captions. 8¾ x 11¼. 26301-0

VOYAGE OF THE LIBERDADE, Joshua Slocum. Great 19th-century mariner's thrilling, first-hand account of the wreck of his ship off South America, the 35-foot boat he built from the wreckage, and its remarkable voyage home. 128pp. 5⅜ x 8½. 40022-0

TEN BOOKS ON ARCHITECTURE, Vitruvius. The most important book ever written on architecture. Early Roman aesthetics, technology, classical orders, site selection, all other aspects. Morgan translation. 331pp. 5⅜ x 8½. 20645-9

THE HUMAN FIGURE IN MOTION, Eadweard Muybridge. More than 4,500 stopped-action photos, in action series, showing undraped men, women, children jumping, lying down, throwing, sitting, wrestling, carrying, etc. 390pp. 7⅞ x 10⅜. 20204-6 Clothbd.

TREES OF THE EASTERN AND CENTRAL UNITED STATES AND CANADA, William M. Harlow. Best one volume guide to 140 trees. Full descriptions, woodlore, range, etc. Over 600 illustrations. Handy size. 288pp. 4½ x 6⅜. 20395-6

SONGS OF WESTERN BIRDS, Dr. Donald J. Borror. Complete song and call repertoire of 60 western species, including flycatchers, juncoes, cactus wrens, many more—includes fully illustrated booklet. Cassette and manual 99913-0

GROWING AND USING HERBS AND SPICES, Milo Miloradovich. Versatile handbook provides all the information needed for cultivation and use of all the herbs and spices available in North America. 4 illustrations. Index. Glossary. 236pp. 5⅜ x 8½. 25058-X

BIG BOOK OF MAZES AND LABYRINTHS, Walter Shepherd. 50 mazes and labyrinths in all—classical, solid, ripple, and more—in one great volume. Perfect inexpensive puzzler for clever youngsters. Full solutions. 112pp. 8¼ x 11. 22951-3

PIANO TUNING, J. Cree Fischer. Clearest, best book for beginner, amateur. Simple repairs, raising dropped notes, tuning by easy method of flattened fifths. No previous skills needed. 4 illustrations. 201pp. 5⅜ x 8½. 23267-0

HINTS TO SINGERS, Lillian Nordica. Selecting the right teacher, developing confidence, overcoming stage fright, and many other important skills receive thoughtful discussion in this indispensible guide, written by a world-famous diva of four decades' experience. 96pp. 5⅜ x 8½. 40094-8

THE COMPLETE NONSENSE OF EDWARD LEAR, Edward Lear. All nonsense limericks, zany alphabets, Owl and Pussycat, songs, nonsense botany, etc., illustrated by Lear. Total of 320pp. 5⅜ x 8½. (Available in U.S. only.) 20167-8

VICTORIAN PARLOUR POETRY: An Annotated Anthology, Michael R. Turner. 117 gems by Longfellow, Tennyson, Browning, many lesser-known poets. "The Village Blacksmith," "Curfew Must Not Ring Tonight," "Only a Baby Small," dozens more, often difficult to find elsewhere. Index of poets, titles, first lines. xxiii + 325pp. 5⅜ x 8¼. 27044-0

DUBLINERS, James Joyce. Fifteen stories offer vivid, tightly focused observations of the lives of Dublin's poorer classes. At least one, "The Dead," is considered a masterpiece. Reprinted complete and unabridged from standard edition. 160pp. 5³⁄₁₆ x 8¼. 26870-5

GREAT WEIRD TALES: 14 Stories by Lovecraft, Blackwood, Machen and Others, S. T. Joshi (ed.). 14 spellbinding tales, including "The Sin Eater," by Fiona McLeod, "The Eye Above the Mantel," by Frank Belknap Long, as well as renowned works by R. H. Barlow, Lord Dunsany, Arthur Machen, W. C. Morrow and eight other masters of the genre. 256pp. 5⅜ x 8½. (Available in U.S. only.) 40436-6

THE BOOK OF THE SACRED MAGIC OF ABRAMELIN THE MAGE, translated by S. MacGregor Mathers. Medieval manuscript of ceremonial magic. Basic document in Aleister Crowley, Golden Dawn groups. 268pp. 5⅜ x 8½. 23211-5

NEW RUSSIAN-ENGLISH AND ENGLISH-RUSSIAN DICTIONARY, M. A. O'Brien. This is a remarkably handy Russian dictionary, containing a surprising amount of information, including over 70,000 entries. 366pp. 4½ x 6⅛. 20208-9

HISTORIC HOMES OF THE AMERICAN PRESIDENTS, Second, Revised Edition, Irvin Haas. A traveler's guide to American Presidential homes, most open to the public, depicting and describing homes occupied by every American President from George Washington to George Bush. With visiting hours, admission charges, travel routes. 175 photographs. Index. 160pp. 8¼ x 11. 26751-2

NEW YORK IN THE FORTIES, Andreas Feininger. 162 brilliant photographs by the well-known photographer, formerly with *Life* magazine. Commuters, shoppers, Times Square at night, much else from city at its peak. Captions by John von Hartz. 181pp. 9¼ x 10¾. 23585-8

INDIAN SIGN LANGUAGE, William Tomkins. Over 525 signs developed by Sioux and other tribes. Written instructions and diagrams. Also 290 pictographs. 111pp. 6⅛ x 9¼. 22029-X

ANATOMY: A Complete Guide for Artists, Joseph Sheppard. A master of figure drawing shows artists how to render human anatomy convincingly. Over 460 illustrations. 224pp. 8⅜ x 11¼. 27279-6

MEDIEVAL CALLIGRAPHY: Its History and Technique, Marc Drogin. Spirited history, comprehensive instruction manual covers 13 styles (ca. 4th century through 15th). Excellent photographs; directions for duplicating medieval techniques with modern tools. 224pp. 8⅜ x 11¼. 26142-5

DRIED FLOWERS: How to Prepare Them, Sarah Whitlock and Martha Rankin. Complete instructions on how to use silica gel, meal and borax, perlite aggregate, sand and borax, glycerine and water to create attractive permanent flower arrangements. 12 illustrations. 32pp. 5⅜ x 8½. 21802-3

EASY-TO-MAKE BIRD FEEDERS FOR WOODWORKERS, Scott D. Campbell. Detailed, simple-to-use guide for designing, constructing, caring for and using feeders. Text, illustrations for 12 classic and contemporary designs. 96pp. 5⅜ x 8½. 25847-5

SCOTTISH WONDER TALES FROM MYTH AND LEGEND, Donald A. Mackenzie. 16 lively tales tell of giants rumbling down mountainsides, of a magic wand that turns stone pillars into warriors, of gods and goddesses, evil hags, powerful forces and more. 240pp. 5⅜ x 8½. 29677-6

THE HISTORY OF UNDERCLOTHES, C. Willett Cunnington and Phyllis Cunnington. Fascinating, well-documented survey covering six centuries of English undergarments, enhanced with over 100 illustrations: 12th-century laced-up bodice, footed long drawers (1795), 19th-century bustles, 19th-century corsets for men, Victorian "bust improvers," much more. 272pp. 5⅜ x 8¼. 27124-2

ARTS AND CRAFTS FURNITURE: The Complete Brooks Catalog of 1912, Brooks Manufacturing Co. Photos and detailed descriptions of more than 150 now very collectible furniture designs from the Arts and Crafts movement depict davenports, settees, buffets, desks, tables, chairs, bedsteads, dressers and more, all built of solid, quarter-sawed oak. Invaluable for students and enthusiasts of antiques, Americana and the decorative arts. 80pp. 6½ x 9¼. 27471-3

WILBUR AND ORVILLE: A Biography of the Wright Brothers, Fred Howard. Definitive, crisply written study tells the full story of the brothers' lives and work. A vividly written biography, unparalleled in scope and color, that also captures the spirit of an extraordinary era. 560pp. 6⅛ x 9¼. 40297-5

THE ARTS OF THE SAILOR: Knotting, Splicing and Ropework, Hervey Garrett Smith. Indispensable shipboard reference covers tools, basic knots and useful hitches; handsewing and canvas work, more. Over 100 illustrations. Delightful reading for sea lovers. 256pp. 5⅜ x 8½. 26440-8

FRANK LLOYD WRIGHT'S FALLINGWATER: The House and Its History, Second, Revised Edition, Donald Hoffmann. A total revision—both in text and illustrations—of the standard document on Fallingwater, the boldest, most personal architectural statement of Wright's mature years, updated with valuable new material from the recently opened Frank Lloyd Wright Archives. "Fascinating"—*The New York Times*. 116 illustrations. 128pp. 9¼ x 10¾. 27430-6

PHOTOGRAPHIC SKETCHBOOK OF THE CIVIL WAR, Alexander Gardner. 100 photos taken on field during the Civil War. Famous shots of Manassas Harper's Ferry, Lincoln, Richmond, slave pens, etc. 244pp. 10⅛ x 8¼. 22731-6

FIVE ACRES AND INDEPENDENCE, Maurice G. Kains. Great back-to-the-land classic explains basics of self-sufficient farming. The one book to get. 95 illustrations. 397pp. 5⅜ x 8½. 20974-1

SONGS OF EASTERN BIRDS, Dr. Donald J. Borror. Songs and calls of 60 species most common to eastern U.S.: warblers, woodpeckers, flycatchers, thrushes, larks, many more in high-quality recording. Cassette and manual 99912-2

A MODERN HERBAL, Margaret Grieve. Much the fullest, most exact, most useful compilation of herbal material. Gigantic alphabetical encyclopedia, from aconite to zedoary, gives botanical information, medical properties, folklore, economic uses, much else. Indispensable to serious reader. 161 illustrations. 888pp. 6½ x 9¼. 2-vol. set. (Available in U.S. only.) Vol. I: 22798-7
Vol. II: 22799-5

HIDDEN TREASURE MAZE BOOK, Dave Phillips. Solve 34 challenging mazes accompanied by heroic tales of adventure. Evil dragons, people-eating plants, blood-thirsty giants, many more dangerous adversaries lurk at every twist and turn. 34 mazes, stories, solutions. 48pp. 8¼ x 11. 24566-7

LETTERS OF W. A. MOZART, Wolfgang A. Mozart. Remarkable letters show bawdy wit, humor, imagination, musical insights, contemporary musical world; includes some letters from Leopold Mozart. 276pp. 5⅜ x 8½. 22859-2

BASIC PRINCIPLES OF CLASSICAL BALLET, Agrippina Vaganova. Great Russian theoretician, teacher explains methods for teaching classical ballet. 118 illus-trations. 175pp. 5⅜ x 8½. 22036-2

THE JUMPING FROG, Mark Twain. Revenge edition. The original story of The Celebrated Jumping Frog of Calaveras County, a hapless French translation, and Twain's hilarious "retranslation" from the French. 12 illustrations. 66pp. 5⅜ x 8½. 22686-7

BEST REMEMBERED POEMS, Martin Gardner (ed.). The 126 poems in this superb collection of 19th- and 20th-century British and American verse range from Shelley's "To a Skylark" to the impassioned "Renascence" of Edna St. Vincent Millay and to Edward Lear's whimsical "The Owl and the Pussycat." 224pp. 5⅜ x 8½. 27165-X

COMPLETE SONNETS, William Shakespeare. Over 150 exquisite poems deal with love, friendship, the tyranny of time, beauty's evanescence, death and other themes in language of remarkable power, precision and beauty. Glossary of archaic terms. 80pp. 5³⁄₁₆ x 8¼. 26686-9

THE BATTLES THAT CHANGED HISTORY, Fletcher Pratt. Eminent historian profiles 16 crucial conflicts, ancient to modern, that changed the course of civiliza-tion. 352pp. 5⅜ x 8½. 41129-X

THE WIT AND HUMOR OF OSCAR WILDE, Alvin Redman (ed.). More than 1,000 ripostes, paradoxes, wisecracks: Work is the curse of the drinking classes; I can resist everything except temptation; etc. 258pp. 5⅜ x 8½. 20602-5

SHAKESPEARE LEXICON AND QUOTATION DICTIONARY, Alexander Schmidt. Full definitions, locations, shades of meaning in every word in plays and poems. More than 50,000 exact quotations. 1,485pp. 6½ x 9¼. 2-vol. set.
Vol. 1: 22726-X
Vol. 2: 22727-8

SELECTED POEMS, Emily Dickinson. Over 100 best-known, best-loved poems by one of America's foremost poets, reprinted from authoritative early editions. No comparable edition at this price. Index of first lines. 64pp. 5³⁄₁₆ x 8¼. 26466-1

THE INSIDIOUS DR. FU-MANCHU, Sax Rohmer. The first of the popular mystery series introduces a pair of English detectives to their archnemesis, the diabolical Dr. Fu-Manchu. Flavorful atmosphere, fast-paced action, and colorful characters enliven this classic of the genre. 208pp. 5³⁄₁₆ x 8¼. 29898-1

THE MALLEUS MALEFICARUM OF KRAMER AND SPRENGER, translated by Montague Summers. Full text of most important witchhunter's "bible," used by both Catholics and Protestants. 278pp. 6⅛ x 10. 22802-9

SPANISH STORIES/CUENTOS ESPAÑOLES: A Dual-Language Book, Angel Flores (ed.). Unique format offers 13 great stories in Spanish by Cervantes, Borges, others. Faithful English translations on facing pages. 352pp. 5⅜ x 8½. 25399-6

GARDEN CITY, LONG ISLAND, IN EARLY PHOTOGRAPHS, 1869–1919, Mildred H. Smith. Handsome treasury of 118 vintage pictures, accompanied by carefully researched captions, document the Garden City Hotel fire (1899), the Vanderbilt Cup Race (1908), the first airmail flight departing from the Nassau Boulevard Aerodrome (1911), and much more. 96pp. 8⅜ x 11¾. 40669-5

OLD QUEENS, N.Y., IN EARLY PHOTOGRAPHS, Vincent F. Seyfried and William Asadorian. Over 160 rare photographs of Maspeth, Jamaica, Jackson Heights, and other areas. Vintage views of DeWitt Clinton mansion, 1939 World's Fair and more. Captions. 192pp. 8⅜ x 11. 26358-4

CAPTURED BY THE INDIANS: 15 Firsthand Accounts, 1750-1870, Frederick Drimmer. Astounding true historical accounts of grisly torture, bloody conflicts, relentless pursuits, miraculous escapes and more, by people who lived to tell the tale. 384pp. 5⅜ x 8½. 24901-8

THE WORLD'S GREAT SPEECHES (Fourth Enlarged Edition), Lewis Copeland, Lawrence W. Lamm, and Stephen J. McKenna. Nearly 300 speeches provide public speakers with a wealth of updated quotes and inspiration—from Pericles' funeral oration and William Jennings Bryan's "Cross of Gold Speech" to Malcolm X's powerful words on the Black Revolution and Earl of Spenser's tribute to his sister, Diana, Princess of Wales. 944pp. 5⅜ x 8⅜. 40903-1

THE BOOK OF THE SWORD, Sir Richard F. Burton. Great Victorian scholar/adventurer's eloquent, erudite history of the "queen of weapons"—from prehistory to early Roman Empire. Evolution and development of early swords, variations (sabre, broadsword, cutlass, scimitar, etc.), much more. 336pp. 6⅛ x 9¼. 25434-8

CATALOG OF DOVER BOOKS

AUTOBIOGRAPHY: The Story of My Experiments with Truth, Mohandas K. Gandhi. Boyhood, legal studies, purification, the growth of the Satyagraha (nonviolent protest) movement. Critical, inspiring work of the man responsible for the freedom of India. 480pp. 5⅜ x 8½. (Available in U.S. only.) 24593-4

CELTIC MYTHS AND LEGENDS, T. W. Rolleston. Masterful retelling of Irish and Welsh stories and tales. Cuchulain, King Arthur, Deirdre, the Grail, many more. First paperback edition. 58 full-page illustrations. 512pp. 5⅜ x 8½. 26507-2

THE PRINCIPLES OF PSYCHOLOGY, William James. Famous long course complete, unabridged. Stream of thought, time perception, memory, experimental methods; great work decades ahead of its time. 94 figures. 1,391pp. 5⅜ x 8½. 2-vol. set.
Vol. I: 20381-6 Vol. II: 20382-4

THE WORLD AS WILL AND REPRESENTATION, Arthur Schopenhauer. Definitive English translation of Schopenhauer's life work, correcting more than 1,000 errors, omissions in earlier translations. Translated by E. F. J. Payne. Total of 1,269pp. 5⅜ x 8½. 2-vol. set. Vol. 1: 21761-2 Vol. 2: 21762-0

MAGIC AND MYSTERY IN TIBET, Madame Alexandra David-Neel. Experiences among lamas, magicians, sages, sorcerers, Bonpa wizards. A true psychic discovery. 32 illustrations. 321pp. 5⅜ x 8½. (Available in U.S. only.) 22682-4

THE EGYPTIAN BOOK OF THE DEAD, E. A. Wallis Budge. Complete reproduction of Ani's papyrus, finest ever found. Full hieroglyphic text, interlinear transliteration, word-for-word translation, smooth translation. 533pp. 6½ x 9¼. 21866-X

MATHEMATICS FOR THE NONMATHEMATICIAN, Morris Kline. Detailed, college-level treatment of mathematics in cultural and historical context, with numerous exercises. Recommended Reading Lists. Tables. Numerous figures. 641pp. 5⅜ x 8½. 24823-2

PROBABILISTIC METHODS IN THE THEORY OF STRUCTURES, Isaac Elishakoff. Well-written introduction covers the elements of the theory of probability from two or more random variables, the reliability of such multivariable structures, the theory of random function, Monte Carlo methods of treating problems incapable of exact solution, and more. Examples. 502pp. 5⅜ x 8½. 40691-1

THE RIME OF THE ANCIENT MARINER, Gustave Doré, S. T. Coleridge. Doré's finest work; 34 plates capture moods, subtleties of poem. Flawless full-size reproductions printed on facing pages with authoritative text of poem. "Beautiful. Simply beautiful."–Publisher's Weekly. 77pp. 9¼ x 12. 22305-1

NORTH AMERICAN INDIAN DESIGNS FOR ARTISTS AND CRAFTSPEOPLE, Eva Wilson. Over 360 authentic copyright-free designs adapted from Navajo blankets, Hopi pottery, Sioux buffalo hides, more. Geometrics, symbolic figures, plant and animal motifs, etc. 128pp. 8⅜ x 11. (Not for sale in the United Kingdom.) 25341-4

SCULPTURE: Principles and Practice, Louis Slobodkin. Step-by-step approach to clay, plaster, metals, stone; classical and modern. 253 drawings, photos. 255pp. 8⅛ x 11. 22960-2

THE INFLUENCE OF SEA POWER UPON HISTORY, 1660–1783, A. T. Mahan. Influential classic of naval history and tactics still used as text in war colleges. First paperback edition. 4 maps. 24 battle plans. 640pp. 5⅜ x 8½. 25509-3

CATALOG OF DOVER BOOKS

THE STORY OF THE TITANIC AS TOLD BY ITS SURVIVORS, Jack Winocour (ed.). What it was really like. Panic, despair, shocking inefficiency, and a little heroism. More thrilling than any fictional account. 26 illustrations. 320pp. 5⅜ x 8½.
20610-6

FAIRY AND FOLK TALES OF THE IRISH PEASANTRY, William Butler Yeats (ed.). Treasury of 64 tales from the twilight world of Celtic myth and legend: "The Soul Cages," "The Kildare Pooka," "King O'Toole and his Goose," many more. Introduction and Notes by W. B. Yeats. 352pp. 5⅜ x 8½.
26941-8

BUDDHIST MAHAYANA TEXTS, E. B. Cowell and others (eds.). Superb, accurate translations of basic documents in Mahayana Buddhism, highly important in history of religions. The Buddha-karita of Asvaghosha, Larger Sukhavativyuha, more. 448pp. 5⅜ x 8½.
25552-2

ONE TWO THREE . . . INFINITY: Facts and Speculations of Science, George Gamow. Great physicist's fascinating, readable overview of contemporary science: number theory, relativity, fourth dimension, entropy, genes, atomic structure, much more. 128 illustrations. Index. 352pp. 5⅜ x 8½.
25664-2

EXPERIMENTATION AND MEASUREMENT, W. J. Youden. Introductory manual explains laws of measurement in simple terms and offers tips for achieving accuracy and minimizing errors. Mathematics of measurement, use of instruments, experimenting with machines. 1994 edition. Foreword. Preface. Introduction. Epilogue. Selected Readings. Glossary. Index. Tables and figures. 128pp. 5⅜ x 8½.
40451-X

DALÍ ON MODERN ART: The Cuckolds of Antiquated Modern Art, Salvador Dalí. Influential painter skewers modern art and its practitioners. Outrageous evaluations of Picasso, Cézanne, Turner, more. 15 renderings of paintings discussed. 44 calligraphic decorations by Dalí. 96pp. 5⅜ x 8½. (Available in U.S. only.)
29220-7

ANTIQUE PLAYING CARDS: A Pictorial History, Henry René D'Allemagne. Over 900 elaborate, decorative images from rare playing cards (14th–20th centuries): Bacchus, death, dancing dogs, hunting scenes, royal coats of arms, players cheating, much more. 96pp. 9¼ x 12¼.
29265-7

MAKING FURNITURE MASTERPIECES: 30 Projects with Measured Drawings, Franklin H. Gottshall. Step-by-step instructions, illustrations for constructing handsome, useful pieces, among them a Sheraton desk, Chippendale chair, Spanish desk, Queen Anne table and a William and Mary dressing mirror. 224pp. 8⅛ x 11¼.
29338-6

THE FOSSIL BOOK: A Record of Prehistoric Life, Patricia V. Rich et al. Profusely illustrated definitive guide covers everything from single-celled organisms and dinosaurs to birds and mammals and the interplay between climate and man. Over 1,500 illustrations. 760pp. 7½ x 10⅛.
29371-8